Paper Daughter

Paper
Daughter

A MEMOIR

M. Elaine Mar

HarperCollins*Publishers*

HarperCollins books may be purchased for educational, business, or sales promotional use. For information please write: Special Markets Department, HarperCollins Publishers, Inc., 10 East 53rd Street, New York, NY 10022.

FIRST EDITION

Designed by Kyoko Watanabe

Library of Congress Cataloging-in-Publication Data

ISBN 0-06-018293-8

99 00 01 02 03 ❖/HC 10 9 8 7 6 5 4 3 2 1

The Chinese term for "careful" is composed of the words "small" and "heart" in juxtaposition.

This book is for my parents,
who never taught me to keep a small heart.

contents

acknowledgments

I'm grateful to my family for allowing me to tell this story. Specifically, I want to thank Jeff and San for answering the most arcane questions at the most random times; my mother for talking about Hong Kong and China; and my father for believing that I could be the next Henry Kissinger. I also want to express my appreciation to Little Uncle (Lau King Wah), who took the author photo; thanks, *kow fu*, for a lovely afternoon.

For crucial advice in the earliest phase of this project, I would like to thank Dr. Ronald David, Craig Lambert, and Henning Gutmann.

For their unwavering support, careful editorial comments, and general good humor, I am indebted to Lane Zachary and Todd Shuster.

Peternelle Van Arsdale guided me through early drafts of the manuscript. Trena Keating picked up where Peternelle left off, reading more versions of this book more frequently than I thought humanly possible. Thanks to Peternelle for her passion, and to Trena for her faith.

I clap my hands fervently in admiration of the HarperCollins copy editors who verified details through absolutely ingenious means—a street atlas of my old Denver neighborhood, their own childhood memories of the game "heads-up-seven-up," and menus from their favorite Chinese restaurants, just to name a few. These efforts not only ensured the accuracy of the finished product, they actually made me laugh out loud.

Without David Potts, this book literally could not have been written. Thank you, David, for the PowerBook.

For his last-minute computer help and an entire autumn's worth of encouragement, I send my gratitude to Scott Fitzgerald.

I am also indebted to the following people, who have kept me together body and soul: Raquel Rosenblatt, Leon Bethune, Jane Stackpole, Tracey Wyatt, Mike Kidwell. Like my family, you are people for whom words can do no justice. I love you all very much.

A special thanks to:

Jessica Dorman, who read the damn thing (and answered the phone every time I freaked out, even in the middle of the night); Linda Cutting, who told me when to stop writing; Scott Horsley, *amigo para siempre*, who gave up being surprised a long time ago. Please don't ever go to Nantucket.

author's note

My family's language cannot be written.

We come from a small rural district called Toishan, located approximately ninety kilometers southwest of Canton, in the southeastern Chinese province of Guangdong. The provincial dialect, Guangdong (literally, "*Guangdonghua* language"), is known to English-speakers as Cantonese. Most people have never heard of the local dialect, which is called *Toishanhua* by the Chinese and Toishanese by Anglophones.

Although Toishanese and Cantonese are generally described as dialects within the Chinese language, they sound sufficiently different to be mutually incomprehensible—anyone who spoke Cantonese exclusively would need a translator to understand someone speaking Toishanese, and vice versa. Neither person would be able to understand Mandarin, the dialect promoted by the Chinese government as the national language.

The situation is mitigated somewhat by the written Chinese language, which is composed of non-phonetic pictographic characters that are common to all dialects. The structure of the written language, however, adheres to rules of Mandarin grammar and word usage. There are no official standards for written Cantonese or Toishanese; those who have been raised in these dialects simply make do, combining the rules of formal grammar with the rhythms of their own speech.

When I was three years old, my mother enrolled me in a Hong Kong school to learn this written language. I know very little of it anymore; I now express myself primarily in English.

Still, Chinese will always be my first language. I can only express certain types of hunger in Chinese. And once, seeing a painting of a woman leading a horse, I was startled into stillness, recognizing a pictogram in the painting's composition. Involuntarily I thought, *Mother*, seeing the black brush strokes of a Chinese character—the straight lines of the words "woman" and "horse" combined to form the word "mother"—rather than the grays and pinks and browns of the painting before my eyes. I know the pictogram for mother that deeply.

There are things I know in Chinese—primal, visceral things—that I will never know in English.

So I have chosen to use Chinese expressions in places throughout this

book, rather than substitute their English translations. To facilitate pro-
nunciation, I've romanized the Chinese—but according to the rhythms
of my own ear, rather than the accepted Wade-Giles or pinyin translit-
eration systems. I've made a similar decision with regard to family
names, spelling them in the manner to which my family has grown
accustomed, rather than one that might be considered correct.

Both Wade-Giles and pinyin transliterate based on the Mandarin
dialect. As explained above, my family communicates using Cantonese
and Toishanese. If I followed style manuals and transliterated according
to accepted academic standards, I would destroy everything that is pre-
cious to me about the Chinese language—the urgency, the intimacy, the
multiplicity of meaning that memory imparts. If I transliterated based
on the Mandarin dialect, I would be writing nonsense sounds. Sounds
that I don't understand, sounds that my family never uttered.

Determining the appropriate spelling of my family's names is a more
complicated issue. Their names have appeared in various ways on vari-
ous documents over the years, making it difficult to keep track of the
proper spellings. In some cases, it's hard even to determine how the
transliterated spelling originated.

The name Mar, for instance. In Chinese, it's clearly recognizable as
the character for horse, which is usually romanized as "Ma," and occa-
sionally as "Mah." The "m" sound, the soft "a." A sound like the word
for mother, but with a different tone. This is, in fact, how the Chinese
say horse—in Cantonese, Toishanese, *and* Mandarin. So it's a mystery
where the "r" in our spelling came from.

Perhaps it started as a government official's poorly-written "h."
Perhaps he truncated the stem and left the final leg lifted, causing the
letter to look like an "r." Perhaps my English-illiterate ancestors copied
this mistake faithfully and handed it down, arguing with all future gov-
ernment clerks that who protested the spelling.

I'll never know for sure. Only one thing is certain: "Mar" is improp-
erly transliterated, and it is the spelling of my name.

Over time, my family has settled into the versions of our names that
we know best or feel most comfortable with. My father is "Yat Shing,"
the two syllables written separately and capitalized in the Wade-Giles
manner, but without the connecting hyphen that Wade-Giles dictates.
My aunt is "Bik-Yuk," a textbook model. My uncle is confounded by
the concept of his name in English altogether. When forced to write his
name in this foreign language, he carefully prints "King W. Lau," plac-
ing the family name last and reducing one half of his given name to an
initial—altering Chinese convention beyond recognition in his imitation
of the Americans, whose habits he can't understand.

For the purposes of this book, my name is "Man Yee." On my birth certificate and passport, it's listed as "Man Yi." On my school and tax records, it's "Manyee." When filling out official documents, I always have to pause and double check before signing, to make sure I write the appropriate name. Otherwise, I would sign "M. Elaine Mar" automatically. Without hesitation. It's an indication of who I've become—the self expressed in English, preceded by the vestige of a name that cannot be written, ending with the mystery of one that will never leave me.

I

Chicken Bones and Mother's Milk

My memory begins with the taste of chicken blood. Coaxed from the two-bone middle section of the wing, the crack of bone splintering between my teeth, the clotted marrow heavy on my tongue—the memory of sweetness began before language, desire born before knowledge of the words to describe it.

Until I was five, I lived in a tenement house near the Hong Kong airport, on the Kowloon side of Victoria Harbour. Our building was a narrow eight-story walkup, a tired-looking column streaked dark with humidity and soot, faceless, unadorned, indistinguishable from any other building in the project. Inside, the walls were concrete, the stairways dimly lit, the landings littered with residents pausing to rest on their climb to the upper floors. Passing neighbors' hellos, their whines, complaints, and words of encouragement, were obscured by the roar of airplane engines vibrating through porous cinderblock.

My parents and I lived on the fourth floor—a stroke of luck, according to my mother, who recognized good fortune in any guise. She didn't mind that we shared a five-room flat with four other families; that our central hall stunk of salted fish and day-old rice; that water only ran three times a week. For her, it was

enough that we could make it home without once resting on the stairs. Home, with breath to spare—what more could we ask?

My father was different. He didn't talk about luck, preferring instead to rely on his own wits. He'd discovered our flat the old Cantonese way—through long afternoons grumbling in tea shops with his cronies, slipping housing inquiries in between puffs on his cigarette, in between the obligatory complaints about the government and Hong Kong's outrageous cost of living. He'd waited through the useless replies: the long-winded formulas for improving the economy; the canny, ever-changing predictions about Hong Kong's future; the wistful, oft-repeated plans to leave Kowloon's projects for untold riches in America. He'd listened to old men describe their latest ailments. He'd commiserated with the young ones who cursed their bosses. He'd nodded and sighed, swirling the tea at the bottom of his cup. And finally, after weeks of tea and cigarettes, he'd heard about the flat on Ying Yang Street, near the Hong Kong airport.

Four rooms each measuring ten feet by ten, a smaller fifth room, every room opening onto a central hallway. A toilet at the end of the hall, shielded by a sackcloth sheet. Enough floor space to cook in the entryway. Overall, the apartment totaled less than six hundred square feet—but the number was irrelevant: Who could afford an entire flat? One family, one room—that was the way we lived in Hong Kong.

My parents, newly married, chose one of the larger rooms, away from the stench of the hall toilet. They furnished it with a sturdy metal bunk bed, a chest of drawers, folding chairs, and a collapsible table. They filled the bureau's drawers with thin cotton undershirts, flannel pajamas, my mother's nylon stockings, my father's brown knit socks. On the bed's top bunk they stacked ricebowls and chopsticks, cases of noodles, sacks of rice, glass jars heavy with dried herbs and bark. Then, amid the foodstuffs' delicious wild scent, my parents lay, squeezed together on the bed's lower berth, blessing the room with their desire for a family.

Afterwards, duty-bound, my father set out for the tea shops again, spreading the news about rooms for rent.

My father was a carpenter who worked on a construction crew, building the skeletons of offices and apartments high into the sky. It was not a profession that he'd chosen, but one that had found him. In his youth, my father had been clever with his hands—he could weave birdcages out of twigs, repair any piece of broken furniture, create toys from scrap cloth. His hands were quick and gentle, able to capture baby birds without squeezing the breath from their lungs. They were hands that loved the feel of warm earth, hands that coaxed vegetables to spring from the sandy ground. As a boy of six or seven, my father had dreamed of the things he could do with these hands: He'd imagined becoming a farmer, a sculptor, an inventor. He'd imagined a future shaped by his own hands.

But the force of history had intervened. My father, *Mar Yat Shing*, was born to a peasant family in the Toishan region of China in 1930, two years into the military dictatorship of Chiang Kai-shek, one year before Japan seized Manchuria, presaging the invasion that was soon to come. These events—and their repercussions—came to shape my father's life more profoundly than any childhood games, his parents' stories, or the strength of his hands.

By the time Father was seven, China was at war with Japan. My understanding of this war comes primarily from textbooks—from them I know about the bombings, the forced-labor camps, the widespread famine. From these same books, I learned about the years that followed—the civil war between Chiang Kai-shek's Nationalists and Mao Tse-tung's Communists, Mao's ascension to power, the decades of violence afterwards. I'm a good student. I've read a lot. But I still don't understand what my father lived through.

In truth, I know very little about the early part of my father's life—he prefers not to talk about those years, and I'm required to respect his silence. Ours is a culture that expects the young to revere elders, women to revere men. Forever his child, forever female, I am not allowed to ask any questions. I am not supposed to know about my father's weaknesses.

At the age of twelve, while China was still at war with Japan, my father started smoking, a sign of manhood. He rationed his smiles, saving laughter for the rare soccer game or bicycle ride, those reminders of childhood pleasure. He caught songbirds in the yard and kept them in bamboo cages. He marveled at their tiny talons, the flutter of their wings, their high-pitched voices. He fed them rice and water until they were plump. Then his family killed them for food.

Huddled on a packed-dirt floor with his parents and four siblings, listening to the sound of war outside, my father remembered how much he'd loved school. He remembered being so excited that he would arrive at school early, before the other kids, before his brothers and sisters. Almost dizzy with anticipation, he hadn't minded waiting on the front steps, crouched down, squatting like a little man, blowing into cupped hands to keep warm. He remembered the first day classes were canceled due to war. He remembered the long wait outside the building, the artillery sounds nearby, the Japanese soldiers shooing him home. Lying there on the floor, he thought about returning to school. He imagined the chill of the early-morning air, the vaporous breath escaping his mouth. He cupped his hands and blew into them.

He returned to school eventually, though for how long, I don't know. To this day, I'm not sure how much education my father got—it's yet another question I can't ask.

In 1957, when he was twenty-seven, my father moved to Hong Kong, leaving his parents and two brothers behind. His family was starving, he was desperate for work, and he'd heard that there were plenty of jobs in Hong Kong. His two sisters, Bik-Ying

and Bik-Yuk, had left Toishan already. Bik-Ying had been married off to a Chinese living in America. Bik-Yuk had married someone in Hong Kong.

Unfortunately, the highest-paying jobs in the British Crown Colony required a knowledge of English—which my father didn't have. He only spoke Toishanese and a bit of Cantonese that fit awkwardly in his mouth. Still, he was thrilled by the vibrancy of city life. He attended soccer matches and saw movies like *Ben-Hur* and *West Side Story*, with Chinese subtitles. He wore narrow-lapeled suits in varying shades of gray, dove to slate, with thick-soled black shoes and skinny ties. He permed his hair, a sign of the hip, modern man. With his clever hands, he became a carpenter. As long as he remained healthy, he had work.

My father was thirty-five when he married, thirty-six when I was born—an old man, by his own reckoning: "Too old," he used to lament, sitting in the middle chair at the barbershop in our Denver neighborhood. These two words, spoken in English, had the weight of a confession, heavy with the memory of childhood, of the many things he'd wished for but never accomplished. And I, aged nine or ten, watching him from a hard plastic chair against the wall, could never understand how he thought himself a failure. I could only see the man whose gentle hands had carried me through the streets of Hong Kong, the man whose clever hands had twisted scrap cloth into makeshift dolls for a daughter who had no other toys.

I can only remember my mother's age by adding twenty-five to my own. It's that hard to imagine her life before me. With a child's egoism, I believe that my body shaped hers, rather than the other way around. I've never called her by a diminutive. She burst forth fully formed from my lips: *Mother.*

Strapped to her back, clutching her hand, curled against her in sleep. When I was a child, we were never apart, and I don't know

the moment when I became separate, don't know when thoughts and memories became my own, don't remember when I learned to say *I*.

My mother, *Lau Woon Ching*, was born in the Toishan region of China in 1941. She was one of four, my grandmother's last baby, born only a few months before my grandfather left the family in Toishan to find work in the U.S. They were starving, so of course he had to go, what can you do? Like many sojourner laborers, he left with a promise to return. But one year became five, and five became twenty, and still he wasn't a rich man, not rich enough to retire and move home. So he satisfied himself by sending money orders and letters scrawled on thin blue aerogramme paper. And Mother had to be content with these signs that her father existed.

There was no possibility of the family joining him in America. For over half a century no Chinese had been allowed to enter the country. Americans had complained about the small-boned foreigners stripping the gold fields and stealing the railroad jobs, so they had to be stopped. In 1882 the United States Congress had passed a law banning the entry of Chinese laborers. In order to circumvent the immigration restrictions, Grandfather traveled under an assumed name, as an American. He purchased fake identity documents, becoming the "son" of an already-arrived Chinese man. During those years, birthing "paper sons" was a lucrative business; enterprising Chinese-American immigrants recorded one new child per year, always male. Once in America, some paper sons reverted to their original names. My grandfather did not. Born in Toishan without documentation, he lived out his life in America with the only name recognized by law. Alone.

For many years, Grandmother and the children remained in China. Every night, Grandmother gathered the children around her for the lessons that would ensure memory of their father. Mother sat with her siblings, shoulder to shoulder, on a hand-sewn mattress low to the floor. They tried not to fidget when the rag stuffing balled and pressed into their buttocks. Slowly,

Grandmother spoke the names of the children, their parents, and their grandparents, pausing between enunciations. When she finished, the children took turns reciting their ancestry. Ordinarily, they called each other by familial terms—*big sister, big brother, little sister, little brother.* They spoke the formal names only during instruction time, preserving history.

"Your father is doing his duty," Grandmother said. And the children shivered at the word *duty,* more powerful than *love* in the Chinese language.

In this way, Mother came to accept her father's absence as one more sacrifice that individuals make for family. Because he immigrated to the U.S. shortly after her birth, Mother has no memory of Grandfather's face, not even in photographs. When he died in Washington, D.C. in 1969, she only said, "He grew too fat. His blood was no good."

My grandmother's lessons. The sound of war. The word *hunger.* Mother reveals little about her life in mainland China, so this part is not mine to tell. I know only that her family survived on Grandfather's wages, because nobody else could find work. In 1958, starving, my mother, age seventeen, moved to Hong Kong with Grandmother and my two uncles. My aunt remained in China with her husband and children.

The relocation disappointed my mother. In Hong Kong she discovered the disadvantages of not speaking English. She wandered from building to building, looking for work, only to be turned away. She spoke three dialects, Toishanese, Cantonese, and Mandarin—each so different it's surprising they're all called Chinese, like saying French, Spanish, and Italian are the same because they're Romance languages. But she didn't speak English, and frustrated by rejection, thought herself too old to learn. She decided to take odd jobs wherever she could, no matter how menial. Money was money, what could she do? With her first pay,

my mother bought two new pairs of chopsticks, one for herself, and one for my grandmother.

Eventually, her brothers managed to find steady work. Her eldest brother, whom I came to know as "Big Uncle," was a clerk in a jewelry store. Her second brother, "Little Uncle," turned out piecework in a clothing factory. Big Uncle married but never had children—a tragedy the Chinese do not discuss. Little Uncle remained single. He lived with Grandmother, accepting her care as his duty, a role that Mother would have chosen happily, if marriage weren't the greater duty for Chinese women.

A traditional Chinese, she saw herself in relation to family. She was a daughter, sister, and aunt. She spent her life waiting to become a mother. In late 1964, when she was twenty-three, family members arranged a meeting with my father. They were ready for marriage. "It's what we all need to do," Mother explains simply. "How else can we have children?"

My parents married in November 1965. A marriage license and banquet pictures verify the union. I was born on Chinese National Day the following year—October 1, 1966. A month later, on November 2, 1966, my parents paid $1.50 to list my birth with the Registrar General's Department, Hong Kong. I was the first in our family to have this honor, the first life documented on paper.

My father shocked relatives with his happiness at my birth—he should have wanted a boy. Instead, he insisted that I was the baby he wanted all along. "What could be better than a girl?" he asked.

"Hew! Crazy man, don't say such things!" the stunned relatives cautioned.

Father only laughed. He lit another cigarette.

My parents named me *Man Yee*, two characters meaning "intelligence" and "righteousness," respectively. They chose *Man* hoping that I would be smart, and *Yee* to commemorate Mao's Cultural Revolution. To my father, I am either a reference point for history or vice versa. All my life, he has said to me, "You were born on a

special day, do you know that? 1966 is important for the Chinese, do you know that?" These words became as familiar as a nursery rhyme or the sound of my own name. But as a little girl, I didn't understand their significance; I accepted the questions only as proof of my importance in Father's life. I had not yet learned that history and culture were irrevocably bound to my identity.

My parents took me home to the fourth-floor flat on Ying Yang Street, the ten-by-ten room rich with the smell of dried herbs and bark. They laid me to rest between them on their bunk bed's bottom berth. Outside, thieves wandered the streets and airplanes took off for the fabled gold mountains of America. I was oblivious to these happenings. Safely nestled between my parents, I believed, as Mother did, that we were the luckiest people on earth.

Due to the shortage of housing in Hong Kong, my father had quickly found tenants for the flat's other rooms: A single woman in her twenties moved into the room next door. In the two rooms across the hall, there were a pair of brothers, thirtyish, and two young parents with a child my age. And at the end of the hall, in the smallest room of all, a grandmother lived with her two adult grandsons.

To show respect, I called the adults "aunt," "uncle," or "grandmother." But because I was slightly older than the baby, I was allowed to call her *Moy-moy*, meaning "little sister." She, in turn, called me *Jia-jia*—"big sister." Understanding the importance of seniority, I was proud to be accorded such status.

The families requested permission before visiting one another, we padlocked our doors before going out, we never loitered in the hall—living in such small quarters, we needed this strict code of conduct to have any privacy at all. From birth, I was expected to abide by the adults' rules: A good baby didn't cry. She was tidy. She didn't raise her voice. She helped with the housework.

I did the best that I could, mimicking Mother's voice, which was always so soft that it could barely be heard, even when she was angry. I greeted visitors in adult tones, asking after their health and offering them refreshments. I learned to play quietly in the corners of our room, demanding nothing from the adults. In return, I was praised as "clever," a compliment invariably twinned with the words "well-behaved"—which, in Chinese, translates exactly as "listens to instructions."

"Your daughter is so clever," Moy-moy's mother said to mine, her eyes averted, habitually self-deprecating. "Our daughter is foolish by comparison! Every night we tell her, 'If only you could be a little more like Big Sister across the hall!'"

"Ah, no," Mother replied, understanding these remarks for what they were—a friendly neighbor's show of respect, politeness that must be answered with an equal degree of self-effacement. "Little Yee listens well, we're grateful for that," she continued. "But there must have been ten thousand things she did wrong yesterday! Not so quiet and feminine as Moy-moy!"

Mother leaned forward and clucked Moy-moy under the chin. "Isn't that right, Moy-moy?" she cooed, her voice suddenly genuine. "Aren't you cute?"

As if on cue, Moy-moy's mother exclaimed, "Isn't auntie kind! Oh, see how much she likes you!"

Moy-moy, who was two, tottered off to fetch her chamberpot for me, prompting laughter from the two mothers. "See how much she likes you, little Yee?" they asked. Perched on the rim of Moy-moy's toilet, I began to understand the meaning of subservience, a proxy for affection in our culture.

Relatives said that I looked like my father—the same square forehead, the same serious eyes. In a culture where physical attributes

were believed to determine character, the resemblance was seen as a mixed blessing.

"Shing's a pretty boy, that's for sure," Aunt Bik-Yuk chuckled, "look how carefully he combs his hair! But he has such fierceness, such passion!" She grimaced. "These traits aren't so good for a girl." She studied my face with a pitying expression.

"We'll teach her to be feminine," Mother promised. "Yee will always wear dresses. We'll grow her hair long and protect her skin from the sun. She'll be pale as a movie star."

Father laughed, dismissing the women's foolish notions. "Yee's a little child! All little children are the same—they like to make noise, dance in the dirt, so what? Boys, girls, it doesn't matter, they all like to roughhouse. The most we can do is feed her, comb her hair, wash her face and feet before bed. She'll turn out fine!" He squinted at the meal laid out in front of him. "Yee, are you hungry yet?"

I nodded, and he pulled me onto his lap.

"Here, a chicken leg, how about that, huh?" He passed me a drumstick, which I proceeded to devour in big, furious bites.

My aunt watched in horror. "So extreme!" she gasped. "I'm warning you now: Drive that fierceness out of her, or you'll be in trouble. How will you ever marry off a daughter like that?"

It was true: Whenever Father was home, I'd forget how to be feminine. I would laugh as loudly as he did. I would slurp at my soup. I would climb onto his lap or dance around our visitors' legs, begging for attention. One time, I became so rowdy that I actually yanked down a family friend's pants, exposing his naked genitals.

"*Aiya!*" the friend exclaimed, doubling over to cover himself.

"You're not wearing underwear!" Mother blurted.

"Time to leave, we've stayed too long!" the man's wife cried.

"More tea?" Mother said quickly.

"These things happen," Father choked out, before collapsing in giggles.

And suddenly the man was laughing too. "These elastic pants!" he sputtered. "Never wear elastic pants around children!"

"*Aiya!*" his wife said, her face red with embarrassment.

Mother could no longer control herself; she rocked forward, laughing so hard tears streamed from her eyes. So finally the wife had to join in, she had to admit it was funny.

Watching the adults and delighting in their mix of embarrassment and hilarity, I reached for the man's pants again.

"Ah, Yee, no," Mother gasped, pulling me away.

"Too clever," the man wheezed, holding his pants tight to his waist. "So young to be so clever."

"Mischievous," Mother corrected. "Not clever. Mischievous."

I clapped my hands. I didn't care what the word was. I just wanted to make everyone laugh.

Mother worked hard to reform me. Whenever I jumped on the floor, she'd whisper, "Quietly, gently. Remember your modesty—you're a little girl!"

At the sound of airplanes overhead, she covered my ears. "Remember to be frightened," she instructed.

Hearing her, Father lifted me to the window defiantly. "See that?" he asked, pointing to a streak of white raking the sky. "That's an airplane trail. Say 'Wow!'"

"Wow!" I laughed.

Mother lowered me to the floor and covered my ears. "You're spoiling her," she hissed at Father.

"Ah, don't fuss," Father grumbled, waving her away. He lit a cigarette. Mother sighed. Then, because he was the father, male, the acknowledged head of our family, she obeyed—she silenced.

* * *

Only on water days did Mother lose her sense of decorum. Water was precious, piped in from mainland China three times a week, four hours at a time, from 4:00 P.M. to 8:00 P.M. Anticipating these days, my parents used to collect the largest containers they could find—pots, bowls, barrels, anything at all. And when water flowed, they would race the other families down the hallway, elbows and arms flying, rushing to gather enough for the days in between. During these hours, Mother didn't care about being quiet, she didn't care about modesty, she didn't care if she shoved a man out of the way. We needed this water, and she was going to collect her due.

We stored the water in the corners of our room, in pots, bowls, barrels, anything at all. Overnight, microbes bred and parasites flourished. We couldn't drink any water without boiling it first. Years later, when I moved to the U.S., the first taste of cold water was like a miracle to me.

Every day at 3:30, while Father was still at work, Mother and I went to buy "accompaniments" for the evening meal—rice being the main course. My job was to remind Mother when it was time to go. As soon as I awoke in the morning, I would ask, "Is it three-thirty yet?" Mother always said no. All through the day, the same question, the same answer, until the sun slanted in a lazy, three-thirty-ish way, and Mother finally answered *yes*. I laughed out loud, glad to have done my job. Mother quickly tidied my hair, slipped her hand into mine, and we were out the door.

The markets near our apartment were always crowded. No one in that neighborhood had a refrigerator, so we all shopped for one meal at a time. Women and men squeezed up to the storefronts, examining the produce piled in boxes near the doors. *How much for the bok choy? Are the green beans fresh? How dare you charge that for pears?* the customers' voices screeched.

Ah, missus, a deal for you, I promise! Look at this tofu, so deli-

cate, doesn't your mouth water at the sight? the shopkeepers replied.

Fish stared blank-eyed from beds of shaved ice. Clams rattled as they were poured from buckets into plastic bags. Nearby, a chicken squawked. Seconds later, the air thickened with the scent of fresh blood. On the corner, golden egg custards gleamed in the window of a bakery. "Mother, let's go there!" I squealed.

Mother laughed knowingly. "Crazy girl, we can't eat egg custards every day!"

I tugged on her hand. "Just a look?" I wheedled. And she would indulge me by standing in front of the bakery window for several long minutes, letting me breathe in the odor of my favorite sweets.

We were only allowed to spend a dollar a day on accompaniments. Mother searched hard for good deals—that one handful of watercress to boil with pork bones, that bit of fish to steam with ginger and scallions. It was only on special occasions that money didn't matter. On those days we listened to the spirits. For instance, eating chicken gave you luck, so Mother always bought a whole one for the lunar new year. "Always take a little bite, just one, even if you're not hungry," she taught me. "Otherwise the spirits will be angry."

I nodded solemnly. I didn't know who the spirits were, I only wanted to obey Mother. I wanted to be the perfect child.

On the way home, we passed a store with feather dusters in the window. Mother pointed. "Do you know? That's what parents use to beat their children."

Wide-eyed, I asked, "Why?"

"To teach them. A good mother needs to teach her children right from wrong. When children misbehave, when they don't do as their mothers say, they need to be hit. It's the only way."

I was confused. I said, "Father hits my legs sometimes. But I don't do anything wrong."

"He *pats* your legs," Mother corrected. "Hitting's different. It

CHICKEN BONES AND MOTHER'S MILK ❀ 15

hurts—like when you bump your head." Noting my expression, she added, "Don't worry, you're still too little to hit."

I didn't feel any better. Shivering, I pulled my mother across the street. I didn't like this store.

At home, Mother prepared our meal in the hallway. I peeked out at her from our room's open door.

"Little daughter, have you lost your senses?" she admonished. "If you leave the door open, the smell of food will stink us to death! How will we sleep at night? Come into the hall or stay inside."

I ducked my head in shame. I should have known better—I was a big girl, almost three! Closing the door, I crept out and leaned against the wall.

Mother stuck her hand flat in the rice pot. "Look here," she said, pointing to the back of her hand. Water covered her fingers and knuckles, stopping just below the point where her thumb joint curved into her wrist. "This is how you measure the water for rice. First you wash the rice, then you pour water over it. To here. Always put your hand in the pot to test. Understand?"

I nodded.

Mother removed her hand from the pot. Water swished and settled. Beneath the liquid lay a dense bed of rice, a mosaic of white on white. Mother set a small metal rack inside the pot. On top of this she placed a small bowl of fish and salted eggs. She covered the pot and plugged it in. The accompaniments would steam-cook with the rice.

She said, "Let's go back inside to wait. It's best not to clutter the hallway—our neighbors need to cook too, you know."

Dinner was ready by the time Father got home. Mother boiled him a cup of water, and he set up our folding table, which crowded our

room so there was barely room to move. I helped serve the meal, carrying Father's full ricebowl in from the hallway, cradling it carefully in my two hands. After I'd brought in his bowl, my mother's, and my own, I was allowed to sit. But before I could take a single bite, I needed to show my respect by asking my parents to begin. Solemnly, I said, "Please, Father, eat. Please, Mother, eat."

If we had guests, I needed to repeat the gesture with each of them. Etiquette dictated that I mention each person in order of seniority, male before female. Fascinated by the mysteries of hierarchy and relationship, I was strangely enamored of this exercise. I loved to puzzle out who belonged to whom, who was older, younger, more or less powerful, and why. Over time, my ability to determine these things became almost instinctual, so that I could sit at a table full of strangers and, without prompting, bid them all to eat in the proper order ahead of me.

For food that couldn't be prepared in our electric rice pot, we had a small, kerosene-powered camp stove. Mother made soups and stir-fries on it. Because soups took a long time, they were reserved for special days—the August moon festival, the lunar new year, Father's days off. Stir-fries were quick but required a strong flame, so we rarely ate these, either—Mother was afraid that the flame would jump up and burn her.

She made noodles on lazy days. This was easy, just a big pot of ramen, the broth enhanced with fresh vegetables and hot pepper flakes. My parents called the ramen "doll noodles," because the packages came with stickers that depicted round-faced cartoon children slurping wavy pasta strings. Each bag contained a different two-inch drawing, with eight or ten variations in all. My favorite was the one of a girl feeding herself with chopsticks held between her toes. I often threatened to try this pose, but ended up laughing too hard to succeed. When we ate doll noodles, I wore the stickers on my shirt. I loved lazy days.

On special occasions the entire family went for tea. *Yum cha,* we said, "drink tea," referring to the ritual Americans call *dim sum.* We ate at the storefront restaurants in our neighborhood, inviting friends and relatives for feasts of chicken feet, solid lumps of boiled cow's blood, and sweet egg custards in flaky pastry shells. After each meal the adults fought over the bill, and even as a little girl I understood the argument: You dishonored the host by paying, but you dishonored your family by not offering.

Laughing adults, pretty clothes, golden custards, digging baby clams from their shells—I looked forward to all these things. But nothing could compare to the two-bone middle section of chicken wings. I *liked* everything else. I *craved* chicken wings. A true Cantonese, I never cared about the meat; I wanted the bones. Watching the adults, I learned to crack the thin-shelled, hollow bones with my milk teeth, voraciously sucking out heavy, clotted marrow. In an overcooked chicken, it clumped, soil-brown and mealy, almost not worth the effort. In one done just right, it spilled out bright red, the color of life, rich and smooth on the tongue. I hungered for that fertile interior where blood cells begin: I wanted to eat the bird's soul.

The adults wouldn't feed me cow's blood—it's too hearty and luxurious for the young. Chicken marrow warm in my greedy mouth, I watched my parents enviously. My legs dangled from the chair seat. I swung them faster, propelling myself to adulthood.

For the first five years of my life, my bare feet never touched the ground. I wouldn't get out of bed in the morning without a pair of plastic slippers on my feet. If we left the house, I traded these for red leather baby shoes, or, as I grew older, shiny black Mary Janes. In Hong Kong, this behavior meant a good upbringing, since only the most uneducated, ill-mannered peasant went without shoes.

From earliest childhood, I was taught that a person's manners were determined by her clothes. According to Mother, a proper lady always wore dresses, never pants. A lady's hair was always coifed, her shoes always shined. Likewise, men shouldn't be seen in public without jackets and ties. Male or female, your outfits should always match. Your shoes and purse should be the same color.

"But Mother," I pointed out, "you wear pants to the market."

"Rotten girl, don't be so clever," Mother snapped. "I'm old and married, it doesn't matter anymore. But you listen to what I say. Act like a little lady, wear nice dresses, and don't muss your clothes. Otherwise, people on the streets will shame you. You won't be allowed in restaurants or stores. People might even think you're crazy; they'll call the police to come get you."

"Yes, Mother," I answered quickly, terrified of the police.

Only the elderly were exempted from these rules. "Live a long life, reap the rewards," Mother said.

"Like Po-po?" I asked, meaning my maternal grandmother, who was allowed to do anything she wanted—wear her house slippers outdoors, part her hair crooked, grow her fingernails long. She didn't even have to learn proper Cantonese; Mother taught me Toishanese for Po-po's benefit. "Grandmother language," we called it.

"Oh, yes," Mother said softly. "Always honor your parents and grandparents."

Of course, I thought. I admired Po-po tremendously. I had thick unruly hair that tangled in my sleep. In the mornings, I cried when Mother combed it. I couldn't wait until I was old enough to go through the day with snarled hair.

Every night after work—after he'd hung up his jacket and tie— Father would tell Mother and me stories about his day. He kept us informed about the progress on a building, he described the heat

of the sun. But one night he came home with a sad story: A man he worked with—a friend, someone who liked to joke and tease, someone with whom we'd shared tea—fell from a high beam that morning. He was seriously injured. He might die.

A few weeks later, my father flew off to America, *Mei Guo*, "Beautiful Land." Remembering the sad story, I believed that my father left because his friend had died. In my mind, injury and departure became inextricably linked.

I don't know how my parents explained his leaving. I don't remember saying good-bye to him at the airport. I only know how I felt afterwards, walking home with my mother in a world gone gray. It was December, two weeks before Christmas. Leaving the airport, Mother steered me past shop windows, trying to distract me with their bright displays. But I refused to look. My stomach hurt. Father had left. There wasn't anything I would want from a store. Overhead, airplane engines continued to thunder, taking off every few minutes, streaking the sky with their white exhaust. I tilted my head back, my mouth opened wide, whispering, *Wow*. I clamped my hands over my ears. As soon as we got home, I flung myself onto our bed and cried.

In my mind's chronology, the next two years are bracketed by recollections of airplanes departing Hong Kong—my father's in December 1969, and my own in April 1972—memories so deep I sense them with my body, primal, visceral, unfiltered by intellect. Sometimes I still dream that I am climbing the boarding ladder. I am very small, and the ladder is endless. In that dream life I am afraid of heights, as I never am waking.

The Chinese language is very specific with regard to familial relationships. Even our pet names for relatives—the equivalents of words such as "auntie" and "grandma"—specify maternal or paternal, younger or older. Therefore, when Mother said that Father lived with my aunt, I knew she meant Father's younger sis-

ter. Her name was *Bik Ying*, but the Americans called her "Becky."
Her first husband had died, and she now had a common-law hus-
band, a Chinese who had randomly chosen the name "Andy."
Andy could not marry my aunt because he already had a wife in
Taiwan, but he lived with her and helped raise her son, a little
boy named *San*—Chinese for "rise" or "upward"—who was
almost exactly my age.

"Do you know?" Mother said, "we were expecting babies at
the same time, your aunt and I. What a thing! We wondered, who
would give birth first? We waited and waited. Then, just three
months before you were born, your aunt had a little boy!"

"What if Father likes him better than me?" I fretted.

"Don't worry," Mother assured me. "Your father likes girls
best. He was so happy when you were born, everybody wondered
what was wrong with him. They thought he'd gone crazy! 'Boys
are best,' they told him, but he didn't care. He wanted a girl, so
strange for a Chinese."

I leaned against Mother's arm happily. "Do you know?"
Mother went on. "Your father lives in a place called Wich-i-ta. He
works in a motel kitchen. Very soon we'll go live with him."

I saw Father climbing down off a skyscraper scaffolding. His
thick black shoes touched the ground. He was somewhere far
away, but it didn't matter. He was safe now. He would never fall
off a building and die. "What does Wich-i-ta look like?" I asked,
pronouncing the foreign word carefully.

"I don't know," Mother said. "I think there's sand there, like a
desert, and big streets, no buildings. That's what your Father
wrote."

Father sent money so I could go to a private school. I was three,
old enough to learn English, Mother said, so that when I grew up,
I would get a good job, not suffer so much. She enrolled me in a
class with a bunch of five-year-olds, but I didn't have the disci-

pline to wake in the morning. Every day, my mother lifted me from bed still asleep, dressed me, strapped my shoes on, and carried me to class on her back. Along the way, she bought a bottle of unpasteurized milk to coax me awake, dribbling the sweet liquid into my mouth over her shoulder. When I came to the U.S., I knew multiplication tables up to nine-times-nine, wrote one hundred Chinese characters, and spoke five words in English—*cap, ball, hello, yes, no*. But none of these lessons were as powerful as the taste of milk fed to me as I lay stomach down, curled on my mother's back.

Moy-moy didn't go to school, so I showed her my books when I got home. "I like helping Mother clean," I read, pointing at the picture of the girl smiling and making beds. "I take care of my little brother. I keep him away from danger." I showed Moy-moy the drawing of the girl pulling a smaller boy away from an electric fan. Moy-moy's parents said, "Wah! Isn't she smart? She obeys instructions so well!" Moy-moy just laughed and brought me her chamberpot.

During walks I recited multiplication tables for Mother. She rewarded me with stories, fables that always had a moral, even if she had to make it up herself. Her favorite was "The Boy Who Cried Wolf." I heard it at least once a day. Mother's voice rose when the boy cried "Wolf!" Her words tumbled over one another as the townspeople rushed to save him. There was a dramatic pause just before she revealed the hoax. And I always shuddered at the end, when the boy is eaten, a victim of his own foolishness.

"You must never lie," Mother added each time. I nodded sincerely, although I'd heard it all before.

But the most important lessons were the ones she'd learned from Po-po. Remembering how her mother had honored her father, my mother told me stories about my father every night.

She said, "When he was around, you never had to walk—he carried you everywhere. You were three years old and the bottom of your shoes like new! All you had to do was touch his hand, and

he'd pick you up. Remember? One time he patted your legs and asked, 'What are these for?' And what did you say? 'For you to pat!' Such a clever girl! Such a loving father!"

I hugged my mother's arm. "When will Father come home?" I asked.

She sighed. "Ah, daughter, don't ask these things! He's in America making money so you can eat and go to school! Where do you think your pretty dresses come from?"

I started crying. "I want Father to come home!"

Mother stroked my hair. "Don't cry, little daughter, we'll see him soon. We'll move to America to live with him."

I wiped my eyes on Mother's shirt. I didn't know where America was, but if Father lived there, it couldn't be a bad place. "Tell me more," I begged. "Did he send another letter? Did he say I was a good girl?"

"Of course," she whispered. "He thinks about you all the time."

In my father's absence, Grandmother helped to raise me. Mother and I went to visit her every day. Usually we waited for the bus, but if it didn't come, we would walk, my mother carrying me part of the way. Between my small steps and Mother struggling with my weight, sometimes it took an hour and a half to get there.

At Grandmother's flat, Mother's composure unwound. She felt free to complain about her loneliness and the way I awoke crying for my father every night. "I don't know what to say," she sighed. "Yee refuses to eat at mealtimes, so she's always hungry at night. She wakes up crying with a stomach ache. I'm afraid the neighbors will complain—you know how small the flat is!"

Grandmother shook her head sadly. "There's nothing you can do when a child cries like that. Feed her warm milk, like she's a baby, and she'll go back to sleep."

"Oh, I do," Mother said. "But you should hear! And she's become so thin! Last week, at the doctor's office, the nurses

accused me of starving her, my own child! I started crying myself,
I was so scared they would call the police on me!"

"Did you explain about your husband moving to America?"

"I did, for all the good that will do . . . "

"It's enough, believe me. Everyone knows, it's so hard to make
a living around here. Men are leaving for America all the time."

Mother gazed at Po-po uncertainly.

Po-po said, "Believe me, daughter, they understand. Husbands
and fathers leave. We have to put up with it in order to eat. How
do you think I raised you?"

Mother looked down in shame. "Mother, of course you're
right," she said quickly. "How dare I question you? I'm just so
frustrated! That rotten girl! I can never sleep through the night!"

"Ah, relax," Po-po soothed. She changed the subject: "Your
brother will be home soon. He'll take little Yee to the park. We can
go with them or stay here. Sit in the sunshine or stay inside, it
doesn't matter, whatever you want. Relax, daughter."

Mother nodded. "Do you think . . ." she began uncertainly.
"Do you think it'll help if I hit her? Will she eat if I hit her?"

"Not yet," Po-po answered. "She's still too little, just a baby.
And hitting's for times when she misbehaves, when she breaks
things or talks back to you, not for things like not eating her rice."

Crouched at my grandmother's feet talking to my imaginary
friends, Big Dragon and Little Dragon, I barely registered her last
comment. For a long time, I'd been aware about the punishments
that parents imposed on children: Sometimes at market I would
see the flailing mothers and the howling children. "See what hap-
pens when children are bad?" Mother would warn. "Don't you
ever misbehave!"

I didn't think I had anything to worry about. Didn't everyone
always say how clever I was? And didn't "clever" mean the same
as "obedient"?

* * *

Our days at Grandmother's had a lively, party-like quality. My aunt, Mother's sister, had moved to Hong Kong from mainland China, and she often visited Grandmother with her two youngest children, Manyee and Leo, who were in their late teens. Leo liked to chase and tickle me. Manyee prided herself on tricking me into doing rude things, like smacking my lips while I ate. Whenever Grandmother had this many guests, we all needed to go outside, because there wasn't enough space for everyone to sit in her room.

We would go to the zoo or the park or simply sit on public benches by the side of the road. If Little Uncle was home, he would bring his camera and take pictures of us to send to Father in America.

Days flowed into weeks, and weeks into months, caught in the easy rhythm.

One day when I was five, my skin suddenly erupted in itchy red blisters. For the first time in two years, Mother and I couldn't go to Po-po's. "You have chicken pox," Mother explained. "Lie still in bed so the blisters don't break. Otherwise you'll be scarred forever!" She went across the hall to tell Moy-moy's parents, who brought Moy-moy over to kiss my face.

"Best to get it over with," her mother said. "Best to have chicken pox when you're young. I've heard such stories about how you suffer if you catch it when you're older!"

Mother agreed. "If you grow up without ever having chicken pox, you're scared to be around children the rest of your life. You're too worried about catching it yourself. You can't be a good mother that way."

"Thank you," Moy-moy's mother said. "Now it's time to go home and rest."

Sadly, I watched them leave the room. Now I had no one to play with. I said, "Mother, when do we go to Po-po's?"

"Not today. You need to rest."

"I'm not tired," I protested. "I'm all sleeped out!"

"It doesn't matter. You lie there and be good; you can't move when you have the chicken pox. If you burst the blisters, you'll be scarred for life!"

I tried to be good and lie still, but the blisters itched. I scratched at my arms and face. Mother pulled my hands away. "Yee, what did I tell you? If you scratch, you'll ruin your skin! Now lie still."

I whimpered, "Mother, I caaan't!"

She sighed and cradled me with one arm. "Lie still and I'll tell you a story," she bribed.

I held our quilt tight, fighting temptation. "I want to hear a story," I whispered.

"Once upon a time . . ." she began. And I only fidgeted a little bit.

Late in the afternoon there was a knock on the front door. Mother went to answer it, and a minute later I heard Grandmother's voice.

"Po-po! Po-po!" I shrieked, leaping out of bed. I danced around her legs. "Mother says I'm too sick to come visit you!"

"Ah! What's wrong?" Grandmother asked, her voice a mixture of alarm and amusement. "You don't act sick."

"I'm not!" I laughed. "Mother, make Po-po a cup of tea!"

Mother shushed me, "Shh! Crazy girl, get back in bed." To Grandmother, she said, "She has the chicken pox, look at the spots on her face. All the children at her school have it."

Grandmother said, "Ah, it's wise to be careful then. Always be careful with your health. The body's not a toy, you know."

I nodded at Po-po. "That's what Mother always says. 'Don't be so rough, you'll break your arms and legs.'"

Mother said, "You rotten girl! How dare you mimic me?" But I could tell she wasn't mad. She was just teasing.

Po-po unfolded a chair and sat down. "I was so worried when

you didn't come visit! Ah, what could be wrong, I wondered? I had to come check."

"Mother, you must be careful," my mother admonished her. "You're older now, you can't go wandering everywhere!"

"Just a short walk to the bus stop, and a bus ride here, very easy," Grandmother said. She gestured to me. "No matter what, I needed to see how little Yee was. Huh, Yee, isn't that right?"

"Woo-hoo-hoo-hoo!" I sang, bouncing around her chair.

"Yee!" Mother snapped. Then, "Mother!" She sounded exasperated. "It's the chicken pox! Burst those blisters and you'll be scarred for life!"

Grandmother chuckled.

"Po-po's here! Po-po's here!" I sang.

"*Mother,*" my mother repeated. "You taught me this yourself. You said that if chicken pox blisters break, the child will be scarred for life. I don't want to have a deformed child—what would I do with her? Who would marry her?"

Grandmother motioned toward me. "Little Yee, let me see your face." I hopped to a standstill in front of her. She cupped my face between her hands. "No blisters popped," she mumbled. Then, more loudly, she said, "Yee, will you be a good girl and promise Po-po you won't scratch?"

I bobbed my head.

Po-po looked up at Mother. "You see? Everything's fine."

Mother unfolded our table and plunked a cup of tea on it. She said, "Yes, Mother. Of course you're right."

I climbed onto a chair next to Grandmother. I didn't understand the fuss. No matter what happened, even if I was sick, even if I wasn't allowed outside, Po-po would come find me. That's what grandmothers were for.

Mother said there were things no one could protect me from. She said that Hong Kong was rotten, we needed to be careful on the

streets, or the thieves would steal money right out of our hands. She sewed a secret pouch into the waistband of all her trousers. When we went for groceries, she folded dollar bills into tight one-inch squares to tuck inside the secret hiding place, and before leaving, we always padlocked our door, to protect against thieves.

They got to us anyway. As we were walking up the stairs one day, returning home with our groceries, an anxious voice called down, "Mrs. Mar! Is that you?"

Mother picked me up and ran the rest of the way. "Yes, sister, what is it?" she panted.

Our flatmate, the young single woman, waited at the front door. She looked like she was about to cry. "Your room! Thieves broke into your room!" She flattened herself against the wall quickly, for Mother was out of her mind, she pushed past without a word. Still in Mother's arms, I felt my foot brush against our flatmate. My mother's heart thumped against my own.

Our thin wooden door was splintered where the hinge had been screwed for the padlock clasp. The lock hung down sadly, connecting two useless pieces of metal. Inside, the room was a mess, our things thrown everywhere. The front of our white veneer dresser had been kicked in; the panels swayed at odd angles. I looked at Mother's face. Her eyes were bright, her mouth a colorless flat line. "They didn't steal the furniture," she said finally. "We're lucky. They didn't steal the furniture."

"Your room was the only one," our flatmate said apologetically. "Everyone else was home, so the thieves didn't dare come to our rooms. I was so scared, huddled inside, not looking, afraid they'd come and kill me!"

"It's the second time," Mother said somberly. "My bad luck. Do you remember the first time, when my daughter was little, maybe eighteen months?"

I didn't remember the story—I was too little the first time—but our flatmate covered her face. She'd heard it before.

"I was carrying my daughter on my back, tied with cloth,"

Mother continued. "I was walking up the stairs, coming home from grocery shopping. The stairwell was so dark, I nearly collided with the boy! He had a knife! He said, 'I'll kill you if you move!' I didn't know what to do. 'I'll give you money,' I said. I'd gone out with ten dollars, you know, and I bought less than one dollar's worth of food, maybe ninety cents, that's all. I was carrying a change purse." Mother paused for a moment. She looked at her empty hand and into our flatmate's eyes, as if for confirmation. I clung to Mother's shirt, afraid that she'd forgotten me, afraid that she'd drop me.

"I held it out," Mother said, demonstrating with her hand. She raised her voice for the next part of the story: "The boy screamed, 'No! Drop it on the floor! Drop it on the floor or I'll kill you!' I started to drop it, then I thought, I need to get my daughter home, I need my keys. 'Please let me take my keys out,' I begged him." Mother shuddered. Her skin felt clammy against my body.

She continued the story: "'Yes, yes, quickly!' he said. He was waving the knife. I thought for sure he would kill me! Immediately I opened the purse and found my keys. I threw the purse on the ground, so quick! He grabbed it and ran. I stood there, frozen. I waited until I heard him leave the building." Mother's voice faded. She blew out a breath. I hugged her neck.

"Hong Kong is so rotten," our flatmate whispered.

"I was frozen, so scared I didn't have the chance to feel it until I got inside," Mother finished.

Our flatmate didn't say anything.

Mother sighed. "Ah, sister, it was kind of you to warn us," she told our flatmate. The woman nodded. She returned to her room.

Mother set me on the ground, and we went inside to begin cleaning. Together we pieced together the dresser drawers with transparent tape that yellowed in scars along the seams. "At least we have something left," Mother kept saying.

* * *

"America will be better," Mother promised. "People there wear nice clothes all the time. It's safe, you can walk the streets and not worry about thieves stealing from you."

Father had sent for us. He had moved to a place called Denver with my aunt's family, he'd saved enough money, and there was room for Mother and me. But I didn't want to go. I was still waiting for Father to return to Hong Kong.

"He's not coming back," Mother said gently. "We need to go there."

"With Little Uncle and Po-po?" I asked.

"No, Yee, just you and me."

"Why?"

"The government won't let them. Father only has papers for you and me."

I started crying. "I don't want to go. Why won't Father come back home?"

"Yee, this was the plan all along. Remember? We explained it to you when he left."

I shook my head wildly. "No you didn't. You didn't say anything."

Mother sighed. She was quiet for a moment. "Maybe you're right," she finally muttered. "We didn't tell you anything. But you're so young. Who thought you'd be so stubborn and remember so much?" She brushed my hair off my forehead. "Little daughter, we have no choice. He's your father, my husband, our family. We need to go."

I continued to cry.

"I . . ." Mother's voice broke. "I don't want to leave Po-po either."

We sat in silence for a long time.

We had no choice. We prepared to leave.

"We're moving to America, a place called Den-veah," Mother told my teacher.

"Ah, no time to win the 'best student' award!" my teacher said.

"Yes, she's only gotten the 'neatest work' award for two years," Mother answered. She laughed suddenly, a little too loudly. "I don't know how she got that, to tell the truth—every day when I came to pick her up, she was sitting in the middle of the floor with her braids undone and her face covered with ink! Do you remember? Do you?" There were tears in Mother's eyes. She wiped at them. "Ah, I'm laughing so hard," she mumbled.

My teacher smiled indulgently. "Where is Den-veah?" she asked. "Is it a big place or a little one?"

Mother's forehead crinkled. "I think it's little, not big like San Francisco. I think that's what her father wrote."

My teacher answered briskly, "Ah, well, it's America, that's the important thing! And it's best for children to be with their fathers." She bent down and gave me a bunch of pencils tied with ribbon. "Be a good student in America," she said. I promised that I would.

Everywhere we went, we got presents. Before we announced our departure, my only toys had been a scrap of cloth and rubber bands, but now I had two dolls, one blonde and one brunette. Moy-moy and I spent hours staring at the dolls. We agreed that the blonde was prettier—like a movie star!—but the brunette was larger and had blinking eyes. Mother wouldn't let us play with either one; she said that we were saving them for America, so they had to stay wrapped up.

Moy-moy's father gave me a jewelry box he'd made himself. It had pounded brass corners and faux jade carvings set into the wooden lid. "It won't mean much to you now," he said, "but you save it for when you grow up." He set it in my hands gingerly and rocked back on his heels, settling into the squat that Chinese men find so comfortable. He blinked rapidly and smiled extra bright. "When you grow up, you can put your pretty things in it."

"Thank you, uncle," I squeaked, surprised by his somber tone. Why wasn't he laughing and teasing me, the way he usually did?

Mother reached down and took the box from me. She wrapped it in plastic bags and tucked it into our luggage. She said, "I'll keep it safe until you're old enough to understand."

For luck, relatives gave us ceramic figurines: Two wild geese, their necks elongated and wings spread in flight, to hang on the wall. A girl in pale blue pants and a pink pinafore, carrying a schoolbag and an orange, to symbolize wisdom and prosperity. A boy with his sleeves rolled up, leaning on a shovel and pulling on work gloves, a sign of hard work. A lion roaring, to protect our home. A horse cantering, to carry us safely. As art objects, these items were worthless, but my mother invested them with real power to secure our safe passage. She cried when one goose broke en route to Denver.

Mother and I needed to buy presents, too. It was only polite. "Something good to eat for Cousin San!" I said, so we got a pound of beef jerky, half of it flavored with chili, the other half with orange. *Lucky cousin*, I thought, mouth watering. We'd gotten him the best brand—the jerky was tender and flaky, dried beef enhanced with hints of fruit and chili. I knew that my cousin would like it.

We shopped and packed, shopped and packed. We bought herbs and boxes of Father's favorite chrysanthemum tea. Mother ordered a crate of ricebowls and flat-bottomed china soup spoons. We bought new clothes—three fancy dresses and two coats for me; dresses, pantsuits, and coats for Mother; packets of underpants, t-shirts, tank tops, and pajamas for all three of us—everything we'd looked at but only touched in the stores before. Now, with the money that Father sent, we could buy things. And we bought enough for a lifetime.

We went to the hair salon. Mother got a perm, and I had my braids cut off. I clapped my hands. "No more tangles! Now it won't hurt to comb my hair in the morning!"

"Your hair's very stylish," Mother laughed.

In a moment of hopefulness, she purchased a guidebook, which I immediately claimed for my own. It was a paperback, about five inches wide by eight inches long, 150 pages thick. It probably provided advice on the new country's customs and culture. I don't know, because I wasn't interested in that part of it. To me, the entire book existed in a four-page section at the back. These pages were filled with tiny, detailed ink drawings in jewel tones. Next to each drawing was a caption in Chinese and one in English. *A picture book for adults*, I thought. I made my mother sit with me over the pages for hours, pointing out the airplane, the shoes, the frock. My memory tricks me into believing that Mother pronounced these words in English, with a British accent, although I know this was not possible. In the years that followed, long after my mother tired of it, I continued to sneak this book from my mother's drawer to study the back four pages. I passed entire afternoons in Denver this way, recapturing that moment when Mother could teach me everything about America.

On our final round of visits, I heard an English conversation for the first time. Some of Mother's friends owned a television set. They tuned it to a British program, pointing out, "Little Yee, that's English. That's what you'll speak in America." I listened for a minute before responding, "How strange. It sounds like they're singing, not speaking!" I thought the adults must be teasing me— I would never speak like that!

No amount of planning could put off the day. We were leaving. Little Uncle gave me a photo album, half-filled with pictures of me, my family, Hong Kong. The rest was blank, for pictures of America, he said. Mother put the book in our luggage, and we left for the airport. It seemed as if everyone we knew accompanied us: Grandmother, aunts and uncles, cousins, friends, Moy-moy and her parents. We filed into the terminal and waited for our flight to

be announced. The adults conversed in short, stilted bursts, punctuated by long silences and the sound of sniffling. Grandmother held my hand for a long time, but she would not speak. She looked like she might never smile again.

"I'll call when we get there," Mother whispered to her. "I'll call to let you know we're safe."

"Little Yee, you behave for your mother," Po-po managed to croak.

"Take care of Mother. Don't let her walk around in dangerous neighborhoods," Mother said to Big Uncle and Little Uncle.

Suddenly impressed by the enormity of my adventure, I handed Moy-moy the yellow-haired doll. "You can hold her for a while," I offered generously.

Little Uncle smiled, his eyes moist. "Such a big girl already," he said. "Come." He lined us up and snapped pictures to remember us by.

Then the loudspeaker crackled. It was time to go. I said goodbye to Po-po and climbed the endless metal stairs.

2

Casey's Palace

When we landed in Seattle, I realized my first loss. I couldn't find the yellow-haired doll. I dangled the brunette one by her curls. "*Mother*," I whined. But Mother wasn't interested in my playthings. She needed to get us through immigration in time for our flight to Denver. She led me off the plane with one hand. A pile of coats overflowed the opposite arm.

Cranky from travel, still sleepy from the long flight, I snatched my hand away. "I don't like this one," I complained. "Where's my other doll? The pretty one? I want the pretty one!"

Mother dragged me along. A line of people trailed behind us. "In the luggage," she stalled. "We packed her away so that she wouldn't break."

"Why didn't you let me hold her? I wouldn't break her!" I pouted indignantly. The two dolls were my consolation for moving from Hong Kong. Up to the day of our departure, I hadn't been permitted to touch them. They'd waited stiffly in the store's cardboard boxes, so formal they'd been inanimate even in my imagination. Before them, I had no others. Now I couldn't live without both.

The coats slipped from Mother's arm, and she bent to retrieve

them. An American man stopped to help. He carried our coats as far as the immigration checkpoint. He set the coats on a chair and waved good-bye. He was allowed to proceed. The immigration official pointed us in another direction. We needed pictures taken for "green cards."

A man from INS plopped me in a chair. Click! I was a resident alien. We walked on to Customs to have our bags searched.

But I hadn't forgotten about the doll. "*Mother!* When can I get my doll? You said I could play with it when we got to America. Are we in America yet?"

My mother sighed. "I gave the doll away," she confessed. "Moy-moy cried when we tried to take it. You don't mind, do you? You're a big girl!"

I *did* mind, but I kept quiet. I felt overwhelmed. My doll was one small, tangible loss to focus on. *My favorite toy,* I thought.

At Customs, a uniformed agent rooted through our luggage. A pink collapsible umbrella, okay. Scented soap, fine. Beef jerky. Pause. The agent pulled the packages out of the suitcase. Prohibited. We had a choice: eat it all or leave it behind.

My distress intensified. "It's our present for Cousin!" I screeched. "We're saving it for him!"

"We have no choice," Mother said. Her voice was gentle, resigned.

She opened one pouch, orange flavor. I was a sucker for orange. She fed me a few mouthfuls. I tried hard, but I couldn't manage any more. We didn't have much time, since the flight to Denver departed in minutes. We relinquished the cellophane bags to board the plane.

We arrived in the U.S. on April 17, 1972.

A big room full of light. Glass walls, cloud-filtered sunlight. Voices in the singsong language I did not know. Men and women with big noses and pale hair, dressed in slacks and open-necked

knit shirts. I felt sleepy and overstimulated, disgusted by the crowds wearing mismatched outfits.

"Yee, look, it's your father!" Mother suddenly said. Her voice tripped over itself in excitement.

I looked up at my mother's face in surprise. I didn't remember her ever sounding so young. But she was no longer paying attention to me—she was focused on the other side of the room, ten or fifteen feet ahead. I followed her eyes, and there, standing on the edge of the dingy carpet, was a skinny man in a dark gray suit. Father! My heart thumped wildly. I wondered if he was real. I wondered if he remembered me. "Father," I said dumbly, testing the word on my tongue. "Father. *My* father."

Mother and I pushed through the crowd, and the next thing I knew, I was being lifted into the air. "Whew! You're here! You made it," a man's voice said. He sounded real enough, but how could I be sure? It had been so long since I'd seen my father— maybe this was a stranger tricking me. Maybe I was still asleep on the plane. Tentatively, I put my arm around his neck. His cheek grazed my forehead, razor stubble scratching my temple. I remembered this feel, I remembered this smell, the tobacco and Brylcreem and Father's own sweat. I remembered his hand patting my leg. My heart contracted and released. I felt warmth spread in a rush through my body. This was my father, and he remembered me.

There were three people with him, two adults and a child—my Aunt Becky, Uncle Andy, and San. Aunt Becky was all sharp angles—skinny legs, pointy elbows, V-shaped jaw, shrill voice. Uncle Andy was the exact opposite. He had a blurred, rumpled quality about him. His head seemed to overflow his hat, his shirt seemed to overflow his pants, his body seemed to overflow his suit. San had big eyes that would not stop staring at me.

After gathering our luggage, we crossed to the airport parking

garage. Aunt Becky led the way. In this backward country called America, she was in charge. Not my father, not Uncle Andy, my aunt. A woman. To my surprise, no one complained. Father and Uncle Andy walked behind her casually. My mother followed without commenting.

Aunt Becky unlocked the car doors. She slid into the driver's seat. San and Uncle Andy sat in front next to her. I sat in back, between my parents. The adults chattered in a noisy mix of dialects, Cantonese and Toishanese. *Grandmother language*, I thought. I pulled on Mother's arm. She leaned toward me, and I whispered into her ear, "When can we visit Po-po?"

"For shame," she answered sharply. "Don't be ungrateful. Look at all the trouble your aunt's gone to." She looked up quickly, checking the adults' expressions to see if they'd heard. No one commented on our exchange.

I heaved a long sigh. I didn't understand what my aunt had done. What was it I should be grateful for? I craned my neck for a view out the window. Everything looked so big—the streets, the trees, the sky. Big, empty, and unpopulated. Where were the people? In Hong Kong, people were everywhere, laughing, talking, jostling each other in the streets. There were no people here, only the six of us trapped in a big maroon car.

Aunt Becky's voice bounced off the windows, into my ears: ". . . the way we do it in America," she was explaining. *In America. America, America, America, America.* She was telling us how to live in America. I looked out the window again. Street signs flew by. The sky was a brilliant blue, unscratched by airplane exhaust. For the first time in my life, I couldn't hear the roar of engines overhead. Suddenly I realized that I was in America. The car hit a bump. My legs bounced on the seat. My stomach felt queasy. I held my breath, afraid that we would plummet off the road, into space. I fell asleep.

* * *

I awoke on a double-sized bed, covered with a pink-and-white nubbed bedspread. Several feet away, Father sat in front of a bureau. Mother sat just beyond the end of the bed, next to a card table. The murmur of their conversation soothed me. I watched them through my eyelashes, feigning sleep.

Father. The word tingled inside my head. In Hong Kong, relatives liked to say that I was a picture of him. I studied his face closely, looking to find myself. His head was turned at three-quarter profile. I saw clean comb tracks in his hair, a fan of laugh lines around his right eye, his breath released in tobacco puffs. The other side of his head was visible in the bureau mirror. I could see the left side of his jaw move when he spoke. No good; he remained two-dimensional. My world had come apart, and I couldn't figure out what I looked like. I shifted my gaze from parent to parent. They sat on foam-padded chairs, the exposed metal legs glossed silver, paint peeling away in places. I blinked at my reflection in the legs. It came back fish-eyed and incomplete.

All at once, I remembered the airport, the airplane, Aunt Becky's car, and my cousin, the strange, staring boy. Panicked, I sat up. "Where are we?"

"Good morning! You're awake, huh?" Father laughed, acting as if nothing were wrong.

"Father," I squeaked—etiquette demanded that I acknowledge him. But I didn't understand what was so funny. "Where are we?" I repeated.

Father said, "*Mei Guo*, where else? You live here now, in your aunt's house."

House. An abstraction beyond my imagination. I sneaked a look around, afraid of what I might find. One room, ten feet square, about the same size as our Hong Kong home. So far so good—I felt safe in small places. I continued my inventory: One bed, no bunks. Two chairs, a card table, a bureau with a mirror, a two-tiered nightstand by the bed. Near the ceiling, daylight poked through a small window. Months later, when I became

brave enough to run around outside, I would discover the light's source, a half-moon airshaft cut out of the lawn.

"It's a basement room," my father said. "We're very fortunate—nice and cool down here."

"It's always best to live in a basement," Mother agreed.

I thought about our flat near the Hong Kong airport. Mother had always said that we were lucky to live there. "Did we live in a basement before?" I asked.

"Oh no!" she laughed. "'Basement' means we're underground. The house is above us. Do you know? We have to climb stairs to go outside."

"Come," Father said, rising. "I'll show you. We'll go see your aunt, say good morning to her." I slid off the edge of the bed, my feet groping their way into slippers. Father wrapped his hand around mine and led me out the door, with Mother close behind. Together we three ascended the stairs into daylight.

A confusion of old and new worlds: Two fat Buddhas on top of a huge television set. TV English competing with my aunt's Toishanese. I wondered why she was speaking Toishanese. I thought it was an old person's dialect, reserved for Grandmothers.

Before I could ask, Aunt Becky called out, "You're up! Good morning, good morning!" Her voice rang from red-drawn lips, quick and sharp as drops of water pinging on metal.

"Good morning!" my parents replied.

I remained silent, cowered against Father's legs. Mother nudged me, and I mumbled, "Gu-jia"—the informal Cantonese term for "younger paternal aunt." To show respect, the Chinese greet their elders by acknowledging positions in the family hierarchy, almost like a military salute.

"For shame! Say it loud," Mother scolded.

"Gu-jia," I repeated. Then I greeted Uncle Andy and San with the Cantonese terms for "younger paternal uncle by marriage" and "older male cousin." Although San and I were the same age, I had to call him "Big Cousin," because he beat me into the world

by eleven weeks—seventy-seven days exactly, although everybody liked to say three months.

Uncle Andy tilted his head, puffy eyes closed to slits as he laughed a compliment. "Ho-ho-ho, very good! Good morning!" He had a big round head with hardly any hair on it. When he laughed, I could see the tobacco stains on his teeth and the gaps in his smile.

Aunt Becky made a sound of annoyance. She said, "How can your cousin understand you when you speak that language? You have to speak Toishanese in order for him to understand!"

Confused, I whispered the Toishanese word for "Big Cousin." To my ear, there wasn't much of a difference between the two dialects. And Mother had always said that educated people spoke Cantonese. I didn't understand why I had to switch now.

Aunt Becky put her hand on San's head. "Isn't that nice?" she asked in a high, overly cheerful voice. "Say good morning to your little cousin; she's come to live with us."

Later that day, I discovered that Aunt Becky's house had separate rooms for bathing, cooking, eating, sitting, and sleeping. *She must be rich*, I thought, peering into the bathroom. A pink sink, pink toilet, pink tub, pink tiles on the walls! Running water every day!

Along the same hallway, there were three bedrooms, one each for San, Becky, and Andy. When Father pointed them out, I was stunned. I tried to imagine falling asleep in a room all by myself, but the idea was too foreign—and a little scary. When I asked to see San's room, Father led me to the door across from the bathroom. Poking my head in, I saw a space slightly smaller than our room downstairs. The floor was bare wood, and there were two twin beds. "Does San switch beds every night?" I asked my father.

He laughed. "He can. That would be fun, wouldn't it?"

I bobbed my head happily, but I wasn't really jealous. I liked sleeping next to my parents. One room, one family, that's the way I liked to live.

"You must be very grateful to your aunt," Father murmured suddenly. His voice sounded distant and sad. "We're fortunate to have our basement room," he continued. "Without your aunt, I wouldn't have a job, and you wouldn't be in America. We depend on her for everything."

I looked up into his face. He looked so sad, I almost didn't recognize him. I tugged on his hand. "Father, I'm here," I whispered. He didn't respond. "Father," I repeated. I held out my arms. "Carry me."

He blinked his eyes. "Ah, little Yee," he said roughly. "What are your legs for?" He picked me up and carried me back to the room that was meant for sitting.

The front room in Aunt Becky's house was furnished with a matching sofa and loveseat set in a green-and-white flower pattern. Dark green towels covered the seat cushions, their edges sewn to the undersides. Crocheted rectangular doilies lay across the sofa backs and arms. The long sofa snuggled against the wall under the big living room window, and the loveseat was positioned against an adjoining wall.

The front entrance to the house was in the corner of the living room between the two sofas. It was secured by a double set of doors, an aluminum frame-and-mesh contraption and a more sturdy wooden one. The wooden door was wide open, letting in the sounds of the neighborhood children laughing and yelling outside. Becky sat in the corner of the loveseat closest to the door. She alternated between peering out the screen door in search of San and talking to Mother, who perched straight-backed on the longer sofa, nodding at Becky as if in a job interview. Meanwhile, Andy had fallen asleep next to Becky. His head slumped over the

loveseat arm, which stuck out into the mouth of the hallway, not far from where Father and I stood. He had one lock of hair that swirled from one ear around to the back of his bald head. It looked funny. Once again I was glad for my own handsome father, with his thick head of hair. I patted Father's shoulder, but he misunderstood the gesture and lowered me to the ground.

"There are plenty of children on this street," Aunt Becky said. "Next door, in the house on *this* side—" she waved her arm "—there are two boys. The one called Evan is San's age. They're in the same class at school, but San's smarter. On *this* side—" she waved again "—there's Joey, the little Japanese boy. He's a few years younger. He looks up to San, of course."

"He came here from Japan?" Mother asked.

"Oh, no," Becky said, "he was born here. I think his father was born here, too, but they're Japanese. Not the mother. I don't know where she's from. I think she's just a *gui*." *Gui*—the slang term for white folks. Mother had said there would be a lot of them in America, and she was right: Aunt Becky lived next door to some.

"On the other side of Joey's house," Becky continued, "there's a little *gui* girl, Nancy, maybe a year younger than San. Black *gui* live next to Nancy's house, the Brown family, but they're all right— Mrs. Brown works at the school." Another use for the word *gui*: Foreigner. Ghost, demon, or spirit. Anyone who was not Chinese.

"Black *gui*!" Mother cried in alarm. I wondered what they looked like. I'd never seen a black person before. "I hear that's the worst thing about America," Mother said. "Black *gui*! They're so rotten."

Aunt Becky nodded. "In general that's true. But these black *gui* are very nice. Mrs. Brown works at the school."

Mother considered this information. She glanced over her shoulder, out the window into the front yard. Her face looked worried, and I could tell she was thinking of the thieves in Hong Kong. She said, "You're not scared to let San play outside by himself?"

"Scared of what?" Becky scoffed. "It's very safe. Yee should go

play, too!" She shot me a look. I clung to Father's side, afraid she would wrest me away from him. Instead, she complimented Mother: "Your daughter seems well behaved." She looked at me again. "Too thin, though. Look at her, she's glad to see her father. I remember how San and Yee were born so close together. Shing was happy to have a little girl. Not me. They're no good. You can't invest too much in a girl. You have to marry them off to another family in the long run, what a waste of energy! I'm glad to have a boy, to stay and take care of me in my old age. It worked out well, Shing and his daughter, me and my son."

I glanced up at Father. He smiled. Mother looked at me help-lessly. We all knew what Aunt Becky said was true, no matter how well my family had treated me in Hong Kong. Nothing I did could improve my status; I was, undeniably, a girl.

Aunt Becky abruptly changed the subject. "Why are you wear-ing shoes?" she scolded me. "We don't wear shoes inside!"

"Mother, what is she talking about?" I asked in Cantonese, thinking that my aunt wouldn't understand.

To my surprise, Becky answered, "We don't wear shoes in the house! This carpet is new, very expensive! Shoes will make it dirty!"

I stared at Mother. "She speaks our language," I whispered anxiously.

"Of course she does," Mother said. "Behave yourself!" She turned to Becky and explained, "Yee never takes off her shoes. She doesn't want her feet to get dirty. In Hong Kong, we used to tease her . . ."

"You're not in Hong Kong anymore," Becky interrupted. She reached back and straightened a doily. "In America things are dif-ferent. In America people have carpets. I vacuum this carpet once a week. I rent a cleaner and shampoo it once a year, do you under-stand? I move the furniture outside, set it on the lawn, to clean the area underneath. On that day, everyone stays outside, no one walks on the carpet until it dries. We don't move the furniture

back until the carpet is dry. Everyone helps, even San, and he's not much older than Yee, only five, but so smart! This carpet is clean. We work together to keep the carpet clean!"

I didn't know what she was talking about, but her voice was scary. I tried to hide behind Father. Aunt Becky must have seen, because she softened her tone to the overly sweet pitch meant for children. "You'll learn," she said. "I can teach you."

She was right. I learned quickly. The next day, Becky gave me a vial of scarlet liquid, with its own miniature brush, and a plastic bottle of scented water. She assumed that these gifts were ideal for a girl, but I'd never seen such things. I thrust the containers at my mother, inquiring.

Mother stroked color on my nails. "Fingernail polish," she said. She sniffed the water. "And perfume. Isn't that nice? Say thank you." She dabbed scent on my wrists and neck.

Two days later, only the smallest red freckles dotted my nails. Aunt Becky wiped them with the "perfume." Her mouth was tight, pursed like a kiss she forgot to give.

"This is polish remover," she informed me. "Don't wear it on your neck. It's bad for your skin."

I could not rely on Mother's judgment, I realized for the first time. Aunt Becky frightened me, but we needed her.

No more tea, no more visits to Grandmother, no more 3:30 market times. In America, we had a different routine, tightly orchestrated by Aunt Becky, who ran the restaurant kitchen where Father and Uncle Andy worked. Every day, Father woke up early to ride off to the restaurant with Aunt Becky and Uncle Andy. Mother woke up early to make San breakfast and see him off to school. Then, for several hours in the afternoon, Mother and I had the house to ourselves—but we always stayed in our basement room.

"It doesn't matter what your father says," Mother told me. "This house doesn't belong to us. It belongs to your Aunt Becky. We have to do our best to stay out of her way. She resents our being here, I know, I can tell by the way she looks at us." She sniffed and rubbed her nose.

"Why, Mother?" I asked plaintively.

"Don't ask why!" she snapped. "Have some maturity. You need to grow up now, not act like a baby anymore. Don't you know? Your aunt has her own child, she wants everything for him. You get nothing, so don't ask. Anything I give you, she'll be jealous of that, too."

I looked down at my hands. I didn't understand anything about America. In Hong Kong, everybody had liked me. Now no one did. I couldn't figure it out.

Becky's house was in a working-class neighborhood called Virginia Vale. Her red brick and white clapboard cube fit like a Monopoly game token on the block of identical ranch-style houses. The coupon-sized lawn matched everyone else's. Our block mirrored all the other blocks, laid out in a careful grid marked with alphabetical street names. Kearney, Jasmine, Jersey, Ivy, Holly. Each yard, each building, was carefully maintained. Everybody knew that peeling paint or wild grass meant trouble within the house.

Every day we left the house at noon to pick San up from school. McMeen Elementary was three blocks away, at the corner of Tennessee and Holly. All through the walk we could hear the noon bells ring, the first chimes preparing the morning kindergartners for dismissal, the second bell five minutes later, to signal the end of their school day. Mother liked to arrive just as the last of the noon bells sounded. We waited for San by the main entrance on Holly Street, where, standing at the bottom of the school steps, I watched the children pour out the doors excitedly.

Their incoherent chatter reached out to me. I searched for San's face, distinguishable in the mass of *gui* students. Blond-, brown-, or red-haired, they were all white. *Bok gui* children, white ghosts. I grew up learning to call Americans by this curse word. For years I would not know that they had another name, unless it was *hok gui*—the black version.

I knew that being Chinese was best. I knew that I should despise the ghost children. Yet, when I saw San chattering with his classmates, indistinguishable in language and gesture, I longed to join him. I wished I could talk to somebody other than my mother. I wanted to run among bodies my own size, and show them how clever and funny I was. I longed for my old school. I missed Moy-moy. I forgave her for stealing my doll.

I stayed by Mother's side while San ran to meet us. We were such different children—he stood half a head taller, and moved with an easy physicality that I lacked. Whenever his mother entered or exited the house, he kissed her, an intimacy that embarrassed me. I couldn't remember my lips touching another living soul. I couldn't imagine my parents' lips brushing my body. Not a graze of my hair in affection, not a sloppy smack on my cheek for hello, not a get-well peck on my bruised knee. To me, San's kisses were scandalous, and I always turned my head in shame.

Nor could I understand San's schoolday. Only three hours of kindergarten each morning, and never any homework! On our walks home San showed me crayon drawings and talked about that day's games.

Games? I wondered. My school didn't have games. "What about math?" I asked. "I can do twelve times twelve. How about you?"

But San didn't seem to understand my question. "I'll teach you a song," he said in Chinese, before lapsing into an American tune. I couldn't follow along. I didn't understand English, and I didn't know any songs. I began to wonder what I was missing.

* * *

At home Mother encouraged, "Play with your cousin—he'll teach you English." So I followed him through the forbidden rooms of Aunt Becky's house. Alone with Mother during the mornings, I wasn't allowed to wander beyond our basement room. This one room was our home, Mother told me. The rest of the house belonged to Becky, and we were permitted upstairs only to cook, use the bathroom, and vacuum. In San's company, things changed. While Mother remained trapped in our room, I was allowed to explore the upper regions of the house. I watched television in the pale green living room, mimicking San's laughter during *Mister Rogers' Neighborhood, Sesame Street,* and *Electric Company.* I sat on the twin beds in his room, leafing through comic books and learning the significance of the name "Snoopy." I reminded myself to speak only Toishanese, and San became my compatriot, the only child in this strange new country who understood my language.

Together San and I attempted to enter the most secret room of all, Aunt Becky's bedroom. It was the only room in the house whose door locked, the only one whose door was always closed. Every day after school, we tested the knob, wrapping both hands around its scarred surface, staring into the single eye at its center. First San would try, then I, arms braced for the knob's resistance. Two unyielding twists, and we were satisfied; we would scamper off to play elsewhere. We never expected the knob to turn, and yet we never failed to try, standing before the door as solemnly as knights questing for the Holy Grail.

I'm not sure what I would have done if the door had opened. I might merely have gawked. I might have gone wild and plundered the two rooms within, the mythical, unseen sleeping quarters and adjoining half-bath. Or, dazed by my first success in this new country, I might have censured myself, and remained frozen forever on the threshold of Becky's open door.

Like Mother, I was learning to disappear. Frequently, I sought refuge with her in the basement room, in the silence of empty spaces. But I was also learning to vanish in full sight of others, retreating into myself when physical flight wasn't possible. My voice withered. Silent desire parched my throat. All I wanted was a glimpse inside Becky's room, but I never thought to ask.

Every day I was reminded of the room's mystery. Becky usually came home for a couple of hours in the late afternoon, from two to four—after the lunch rush and before dinner prep. When we heard the screen door's tinny bang, San would rush to kiss his mother. I ran to greet her too, dreading the intimacy of their embrace, but never delaying long enough to avoid witnessing it. Watching them kiss, my eyes half-averted, I cringed with guilty desire. I waited. I don't know what for. But as I stood there, my stomach hopped with a distinct sense of anticipation. As if I waited long enough, I, too, would be embraced. As if I, too, would become a wanted child.

It never happened. Becky lay down her packages, she asked San about his day, she inspected the house. I hovered on the periphery, a wraith, the ghost child I despised. After fifteen minutes, or an hour, Aunt Becky would go to her room for a nap. Sometimes San would follow, but not I. I watched from the living room. I studied Becky's leisurely gait, the bend of her head, the hands choosing the key. I concentrated so hard that when she slid the key in the lock, I thought I could hear the tumblers clicking. I could feel the knob give beneath my hand. I prepared to walk through the door.

In the next instant, I awoke from my fantasy. Light sliced a diagonal out of the hall. Becky and San appeared in silhouette, the corona in the shape of their two bodies blazing toward me. They entered, the door closed, and I gazed into darkness again. I ran downstairs to join Mother in our basement room.

*　　　*　　　*

Day after day we ate bland lunches. Sandwiches and cans of SpaghettiOs that Aunt Becky had taught my mother to prepare. Foods that erased memory and leached my body of desire. I swallowed numbly, forgetting my presence at the table. Only Mother's own meals awakened me, but they also taught that passion comes with consequences.

There was, for instance, the day that Mother served chicken wings. I felt exhilarated, a long-absent sensation. With a hunger deeper than my whole body, I snatched a piece of chicken off the plate. I devoured the flesh quickly. My tongue rubbed bone surfaces dry. Dizzy, desperate, I nipped joints free, discarding the useless, naked drumette. I gnawed tender skin off the wingtip, exposing pin-sized bones. I chewed them. Empty, far too fragile. I spit. I was so ready for real food. I pried the two-boned middle section apart. The narrow lengths weren't much thicker than my fingers; I conquered them easily. Nibs of cartilage winked at me. They glistened off ball-round ends, translucent yellow against bone-dull white. Two pieces left, the tiny one like a key to my past, the heavier one a chopstick fragment that would feed me. I chose the skinny one first. Not much marrow in that, and I wanted to save the best for last. My front teeth clamped down the bone's length, forcing red ooze out the ends. I licked hard, nicking my tongue on the brittle break. I swallowed. Oooh, the thicker piece. I snapped it open, sucked hard. I wanted the marrow so badly I could barely taste. There wasn't enough, not nearly enough. I stuffed bone shards in my mouth, grinding them soft with blunt molars, swallowing chicken blood and saliva. I spit out pulp and splinters. Only then did my eyes focus, looking for more.

In horror, San shrieked, "She's eating *bones!* Little Cousin is so hungry, she's eating *bones!*" He ran from the table in disgust.

"I'm not! I'm not!" I cried through my raw and oily lips. I wasn't sure what I'd done wrong, but I didn't like his reaction. Breathing back tears—regretfully—I reminded myself to behave as San did. No more chicken bones. I lived in America now.

* * *

We were a family of urban sharecroppers. The restaurant where Becky, Andy, and my father worked was in southeast Denver, a twenty-minute drive from our house. Six days a week, from ten in the morning until midnight or after, they chopped and ladled and stirred. Egg foo yung. Chicken chop suey. Moo goo gai pan. Soup or salad included, breadsticks on the table. On the seventh day, Sunday, the restaurant did not open for lunch, so my family rested until four. They closed the kitchen at ten and sometimes made it home before the end of the evening newscast.

Aunt Becky ran the kitchen, but she had no control over the hours. She didn't create the menu or set the prices. These aspects of the business were dictated by Annie and Casey Rosenberg, the restaurant's owners, who traded kitchen space for a percentage of the food receipts. The Rosenbergs also hired the waitresses and supervised dining room operations. Otherwise, they left food service details to Becky. They didn't deal with suppliers or kitchen staff; Aunt Becky paid for these costs out of her percentage of the receipts. Annie and Casey's primary stake was in liquor sales, evidenced by their allocation of half the interior space to a bar and lounge. There was only one cash register for the entire business, and it was located behind the bar. When restaurant customers paid their bills, the money went directly to the Rosenbergs, and my family didn't see their share until Aunt Becky proved that it was owed.

At the end of each night, Aunt Becky slid the waitresses' order forms off the metal spike that secured them. She aligned their corners and bundled the sheets with a rubber band. At home, alone in her room, she totaled the amounts on an electric adding machine. Food prices translated into mechanical *chigachunk!* sounds. The machine spit numbers out on a long white tape. Its stop-and-start motor vibrated through the house, confessing the restaurant's nightly fortunes. Becky met with the Rosenbergs

once a week to compare tallies. If the numbers matched, she got paid. If they didn't, there was a laborious examination of the adding machine tape, a dig through piles of order slips, and more *chigachunk!* sounds late into the night. With the kitchen's share of the money, Becky paid suppliers, the dishwashers, the busboys, and my father.

I can't remember the first time I saw the restaurant. I do know this: From the moment Mother and I stepped off the airplane, we spent our weekends there. Mother washed dishes, while San and I played in the back lot. It was the only way the whole family could be together.

Neither the restaurant's name nor its decor suggested a Chinese kitchen. It was called "Casey's Palace-Annie's Castle Restaurant & Lounge," a name the Rosenbergs chose with Las Vegas in mind. The homage was apparent in the design of the sign out front: a giant heart and an enormous spade—two suits from a deck of cards—side by side. Lit by scores of clear incandescent bulbs, the heart-and-spade pair rose thirty feet above street level, supported by thick steel posts. The words "Casey's Palace" beamed from the spade's center. A woman's body rested inside the heart, nearly obscuring the caption that said "Annie's Castle." Casey, the ace of spades, the highest card in the deck, and Annie, queen of hearts.

The building itself was a gray brick cube in the middle of its lot, fortress-like, windowless on three sides. Bright red trim scrolled around the roof's edge in a pattern meant to suggest battlement walls. There were two customer entrances, one on the south, facing the street, and the other on the west, facing the parking lot. Both were guarded by heavy carved wood doors that led only into airless vestibules. A second set of doors, sheet glass completely covered with thick red velvet drapes, protected the dining room and bar from outside light.

The fourth wall belonged to the kitchen, the permeable rear of

the castle. Light flooded the interior through a bank of windows. The battered back door was left open for most of the year, so air, children, flies, dishwashers, and busboys flowed in and out freely. On summer nights white light and the *clatter-clink* of dishes streamed onto the back stoop. There was so much activity that customers sometimes became confused and tried to enter through the kitchen door. I didn't blame them. As a child, I, too, reversed front and rear, preferring the vitality of the kitchen to the darkness of the dining room. I always felt sorry for the customers turned away from the kitchen door. They had glimpsed the restaurant's heart, only to be banished to its nether regions.

The dishwashing station was immediately to the left of the kitchen door as you entered. From outside, through the window screens, you could see a white-t-shirted back moving within the one-person corridor, hands passing dishes from right to left, dirty to clean: tub, nozzle, rack, sanitizer, over and over.

A wall separated the cooking area from the dishwashers. Father, Andy, and Becky worked in a twelve-foot-long, three-foot-wide aisle, with chopping blocks and a steam table on one side, an industrial-size stove, two-compartment deep fryer, and flat black griddle on the other. A window was cut out of the wall above the steam table, for waitresses to pick up orders. Three heat lamps were screwed into the window ceiling, but one was usually burned out. Single-footed platters of sweet and sour pork and thick white cups heaped with steamed rice huddled under the remaining lights to warm like campers under a solitary fire.

At the end of the cooks' aisle, there was a storage closet, about five feet square. This space was filled with metal shelves, rows of skinny silver-colored bars placed an inch apart and welded to a flat frame. It hurt to sit on them too long; when you got up, the criss-cross pattern was tattooed on your thighs. Extras were kept here—gallon cans of bamboo shoots, barrels of soy sauce and vegetable shortening, a trash can full of flour. On busy nights the closet floor was also used as a work space. Seated there on an over-

turned bucket, Mother wrapped egg rolls and shaped balls of almond cookie dough.

The bottom shelf against one wall was always empty and lined with a double thickness of cardboard, reserved for family members to sneak the occasional nap. At the age of five, San and I fit on it at the same time. On busy nights, our mothers tucked us on the shelves with a deck of cards and comic books. They slid the closet door half-shut, and San and I lived in a miniature world until they checked on us again.

This shelf was coveted space, not the exclusive domain of little children. Most often, it was occupied by Uncle Andy, who had serious health problems. He was overweight and had high blood pressure, a bad heart, and a ferocious smoking habit. For these reasons, his needs always took precedence over mine. If Uncle Andy wanted a nap, I did without. I continued to play on the back stoop or, during the cold and rainy days before summer, down in the basement.

The suggestion of Las Vegas was not limited to the restaurant sign. In my family, the rumor was that organized gambling accounted for the restaurant's success. Mother assured me that bookies and the occasional big winner from the tracks filled our tables on Saturday nights, ordering platters of sweet and sour meats slicked red as maraschino cherries.

While exploring the low-ceilinged basement one afternoon, I discovered a doorbell apparatus attached to a supporting pillar. It was the long, narrow kind, like a single ivory piano key embedded in a slightly larger case. *It's on wrong,* I thought, reaching up to touch the horizontal length. *It should stand up, not lie sideways.* Then it occurred to me that there was no door. I wondered where it rang. Curious, I pressed it, listening for the bell. Silence. I dragged a chair over and climbed on top of it. I traced my finger over the wire that ran from the bell up the pillar's length and out

of reach, onto the ceiling. I couldn't tell where it led. Oh well. I jumped off the chair.

For the rest of the afternoon I played "neighborhood." The "houses" were the structures formed by boxes stacked on wooden pallets all over the concrete floor. I assumed a different character each time I stepped on a new pallet. I ran from pallet to buzzer to pallet, asking the kids in my neighborhood whether they wanted to play. "Ding dong!" I whispered happily.

After a while San came rumbling down the stairs. "Have you been pushing that bell?" he asked fiercely. He pointed at the wall. Some instinct told me to shake my head.

"You better not!" he warned. Bucket, the bartender, was mad because somebody kept buzzing from the basement when he knew that no card games were going on. The bell was used to call for drinks during the games that the Rosenbergs ran, San explained. "We can pretend to be gamblers," he said. "As long as you don't push the bell." He stretched and yawned, acting out a long night at the card table. "Let's get snacks from upstairs!" he suggested, pressing the wall below the doorbell. I shied away guiltily, avoiding any more trouble.

Later that spring the Mile High Kennel Club opened for the season, and suddenly I could sit on the storeroom shelf as much as I liked. Whenever he wasn't needed in the kitchen, Uncle Andy was off at the races. Like most Chinese, he was fascinated by games of chance. He went for the entire night on most Mondays, Wednesdays, and Thursdays, catching a ride with old Mr. Fong or Uncle John Lock or Mr. and Mrs. Gee, all of whom dropped by the restaurant on the pretense of grabbing a cup of coffee. Fridays and Saturdays he usually worked until ten. But as the nights grew late, Uncle Andy would dart quick, mournful glances out the back door. He would check the dining room every few minutes, reporting back, "Oh, it's slowing down." And finally Becky

would tell him to call this friend or that friend, whoever could pick him up. If they'd all left already, he'd go in a taxi. Sundays were hopeless—he went to the tracks straight from home. He skipped Tuesdays only because it was Father's day off from the restaurant, and Becky needed his help.

Uncle Andy littered the house with racing forms. The covers were as brightly colored as comic books, and San taught me to read them that way. We flipped through the pages looking for drawings of Rusty, the mechanical rabbit. San said that there were even "kids' nights," when we would be allowed to go with our parents to eat ice cream and collect the losing tickets scattered on the floor.

Since I wasn't enrolled in school yet, I was allowed to wait up for Father every night. I could tell when Uncle Andy had gone to the races, because he wouldn't get home until after everyone else. And as soon as he walked in the door, I knew how much he'd lost by the way he swore—*you bastard's mother* for a negligible sum, *kill all the bastard's dogs* for larger amounts. If he won, Uncle Andy gave me a dollar. Some nights Father came home in a taxi alone, because Aunt Becky had snuck off to the races, too.

One night Becky came home giggling. She told us how she'd been in such a hurry to get to the tracks in time for the last few races that she'd forgotten to untie her apron. "There I was," she laughed, "walking around the dog track with this dirty apron around my neck! I didn't even notice it until Mrs. Gee pointed it out! Everybody had a good time laughing at me, even Andy Wong here. They said, boy are you addicted to gambling!"

Uncle Andy and Father laughed, but Mother was grim-faced, like she always got when the adults started talking about the greyhound races. I didn't understand. I thought the dog tracks sounded like fun, a place to see all your friends and eat ice cream. "Father, why don't you ever go to the dog track?" I asked.

Mother gasped in response. "What are you talking about, daughter? Don't ever say such a thing! Gambling will ruin you!"

"Oh, relax," Aunt Becky said. "Yat Shing's a good boy. You haven't seen him go once, have you?"

"It's very dangerous," Mother insisted, glaring at my father. "You can become addicted and lose all your money."

Father said, "Don't look at me like that! I haven't done anything!"

"It's true," Aunt Becky said in defense of my father. "He went sometimes when he first came to this country—he was lonely in Wichita, you know—but he's never taken the races seriously. He just plays at it, never gambles big." Her tone suggested that my father's moderation was a bad thing.

"I'm just warning you," Mother said ominously. I didn't see why she was so upset—if Father won at the dog tracks, I would get a dollar.

Over time, Mother's attitude relaxed. She learned that summer nights at the dog track were as important to Denver's Chinese-American community as lunar new year banquets. She began marking "kids' night" on our calendar and choosing outfits for me to wear to the Kennel Club. The dog track, she realized, was not just a place to gamble away your wages. It was an excuse to wear your party clothes, show off your children, reminisce about the old country, complain about your bad luck in America, and hope for untold riches. The track was necessary.

Aunt Becky displayed Buddhist figurines on the TV set, Mother talked about Taoist principles of moderation, and Father liked to quote Confucius and Mao in equal measure. But luck was our true religion. In the name of luck, we ate chicken, wore red, and lit joss sticks on holy days. In the name of luck, we prayed to our ancestors. As far as my family was concerned, Memorial Day was the most important and most solemn holiday of the year. On that day we woke up early to pay respects to our dead ancestors, a tradition the Chinese call "walking the mountain." We filled the

trunk of Becky's Chevrolet with potted flowers and drove to Fairmount Cemetery. As we approached, San convinced me that I needed to hold my breath as long as the cemetery was in view. *For luck*, he said. *Otherwise the dead will haunt you.* Believing him, I sucked air in nervously, developing hiccups in the process.

Upright slabs of granite and marble flanked the cemetery's entrance. I admired the bas-relief angels' faces, the deeply etched praying hands, the occasional stone mausoleum. I imagined our ancestors inside the grandest tombs. But Aunt Becky continued to drive, and as the road wound more deeply into the cemetery, gravestones flattened into discreet plaques set into the grass. Disappointed, I climbed out of the car to search for our ancestors.

Becky, Andy, and my father had memorized the location of the graves, but they were confused about the names. "Are we looking for Hom or Mar?" Aunt Becky muttered. "I always forget."

Father said, "It's really Mar, of course, but I wonder whether he changed it back."

"Who are you looking for?" Mother asked.

My father gave a detailed genealogy, explaining old and new names. "I think he went back to the old name," he concluded. "Now, the family, the ones who are still alive, they use Hom."

"Maybe you're right," Becky said. "When did he change it?"

Uncle Andy joined the discussion. "A few years before he died, remember? He wanted to die with his real name."

"Such a bother," my mother sighed.

Father coughed. "Well, *you* know that there was no other way. How else could these old men come to America? The restrictions, you know."

Mother stared off into the distance. "Of course I know," she said shortly.

I scowled. Here was another grown-up conversation I didn't understand. How could anybody have more than one name? *Mar Man Yee.* Yee, for short. That was me.

When we finally found the marker, Aunt Becky knelt to pull

the grass that had grown up around its borders. She left flowers on the ground and stood. Uncle Andy and Father stepped forward and kowtowed. At his mother's urging, San followed their example. He clasped his hands together and bowed three times, saying, "Let me be a good boy and honor my family in the coming year."

"Me too?" I asked Mother excitedly, although I couldn't decipher who exactly the ancestor was.

She laughed. "No, not you. You're a girl. Girls don't have to bow, not even grown-up girls like your aunt and me."

That's not fair, I thought. The theatrics of the ritual were the best part. I decided to kowtow in my head, where my family couldn't see. After all, they were my dead ancestors, too.

A week later, school let out for the summer. San and I spent most days at the restaurant, usually in the field out back. Casey liked children enough to say hi and give us Cokes from the bar, but after these pleasantries, he ushered us outside. Annie either didn't like children at all, or she didn't like them in a business establishment. Whatever the case, she also encouraged us to stay out of the way.

We amused ourselves at the gas station that shared the block. Its major charm was a glass-enclosed automated car wash, offered free of charge. I hung around the service bay waiting for cars to drive through. When they did, the effect was thrilling: Jets of blue soap and water cascaded on dusty hoods and bumpers. Red and blue mops spun wildly, a kaleidoscope scrubbing the metal bodies clean. Fresh clear water on the other side, more mops to quickly buff dry, and a shining car came out the other end. On slow business days San and I could persuade Aunt Becky to take her Chevrolet through the glass tunnel. From the inside, it was even more fun.

When we weren't watching cars being cleaned, we were treasure-hunting in the undeveloped prairie land beyond the kitchen

dumpster. The lot's hard-packed dirt was eroded beyond repair, a sun-baked crust over softer dust. Nothing grew there but thistles and the occasional sunflower. About ten yards farther out, the ground dipped and became softer. Children our size couldn't be seen behind the dirt hills below. This was the place we searched for treasure. San taught me to plunge my fingers into the sand and scoop until we found the darker, moister dirt beneath. We lumped the dark, wet soil into balls in our fists, threw it aside, and dug for more.

Mother hated it when I played in the field. "Remember how neat you were in Hong Kong?" she'd remind me. "You wouldn't even take off your shoes." Then she'd hose me down with the nozzle from the dishwashing station, stretching the hose out the kitchen door. I wanted to please Mother, but there was something oddly soothing about the feel of the dirt in my hands.

One day I squatted on the back stoop, trying to tie my shoes, two-dollar, tricolor sneakers from K Mart. San was crawling around in the field behind the dumpster, looking for bugs to add to our collection. We stored rows of mayonnaise jars in the shadows on the side of the building. We preferred hard-to-catch grasshoppers, and caterpillars that might turn into butterflies. A frustrating enterprise—although we poked holes in the jar caps and conscientiously fed the insects blades of grass, they kept dying on us. Well, this time it was San's turn to find more. I couldn't run out there with my shoelaces flopping around, and I was sick of asking adults to tie them for me.

I was probably on my fiftieth attempt when the car pulled up. There were two people in it, a man and a woman. I knew they weren't customers because the man was Chinese. The car doors opened. The couple unfolded their bodies from the car shell. I didn't understand about adults and their number ages yet, but I could tell that these two belonged somewhere in between my par-

ents and my grandmother. Aunt Becky rushed out of the kitchen, welcoming the man in Chinese, the woman in stilted English. They went inside together, and all I could hear was a flurry of voices. San ran in from the field, his bangs slanted across his forehead, fallen from a side part. Shoelaces forgotten, I edged over to the door and peered in.

The strangers were headed back outside. The man held a cup of coffee. The woman stirred a glass of ice tea, chasing a sliver of lemon in rapid circles. Aunt Becky and my mother followed, carrying metal fold-out chairs. "Ah, San, what a big boy!" the man exclaimed. I watched San hug the woman, surprised as always by his easy physical affection. Becky and Mother set up the chairs for our guests, then seated themselves on cardboard-padded lettuce crates. I stood next to Mother, my hand on her shoulder.

"This is Ching's daughter, Man Yee," Becky told the man. He looked in my direction. I ducked my head. "She's shy," Becky said. Then she spoke to me: "This is Elder Uncle Wong and Carmen. Say hello to them."

They were Bill and Carmen Wong, not really my family. "Elder uncle" was the polite term for male acquaintances of Bill's age. Ordinarily, I would have called Carmen "Elder Aunt," but she didn't speak Chinese, so "Carmen" sufficed. Bill was related to Becky through her marriage to San's biological father, who died when San was just a baby (and of whom we never spoke). In some vague way, he was also related to Andy—they were all Wongs. Bill was the head of the Denver Wong clan. Carmen, his wife, was of Mexican descent. Their marriage was unusual in our community: A bachelor immigrant might have a non-Chinese lover, but he rarely sanctioned the union by marrying her.

Carmen and Bill had come by to help with my school enrollment. It was late July, time to register me at McMeen for the approaching school year. The problem was, Becky explained to Bill, I didn't have an American name yet.

I leaned on my mother, rubbing my face against her shoulder,

cat-like. "What does she mean?" I whispered. "What's wrong with my name?"

"You need a name that the teachers can say," Mother replied. "*Man Yee* is too hard for Americans. Like my name, Ching, nobody can pronounce it. That's why the waitresses call me 'Jeannie.' Your aunt has an American name, 'Becky.' You can't go to school until you get an American name."

I nodded doubtfully. "What's Big Cousin's American name?" I asked. I knew his Chinese name was "San," although I wasn't supposed to address him that way.

Mother and Aunt Becky exchanged glances. "It's the same," Mother said. "The Americans just say it differently."

"Then why do I need a new name?"

"It's different," Becky snapped impatiently. "San was born here. You weren't. You need an American name to fit in."

"Mother won't be able to say my name if it's American. She doesn't know English." A horrible thought struck me: "I don't know English, either. How will I know my name?"

"We'll call you Yee at home," Mother assured me. "You'll still be Yee. We're just giving you a name to use at school, that's all. You'll learn it today, and practice it until school starts. You'll know your American name when the teachers use it. It's very important for you to remember, so you can follow your teachers' instructions."

"That's why Elder Uncle Wong and Carmen are here," Becky explained. "They're going to choose a name for you."

"Carmen will," Bill said. He leaned forward, smiling at me. His eyes crinkled. The late afternoon sun threw his shadow onto my legs. I dared to look at him, since I had to trust him.

Carmen's chair was very close to his. She put her hand on his forearm and said something in English. "She's happy to choose a name for you," Bill translated, "because we have no daughters of our own. She's always wanted to name a girl."

I glanced at Carmen quickly. She looked ginger-warm, but I

couldn't communicate with her. She said something. "She wants you to help her choose. Then you'll be special friends. She'll be your godmother. All right?" Bill coaxed.

I inclined my head uncertainly. What choice did I have? Carmen cocked her head. She said a few names slowly. I looked at San. He was hopping around, no help at all. My mother was waiting for Carmen's decision; she had no input to give. I shook my head helplessly. Everything sounded alike.

"Elaine," Carmen decided on her own. "I've always liked the name Elaine. How about that?" She smiled.

"Good!" Bill proclaimed. "Elaine is your American name."

Becky and my mother consulted one another. "Eee-laine," they murmured awkwardly. "What does it mean?" Mother asked. Bill translated for Carmen, and she shrugged. "It's just a name." Mother and Aunt Becky nodded.

"How do you write that?" Becky asked. She fetched notebook paper from the kitchen. Father followed her outside. He handed Carmen a clicking ballpoint pen from his breast pocket. Carmen wrote the name in capital letters and showed the adults.

"Your American name is 'Eee-laine,'" my mother said. "Say it."

I repeated the sound. So that's who I was. My life cleaved in two.

3

American Children

Mc̲Meen's principal, Mr. Myers, didn't want to put me in first grade. He said that I was too young, because my birthday came after the September deadline.

"San in fir-see gray," Aunt Becky argued. "She go San rloom. She no English-ee."

That was the second problem, Mr. Myers stated—McMeen didn't believe in placing relatives in the same classroom. The school didn't want siblings (or, in this case, cousins) to become overly dependent on one another. Children needed to learn to socialize with people outside the family, he informed my aunt.

Becky countered that we were Chinese, and Chinese help one another. San and I were nearly the same age, just three months apart! San helped me with everything, Mr. Myers should see what a good cousin he was! I needed San to learn anything in school, she insisted.

I listened to the debate from Mother's hip level, staring up into the faces of the arguing adults and trying to determine the outcome from their tones of voice. After every exchange, Aunt Becky stopped to translate for Mother, and I adjusted my evaluation accordingly. Standing there in the school office, waiting for my

fate to be decided, I sort of hoped that the principal would say *no*: Based on San's descriptions, I *wanted* to attend kindergarten. It sounded like fun. I'd already had two years of school in Hong Kong; I could add and subtract and multiply. But I'd never played the way San did. *Say no, say no,* I implored silently. I knew kindergarten would mean lagging one school year behind San. It would confirm Becky's pronouncements that I wasn't as smart. It would probably make Mother mad. I didn't care—I suspected that there were lots of yellow-haired dolls in kindergarten, and I wanted my chance to play with one.

Mr. Myers made his decision. He touched Becky's elbow, steering her out the door. Mother and I followed them down the first floor hallway. Bright windbreakers hung on coathooks. Room 101. We stopped. Mr. Myers motioned with his index finger: *One minute.* He stepped inside to talk to the teacher. "Okay," he said when he returned. He shook the adults' hands. He touched my shoulder and left. I turned to Mother expectantly.

Mother said, "This is your classroom. You're in the first grade with Big Cousin. Your aunt arranged it for you, so you be good, listen to what your cousin says. Obey your teachers. Listen well. You must be very grateful."

"Yes, Mother," I agreed automatically, although I didn't want to be grateful. Five months in the country, and I was already tired of being grateful.

My teacher's name was Mrs. Tate. She looked like the comic book drawings of Lois Lane—cap of dark curls, red lips, neatly belted dress and matching pumps. She seated me next to San and let me follow him everywhere except the bathroom. We weren't supposed to talk in class, but she didn't mind when he whispered translations for my benefit.

I also had an adult helper, the teacher's aide, who turned out to be Mrs. Brown, the black *gui* who lived down the street. She

would kneel by my desk to help with things that San didn't know, like the spelling of my new name. At the end of the first day, she asked me to stay after school, so San and I waited by Mrs. Tate's desk while the other kids filed out. After they left, Mrs. Brown gave me a hug and asked San, "How are *you*?" That day, Mrs. Brown told Mrs. Tate about the day Mother and I came to live with San and Aunt Becky. Then Mrs. Tate hugged me, too, and I felt better about being in the first grade.

To my surprise, Mrs. Brown was already in Mrs. Tate's classroom when I showed up the first morning. For the longest time (years, in fact), I believed that Mrs. Brown came to school just for me. I thought that she'd chosen me some summer afternoon while sitting on her front porch: She'd seen me trailing behind the other children tearing across the neighborhood lawns. She'd noticed how blindly I ran, always in the wrong direction, confused by the game, never knowing who was "it." Watching me stumble across the tree roots in her lawn, she'd decided. She would follow me to school to be my fairy godmother. Nothing could persuade me otherwise. I didn't mind when Mrs. Tate referred to her as the "teacher's aide" and allowed her to help other students. I ignored my parents when they referred to Mrs. Brown's "job" at McMeen. I knew it wasn't a job. She was there to be my friend. The fact that Mrs. Brown quit the following spring (in order to care for a newly adopted son) only confirmed my beliefs—I'd made it through the year, so she was able to retire her angel's wings.

The truth was, I needed all the help I could get. Nobody cared that I knew twelve times twelve. My classmates laughed at me. I wasn't able to communicate in English, so everybody thought I was stupid. I couldn't count to ten when everybody else did. I couldn't answer any of Mrs. Tate's questions, not even the simple ones, like "3 + 4."

Mrs. Tate wrote the equation in big chalk figures on the board. She asked for a volunteer. The more enthusiastic students raised their hands. Mrs. Tate scanned the room, then decided, "Let's

give Elaine a chance." I didn't understand a word, not even my new name. There was silence. "Elaine?" Mrs. Tate repeated. I didn't respond. "That's your name," San reminded me. My classmates started giggling. "Oh," I said. I immediately knew the answer, but I couldn't think of the word for "seven" in English. "Um," I said. The children laughed some more.

Mrs. Tate made a shushing sound, one finger in front of her lips. She drew tally marks next to the numbers. "Now, here we have one, two, three," she said. "And here we have one, two, three, four. If we put them together, how many do we have?" She looked at me significantly.

I still couldn't think of the word. I wanted to ask San, but I wasn't allowed—Mrs. Tate would think I was cheating. *I'll write it on the board*, I thought. I slid out of my seat.

Misunderstanding my action, Mrs. Tate said, "No, no, you can't go to the bathroom now." The class exploded with laughter. San translated the sentence for me. "I want to write the answer," I told him.

Too late. Mrs. Tate decided to solve the problem herself: "All together, class, one, two, three—" she tapped at the lines she'd drawn "—four, five, six, seven. The answer's seven!"

The experience was repeated several times a day. Mother's friends and my teachers in Hong Kong had always praised my intelligence. Now Mrs. Tate needed to shush my classmates' giggles and give me extra time whenever I tried to speak. I began to wish that I *were* stupid—then at least they'd be picking on me for the right reasons. There was nothing worse than knowing the answers and not being able to say them.

I felt trapped inside my body. Language seemed a purely physical limitation. Thoughts existed inside my head, but I wasn't able to make them into words. As a consequence, I was forced to observe my classmates from a place inside myself. And the kids just laughed, not able to see beyond my physical shell. They had no idea who I was beyond the mute, lifeless form in the classroom.

My fumblings extended beyond math equations. I couldn't do anything right. Even my small amount of English was inadequate. I'd learned the alphabet in my school in Hong Kong, but now I discovered that I pronounced the letters wrong, particularly the "r." No matter how hard I tried, I couldn't make it come out the way the other kids said it. My "r" had two syllables, *ar-lu,* and years of training dictated that I continue to pronounce it this way. Not so much out of ineptitude as the conviction that I was right: My teachers had taught me the correct answer for 3 + 4, they knew the sequence of the letters in the alphabet, so why would they be mistaken about the pronunciation of *ar-lu*? To my ear, the American "r" sounded funny, more like a burp than a way to say the alphabet. So I persisted with my polysyllabic "r," to the malicious delight of my classmates.

I mimicked to the best of my abilities. I stood when they stood, sat when they sat, laughed and sang and followed them single file to the gym, where my hokey-pokey was always one step behind. I concentrated so hard that by recess time I was too exhausted to go outside and play. On their way out each day, a few of the girls in my class pushed their chairs together in order for me to nap on the combined length. Mrs. Brown supervised recess, and Mrs. Tate sat inside with me.

On rainy days we had recess inside. With so much noise, I wasn't able to nap; I was forced to join in the games. A first-grade favorite was "heads-up-seven-up," which, like so many grade school activities, served to distinguish between the brahmin and the outcasts. Seven children were chosen to be "it." Everyone else hid their eyes. They lowered heads to desks, foreheads on curled arms, the thumb of one hand protruding. The "its" tagged their replacements by pinching the exposed thumbs. Anyone whose thumb was pinched tucked the digit into her fist, so that no one could be chosen twice. When the seven children finished prowling the aisles, they stood in front of the chalkboard, and Mrs. Tate called, "Heads up, seven up!" The seven children with pinched

thumbs would stand. They would have three chances to guess who had chosen them. If they guessed correctly, they replaced the person who had chosen them; if not, they sat back down.

A beautiful blonde girl named Dawn sat near me. No matter which seven students were "it," Dawn's thumb was always pinched before anyone else's. From the nest of my curled arms I could hear the cries of dismay when latecomers approached her desk only to see the tucked thumb. Children like Dawn might use up their allotted three guesses and still not identify their pincher. I never had that problem. No one ever picked me, especially not San. We both understood how pathetic that would have looked, the two cousins defending one another. As if they didn't have another friend in the world. And that wasn't true, at least not for San. He'd gone to kindergarten.

The first time my thumb was pinched, I didn't even lower it. I didn't stand up when Mrs. Tate said, "Heads up, seven up!" I raised my head and stared blankly ahead, waiting for the game to proceed. Mrs. Tate counted the students as they stood. "One, two, three, four, five, six. Hmm, okay, one more." She waited. There was a mystified silence, during which the seated children searched the room for the missing individual. "How about you?" they mouthed to the more popular kids, who shook their heads, perplexed. After a while, Mrs. Tate turned to the seven children lined up at the front of the room. She asked, "Did someone not choose?" *I did, I did,* they each murmured. "I don't understand," Mrs. Tate mumbled. "Maybe we should start over."

At that moment, one of the girls by the chalkboard caught my eye. She was motioning with both hands. *Stand, stand,* she was saying. I couldn't believe it. Janet was another of the beautiful ones, always chosen, and she was gesturing at *me.* I was afraid she'd made a mistake. I pointed at myself, questioning. She nodded discreetly. Slowly, I rose. The other kids started laughing. "No, you don't understand!" they said. "San, tell her!"

"Maybe we *should* start over," Mrs. Tate suggested gently.

"No, me," I said awkwardly, blinking back tears.

"Are you sure?" Mrs. Tate asked.

"Yes," I said. I held out my thumb, as if Janet's pinch were indelible.

Since the seven "its" didn't protest, Mrs. Tate let the game continue. The chosen ones began guessing, one name, then two, then the right answer. Mrs. Tate called on me. My turn to guess. Five "it's" remained. I studied their faces. Janet looked at me expectantly. I did not call her name. Janet looked confused. I knew she thought I was stupid, but I didn't care. I couldn't choose her right away. I had to stall. I had to pretend that I was desirable, befriended. But I gave only one false name. I didn't dare push my luck. The kids would laugh at my delusion of having so many friends.

I waited a few heartbeats. I scanned the row of faces again. Finally, I said Janet's name. She nodded happily, and we moved to change places. My turn to be "it." Janet beamed as we passed each other in the aisle. I felt the stares shifting between my back and Janet's. I knew instantly that the kids had recognized her act as charity. I wasn't anyone's friend. Playing with me was no more desirable than it had been before. They were all wondering how to hide their thumbs from me.

I couldn't explain these difficulties to Mother. Our language didn't leave room for such a conversation: The Chinese don't ask their children, *How was school today?* They say, *What did you learn?* and *Do you understand your lessons?* In Cantonese I could only describe the equations we'd solved that day. I was able to show her my spelling list. And I could honestly say that I *did* understand, on paper, at least. It was harder to explain that kids groaned when I was chosen to be "it," that I hated dodgeball, and that I was largely mute. As far as Mother was concerned, the first two complaints were just silly—she didn't send me to school to play with the ghost

children. Nor did she view silence as a problem; in our culture, a student *should* be quiet, the better to hear her teacher's wisdom. If I explained that the difficulty was my inability to speak English, Mother answered that I simply required practice. It was a problem that could be solved by rote, by repetition and practice, like calligraphy. Her advice was to listen harder.

In general, Mother was not impressed by the American school system. She was shocked when I returned home day after day without homework. "First grade, what is this first grade?" she snorted. "No work at all. You're learning simple addition, how lazy! Why did we come here, to have you learn nothing? The schools in Hong Kong are so much better. You'd be learning long division by now, not one plus one. You're forgetting everything, I know it! Look how stupid the *gui* are. Look at San, he doesn't even know multiplication, that's what America does to children!"

Mother created her own homework assignments. Every day after my snack, she sent me down to the basement, where I practiced calligraphy for hours on end. *Heart, liver, lungs. Left, right, up, down.* My grandmother's name. My father's name. My name. I could hear San laughing with his friend Daniel in the living room. *He* was allowed to invite people over. The Looney Tunes theme played. I wrote my grandmother's name. My name. My father's name. For the first time I resented these exercises, this language that separated me from my classmates. I wanted to be American, like San. I wanted to fit in, to be chosen during games of "heads-up-seven-up." But I also didn't want to disappoint my mother. I dipped my brush in ink and began another row. *Heart, liver, lungs.*

Father had Tuesdays off from work, and his presence made Mother happy, so I didn't get in trouble for skipping calligraphy. On Tuesdays Mother didn't sneak around the house looking scared. She spent the day cooking a special meal to honor Father's day home—beef bone soup, or curried chicken wings, or pork

ribs in black bean sauce. When San and I got home from school on Tuesdays, we only got little snacks, so as not to spoil our appetite for dinner. On Tuesdays Father took us out for walks. We went to drink coffee at the Yees' house, two blocks away, or to shop for groceries at Friendly Market, down the street from the Yees. San and I traded turns riding in the grocery cart, and San showed me which cereals were the best, Count Chocula and Trix and Lucky Charms. On Tuesdays I accepted San's advice easily. I liked having both parents home so much that I didn't mind that San knew everything and I knew nothing. I loved Tuesdays.

I'd moved to America for Father, but we rarely saw one another. He was still asleep when I woke up for school in the mornings, and I was in bed by the time he came home at night. Tuesdays were the exception, and they quickly became my favorite day of the week. Every Tuesday I awoke giddy and full of anticipation. On Tuesdays I breezed through school. On Tuesdays, the children's laughter didn't hurt. For the rest of my life, I will awake on Tuesdays expectantly, before consciousness hits and I realize that I have grown up.

For a long time, I was afraid that Father would disappear if I didn't stay by his side. So like Mary's little lamb, I followed him. Every so often I touched him—his arm, his sleeve, his face—to reassure myself of his presence. I joked and danced for him, ignoring Mother. Whatever she told me to do, I asked Father for permission first.

By the fall of my first grade year, Mother was sick of it. She exploded over dinner one Tuesday night. Mother, Father, San, and I sat around Becky's yellow formica table, rice bowls in one hand, chopsticks in the other. Everyone else was eating, but I wasn't interested in food. I jiggled in my chair, animated by the energy of six days' silence. I talked and talked; nobody else got a turn. I only had a voice on Tuesdays.

Without warning, Mother snapped. "Shut up!" she screamed. "You've been naughty ever since we got to America! Everything is

'Father, Father, Father.' You behave like a fool around him! I can't stand it. It's embarrassing how you follow him, like a crush. Now he's your favorite parent, whoever heard of such a thing? You should be ashamed. Stop it! Sit still, act like a big girl, and eat your food!"

After the outburst, we finished the meal in silence. I didn't dare look at San, or Father. I felt heavy and lifeless, too frightened to cry. My insides constricted until they hurt, dense as stone. It was best not to enjoy anything too much.

Chink eyes! the more aggressive first graders said. In the playground, the older grades taunted me with more elaborate jokes. They swept their hair back off their faces with both hands, pulling the skin tight around their eyes. They screamed, "Mommy, mommy, my hair's too tight!" Then, collapsing in laughter, they asked, "Is that what happened to you? You should tell your mother to loosen your hair!"

"No, you're wrong," I whispered. "My hair's fine."

My response elicited full-throated cackles, the sounds of true pleasure. The children's voices crawled inside me and took residence. I wished I weren't so pathetic. I hated myself almost as much as they did. Perhaps I should have kept quiet, or tried to run. But there were so many of them, and they weren't finished yet. They timed the next part carefully. They paused, just long enough for me to think I'd been given a reprieve. Then they gasped, as if in sudden realization. They finished the joke: "Oh, no, your eyes are stuck that way! Does it hurt? Does it hurt?"

"No, no," I whispered over and over, sapped of strength, defenseless. When the children were feeling particularly mean, they grabbed at the elastics fastening my ponytails. "Let your eyes down! Let your eyes down!" they screeched. They reveled in my weakness, the way I cringed at the punchline every time.

The teachers supervising recess helped when they could, but

they were often distracted—by other fights or children who'd fallen down or their own conversations. I was equally to blame for their negligence; I never sought these teachers out to ask for assistance, understanding instinctively that such a move would only incense my tormentors further. Besides, I didn't speak enough English to plead my case.

So I was left alone with my tormentors. I whimpered. I cowered. I whispered, "Leave me alone." But I refused to cry—not so much out of bravery as the need for vigilance. *Pretty soon,* I thought, *words won't be enough. Pretty soon they'll beat me.* Backed against the school wall, surrounded by my tormentors, I studied their movements for the fulfillment of their violence. When they raised their hands to pull at my hair, I looked for an escape route, any gap in the circle. I batted at the probing hands, I said *no* repeatedly. But I didn't expect to live through the year. I felt certain that one day they would pummel me to a pulp. All because of my eyes.

I never knew whether San suffered the same abuse. We subscribed to the tacit schoolyard edict: *Save yourself.* No one was popular enough to intervene without fear of reprisal. Anyone who tried would become the next victim.

Then suddenly it wasn't just the children—Mrs. Tate also thought there was something wrong with my eyes. One day that fall she sent me to the school nurse to have them checked. I hadn't noticed anything wrong, but Mrs. Tate said that I was squinting.

The nurse flashed slides of the letter "E" on the wall. I was supposed to tell her which way the legs faced—left, right, up, or down. The nurse said that if I wanted, I could point, instead of saying the words. Her voice was very gentle, and I was grateful for the quiet. I wanted to tell her that when the "E's" legs pointed up, it looked like the character for "mountain," but instead, I jabbed a finger in the direction of the ceiling. Half an hour later,

the nurse wrote a note for my parents and sent me back to class without telling me what was wrong with my eyes.

After school I gave the note to Mother. Sitting on the bed in our basement room, she unfolded the page anxiously, although she couldn't read English. "What is this?" she fretted, smoothing the creases.

"I had my eyes checked," I told her. "My teacher sent me to the nurse today."

Mother said, "Ah, daughter, what have you done? Squinting all the time, looking at things funny, no wonder you get in trouble." She squinched up her eyes and jutted her head forward, mocking me. "You'll make yourself blind, looking at things like that!" She pointed at the table where I kept my calligraphy books and brushes. "Now sit down and get to work!"

I slid into the chair, trying to keep my eyes wide open. "Like this, Mother?" I asked, bugging my eyes out. She sighed and left the room. I opened my workbook and placed a piece of blotting paper between the uncut pages. Mother brought me a glass of water. I dipped my brush in the water and rubbed it on the ink tablet.

Mother continued ranting, "Rotten girl, what are we going to do? We have to impose on your aunt to read this note, and she resents us already! If she didn't need someone to take care of San, she'd have no use for us at all!"

I looked up sadly. "Why does she hate us?" I asked, puzzled. Mother always said that family was most important of all, family members always stuck together. "She's *family*. She's Father's sister."

"Doesn't matter! They fought long ago," Mother said. "Don't you ever act like that, turning on your family!" She looked over my shoulder. "Hold your brush straight! Keep your eyes open!"

I listened for movements upstairs. "Maybe we can call the restaurant and ask Aunt Becky to come home," I suggested.

"Crazy girl, what are you saying?" Mother exclaimed. "We can't bother her like that. You think she comes home to see us?

She comes home to see her son! Now he's in first grade, doesn't get out of school until after three, she doesn't come home every day. Too busy setting up for dinner business! Of course, that San, he's not a good son, always running off to that *gui* boy Daniel's house, no sense of home! Don't you act like that!"

I didn't say anything. I wanted to tell her how much I wished for *gui* friends to have no sense of home with, but I knew she wouldn't understand. I continued to work on my calligraphy, trying to keep my eyes wide open.

Mother kept me up late to show Aunt Becky the note. I perched next to Mother on the sofa, listening for the sound of the car in the driveway. We watched the late newscast and the sitcom reruns that followed. When Becky finally came through the front door, I sat up straight and said, "*Gu-jia!*" Father and Uncle Andy walked in behind her. I said their names, too.

They all looked surprised. Father said to Mother, "Why is she still awake?"

Uncle Andy said, "Little children should be asleep by now."

Aunt Becky said, "San's in bed, why aren't you? You have school tomorrow!"

"*Gu-jia,*" I mumbled, "I have something to show you, a note from my school."

Aunt Becky held out her hand. "Don't speak so quietly," she reprimanded. "If you need something, you should ask for it in a loud voice."

I ducked my head and passed her the note. Aunt Becky frowned, squinted, and held the paper at arm's length. Father said, "What's wrong? What is it?"

Aunt Becky moved her lips. She scowled. "It says that Yee needs an eye doctor, probably glasses."

I felt sick to my stomach. "Mother, I can try harder," I said. "If I open my eyes wider, maybe I won't need glasses!"

Mother ignored me. "*Aiya!*" she wailed. "Rotten girl, what are we going to do with her? She was like this even in Hong Kong, squinting all the time, no wonder she can't see! She's brought this on herself! Glasses! Where are we going to get the money for glasses? She's only six! How terrible this is! How's she going to live? If she gets glasses now, she'll be blind soon! What a waste to raise a daughter like this!"

"Maybe I don't need glasses," I repeated. "Maybe the nurse made a mistake. I can see. I'm not having any problems."

"What do you know, making your eyes ugly all the time!" Mother yelled.

Father told Mother to be quiet. He said to me, "Don't worry, I'll take you to the eye doctor. If you need glasses, of course we'll get you glasses, there's no question about that. Now go to sleep. You have school tomorrow."

For the rest of the week I crept around opening my eyes as wide as they would go. "Stop making faces," San complained.

"I'm not," I retorted. "I'm fixing my eyes."

"It won't help," San said. "You'll have to get glasses no matter what."

I bugged my eyes out some more. "It's working," I insisted, although I didn't notice any difference.

In truth, I didn't think there was anything wrong with my vision. I couldn't imagine seeing any other way, and I refused to believe that everybody else passed the test with all those acrobatic "E's." If Mother weren't so mad, and if the kids didn't torment me so much, I'd be perfectly happy with my eyes.

Of course, the optometrist disagreed. A week later I was at the optician's choosing eyeglass frames. I spent a long time deliberating—if I had to have glasses, I thought, I wanted the prettiest pair

in the store. I ignored the trays of plain brown ovals. I fingered the pale blue ones that caught the light. At the far end of the store, I spied rows of pink cat's-eye frames trimmed with rhinestone studs. "These," I declared. "These are the prettiest!" My parents and the optician laughed.

"These aren't for little girls," Father said. "These are for ladies."

The optician steered me to the other end of the store. "Here are the children's glasses." He showed me a shelf full of dull brown frames. My shoulders sagged with disappointment.

I let my parents choose a pair for me. I put them on and scowled at my reflection in the mirror. "The glasses are very pretty," Father insisted. "You look good."

The optician reached over to adjust the frames. "Here," he said. He touched the bridge of my nose. "Too flat here." He meant my nose. He removed the glasses and pointed at the nose piece, "We need to attach special nose pieces to hold the glasses up." He pantomimed for our benefit. "A little more money," he added at the end.

Mother was squinching her eyes, and I knew she was worried about the money, but I didn't care. I wanted to cry. First my eyes, and now my nose! I wondered if anything about my body was right. "Maybe I don't need the nose pieces?" I suggested, in halting English.

"The glasses will fit much better with the nose pieces," the optician stated firmly.

I heaved a big sigh. "Why don't I have a bigger nose?" I asked in Chinese. I gazed at the *gui* optician's nose enviously.

Mother said, "I told you to do your exercises when you were little, pinch your nose at night, make it not so flat, but you didn't listen." She grimaced. "Now you need special parts to make your glasses fit. I don't know where you think we're going to get the money for all this!"

Father said, "Don't fuss. If she needs them, she needs them, that's all. What's a few more dollars?" He fiddled with a display on

the counter. "Look here!" he exclaimed. "A chain for the ear-pieces. A good idea, huh? So she won't lose her glasses."

Mother snorted. "How generous you are! When did you become rich?" She handled the blue metallic chain Father was holding. "Yes, I suppose she needs this," Mother said. "You know how your daughter is, so clumsy!" My parents pushed the chain across the table for the optician to add to our bill.

I didn't think I was clumsy, but I didn't object. I was in enough trouble already. Watching Father pull money out of his wallet, I wished that I hadn't done whatever it was that made my eyes go bad. I didn't mean to squint. I didn't mean to have a flat nose. I wanted to be a good daughter, and not cause my mother all this suffering. My hand reached up. I started pinching my nose.

After I got glasses, I was called *slant eyes, chink eyes, four eyes*. I was tormented on the playground. I was scared all the time.

My mother resigned herself to my glasses. She said I was ugly-looking now, but it couldn't be helped, too late. She insisted that I turn on the table lamp extra bright when I did my calligraphy after school. "If you go blind, what will we do?" she asked. "A waste of money to raise you in that case!"

I did my best to be a good girl. I opened my eyes wide, I wrote lots of calligraphy, I pinched my nose fifty times every night. I thought that Mother had stopped being so mad at me, but then she disappeared one January morning.

I knew something was wrong as soon as Aunt Becky shook me awake. She never entered our room! "Hurry," she said. "You're late for school."

I didn't budge from the cot at the foot of my parents' bed. Aunt Becky hadn't turned on the ceiling lamp, and my eyes were adjusting to the pale gray sun filtering through the window. Even in the shadowy light I could tell that my parents' bed was empty.

"Where's Mother?" I asked anxiously.

"In the hospital." Aunt Becky didn't elaborate, she just shoved clothes at me. I dressed quickly, reading the urgency in her movements. I didn't have enough experience to wonder about Mother; I barely knew what a hospital was.

Wearing only pajamas and a quilted nylon robe, Aunt Becky rushed us out the door and into the car. It was a cold morning, not snowing, but a residual crust of white frosted the lawn, and the roads and sidewalk were slick with ice. She dropped us off at McMeen's back entrance, by the teachers' parking lot. San and I scooted up the slippery drive. *Bang!* My heels upended, and I landed on my back. My new glasses flew off. I coughed, willing air back into my chest while I blinked tears out of my eyes, trying not to cry.

San retrieved my glasses and helped me stand. "Are you okay?" he asked.

I blinked again. My vision was funny—smeared at the edges, lacking depth, like figures torn from construction paper. I thought the adults might be right—I might have bad eyesight. I wiped at my eyes. My vision didn't clear. I started to feel scared that the fall had broken something inside of me. But it was probably best not to mention it. I muttered, "Yeah. These stupid glasses don't work right."

We minced our way inside. We'd missed roll call and the Pledge of Allegiance. Mrs. Tate was writing on the chalkboard in the perfectly articulated letters of a grade school teacher. She turned as we entered. "Do you know what time it is?" she demanded. "I'm going to talk to your mother!"

Something did break inside of me. I burst into tears, exhausted by the effort of my first grade year. I was tired of being ugly and stupid and hated. I was tired of not comprehending half of every sentence. I didn't want to live in America anymore. In Hong Kong, nobody ever yelled at me, and Moy-moy liked me so much she brought me her chamber pot. In Hong Kong, I won "neatest work" awards. In America, I got called a bad girl, and mothers

disappeared to the hospital. In America, I feared for my life on the playground every day. I hated America. I didn't care if I could drink water straight from the faucet.

"My mother's in the hospital!" I sobbed.

There was a horrified silence. Finally Mrs. Tate said, "I'm sorry. I didn't realize." She let Mrs. Brown take me out into the hall. Mrs. Brown unbuttoned my coat. She slipped it off my shoulders and hung it up. "I'm sure your mother will be fine," she kept saying. I didn't care; I just kept crying. We sat together on the boot ledge underneath the coat rack. Mrs. Brown gave me Kleenex from a plastic pack in her hand, but I didn't know what to do with it. I crumpled it up in my hand. Mrs. Brown said, "For your nose. Blow." She gave me more Kleenex, but I didn't want to blow my nose. I snuffled loudly and added the Kleenex to the ball in my hand.

That was the only day none of the kids picked on me.

I felt slightly dizzy the rest of the day. No matter how hard I rubbed my eyes, my vision wouldn't clear. Walking home with San after school, I hoped that Mother had returned. I was certain that she could fix my eyes. No matter what she said, I would do it. I would open my eyes wider than they'd ever been before, I would turn on all the lights before I did my calligraphy, I just needed Mother to come home.

But only Aunt Becky awaited us, and I didn't mention my eyesight. What if she'd made my mother go away? Mother had said that Aunt Becky resented us.

"Is Mother coming home?" I asked her softly.

"Good news, good news!" my aunt said in reply. "You have a baby brother! Such good luck! A boy! A new boy for the family!"

So that's why Mother went away, I thought. *To get a new baby boy from the hospital. Maybe she doesn't want me anymore.* I almost started crying again. "When's Mother coming home?" I asked.

"Not for a few days." Aunt Becky changed the subject. "Come on, hurry up! You and San are coming to the restaurant tonight; there's no one to stay at home with you."

We drove off to the restaurant, where everybody was very busy and very happy. I didn't tell anybody about my eyes. Later that night, putting myself to bed, I finally realized that one lens had popped out of my glasses when I fell. The missing lens had caused the fuzziness in vision. All day long, nobody had noticed.

They named the baby Jeffery on the advice of Joe Yee, the friend who lived on Jersey Street, two blocks from Aunt Becky's house.

Mother sounded out the syllables awkwardly "Jeah? Fee?" Her eyebrows drew together. "What kind of name is that?" she asked.

"It's a good name, an American name," Mr. Yee assured her. "And 'Ted' for a second name. The *gui* do that, you know, give their children two names."

"What will we call him in Chinese?" Mother asked. "How do we write it?"

"Jeah-Fee," Mr. Yee said with assurance. He scrawled two characters on a scrap of paper and pushed it across the coffee table. "The first syllable, 'Jeah' sound, like the word 'bright,' like fire. The second syllable, 'Fee' sound, like the word 'shine' and the word 'soldier.'"

Mother studied the paper silently. She looked into the baby's face. "Jeah-Fee. Fee-Fee-ah," she clucked.

"A baby with an American name," she continued softly, sounding confused. "I don't even know how to write it in English, but of course we must give him an American name—he was born here, in America."

I didn't understand why she sounded upset; *I* thought the baby was lucky. He was born in America, so he only had one name to learn. He would understand when the teachers called on him. He wouldn't get confused and forget who he was in school. He

would learn English right away, and the kids wouldn't make fun of him for saying *ar-lu*.

Mr. Yee said, "Born in America. He can even be *tung-hung* if he wants! Wouldn't that be something?"

"What's *tung-hung*?" I asked.

Father chuckled. He hadn't stopped smiling since the baby was born. "*Tung-hung* is the number one leader in this country. The Americans say 'Pres-ee-den.' Have you learned that word in school? The American President is Nix-on-ah. He's good friends with the number one leaders in China." He took a puff on his cigarette. "You've seen Nixon's picture in the newspaper, Yee. He has a big nose and fleshy jowls." Father illustrated by tugging at the skin around his jaw.

I nodded. Mrs. Tate had taught us about the President. She said that he was elected by popular vote, which meant he was the most popular person in the country. "Can I be President?" I asked.

The adults laughed. Mother said gently, "No, you can't be President, because you weren't born here."

"But Little Brother can be President?" I asked. *Yes, yes, yes,* the adults said. I thought for a minute. "And Big Cousin, can he be President?"

"Oh, yes," Aunt Becky said proudly. "Your Big Cousin can be President. He was born here!"

I scowled. Why were American children always more popular? "What can I be?" I asked.

Father said, "If you become a citizen, you can be a senator. You can be Secretary of State, like Kis-sin-ge-ah. He wasn't born here, either. You can be whatever you want, you just can't be President."

"Who is Kis-sin-ge-ah?" I asked, pronouncing the name carefully.

"He's a very important man," Father answered. "He gives advice to President Nixon."

That didn't sound like much fun. I didn't want to be Kis-sin-ge-ah. "What's a senator?" I asked.

"A senator works in the government," Father explained. "You have to be elected to be a senator—like a President, but not as important."

If I could be elected to something, that meant I was popular. I would be a senator, I decided. "You don't have to be born in America to be a senator?" I asked.

"You don't have to be born in America to be a senator," my father confirmed.

I said, "I'll be a senator, then. Is that a good job?"

The adults laughed again. Mother said, "Yee-ah, daughter, what will I do with you? Senator! If you could do such a job, the whole family would be proud, but first you must learn English. Concentrate on English for now."

The adults didn't believe me, I realized. They thought that because I wasn't born in America, I would never catch up to the boys. San and Jeffery could become President, but I couldn't even learn enough English to be a senator. I would surprise them, I decided. I would do better than anyone thought. I would be whatever I chose, just as Father said. My stomach clenched with the strength of my determination.

At home, my parents spread Jeffery's baby pictures on the coffee table. "We need to send some back to Hong Kong for everyone to see," Mother said. "We'll have to explain about the name, how it's American, but we've translated the sounds back into Chinese. Such an unusual thing to do!"

"We're in America, we learn as we go along," Becky sighed. She scraped one of the photographs off the table. "Jeah-Fee's a cute boy," she commented. "Too bad he ruined the picture by screwing his eyes shut. You should see San's baby picture, his eyes are wide open, so alert! He looks like the smart boy that he is. I wasn't at all ashamed to send *his* pictures back home." She replaced Jeffery's picture on the table and rose. "Let me get them to show

you. It's no trouble at all. You'll see what a beautiful baby San was." She strode off in the direction of her room.

Seated on the floor next to Mother's legs, I felt her body tense. She whispered urgently to Father, "She's right, you know. It's been a week and the baby's eyes haven't opened yet. I wonder what's wrong with him. What if he's blind? What will we do with a baby who's blind? What if he's wrong in the head?"

"What did the doctor say?" Father asked.

Mother told the story: "In the hospital I pointed out the eyes to Becky. 'Have you ever seen such a thing?' I asked. 'Maybe he's blind,' I worried, '*Wey, wey,* ask the doctor for me,' and she did. She showed the doctor his eyes and said, 'Why aren't they open? Is he blind?' The doctor laughed." She paused and frowned. "He told me not to worry," Mother finished uncertainly.

"Then there's nothing to worry about," Father asserted. "The doctor knows. The baby's healthy." But he put down his cigarette to look into my brother's face.

I crawled up onto the sofa next to my mother. The baby was cradled in her arms. His face was wrinkled and very red. His eyes were two little slits, squeezed shut, with tiny eyelashes spiking downward. He looked like he had too much skin for his face. I thought that must be why he couldn't open his eyes—the skin was too heavy. I hoped that my brother opened his eyes soon. I hoped that he wouldn't end up needing glasses, like me.

Aunt Becky returned to the living room. She held a photograph gingerly, balancing its edges on the pads of her fingers. "Look here," she said, smiling. "Wasn't San a beautiful baby?"

"He was very cute," Mother agreed politely. "Much better looking than Jeah-Fee."

"Was I a pretty baby?" I asked tentatively. I wondered why Mother didn't bring out my baby pictures.

Aunt Becky laughed. "You were a fat baby! You should see the pictures your mother sent!"

"I've never seen my baby pictures," I hinted.

Mother said, "What do you need to see them for? You know what you look like now. I don't even know where to find your baby pictures!"

I looked at the pictures spread on the table, my little brother's, and San's beside his. I was sick of being told that San was better at everything. What about me and my little brother? We were just as good as stupid old San. "Big Cousin's not so cute!" I blurted. "His eyes are open, so what? My little brother's cuter! Look, he's waving his arms! Big Cousin's not doing anything, just lying there!"

Aunt Becky glared. She pressed her lips tight and put San's picture away.

"For shame!" Mother breathed, shushing me. "How can you say such things? Didn't I teach you to be modest?"

"My little brother's the cutest of all," I stubbornly repeated.

My parents' friends seemed to agree, although the baby was loud and boring for the longest time. All he did was cry and sleep and throw up, and since he didn't sleep through the night, neither did I. Every day I was tired at school. Our room was stinky from the baby spitting up, and the bathroom was stinky because Mother washed his diapers in the sink. But every day people came to visit, women with frizzy perms and men with gold teeth, all of whom I called "aunt" and "uncle." They brought bags of oranges with their congratulations. They lounged on Becky's sofa, eating bowls of peanuts that I carried in from the kitchen. They cracked the shells between their teeth and filled our ashtrays with the empty husks.

"Ask aunt and uncle if they want a cup of water," Becky instructed. "Empty the shells from this ashtray!" she called out.

I ran back and forth meekly, barely daring to look into the visitors' eyes. Father's face flushed red from laughing, while Mother explained the baby's name over and over.

"Now your family is complete," our guests always said. "Such good luck! You have a boy. So fortunate!"

I listened indignantly. I wanted to remind them that Father liked girls best, but I was too scared to speak. Mother would remind me to be modest, stay out of the adults' way. And Father looked so happy, what if he'd changed his mind? Worse yet, what if he'd never liked me? What if he'd wanted a boy all along, and didn't really want me?

In the spring Aunt Becky brought home a load of lumber for Father to build another basement bedroom. Aunt Bik-Yuk's immigration papers had been approved, and she would be arriving with Cousin Dani and Cousin William in a few months. They were grown up, more than twenty, but they were still her children. We would all have to scrunch up: Uncle Andy moved out of his bedroom to share Becky's. San moved into Andy's old bedroom, leaving his two twin beds for Cousin William and a family friend named Wing, who'd come to work and live with us. ("Big Foot," my parents called him when he wasn't listening, nicknaming him by physical characteristic, the way Chinese do.)

Aunt Becky said that I should also move—now that we had a baby, my parents' room was too crowded for me. She folded up my cot and put it in a corner of the basement. She got San's old crib out of storage and set it up in the space between the foot of my parents' bed and my calligraphy table—where my cot had been.

The crib was white and had slatted sides that moved up and down. A dancing bear was painted on the headboard. "Isn't your aunt generous?" Mother exclaimed. "San's own baby bed, for us!"

Aunt Becky looked satisfied. "It's the least I can do," she said, leaning against the doorjamb. "A baby boy deserves a proper bed!"

Using my parents' bed as a step, I climbed over the crib's raised slats and tumbled onto its mattress. I lay down. "It fits!" I announced. "It fits me! I can sleep in it!"

"It's a baby bed," Aunt Becky protested. "Not for you. You're a big girl now, an older sister. You sleep in the new room with Aunt Bik-Yuk and Cousin Dani, like an adult. Won't that be nice?"

I peered at my aunt over the crib's headboard. I didn't want to move out of my parents' room, especially for some stupid baby. "This bed's big enough for me," I pointed out. "And it has sides, so I won't fall out. We worry about me falling out of bed, don't we, Mother? If I sleep here, we won't have anything to worry about."

"It's much better to share the other room, like an adult," Aunt Becky wheedled.

"I don't want to sleep there!" I insisted.

"We'll work it out later," Mother told Aunt Becky.

We didn't have to discuss it; my parents let me sleep in the crib. Little Brother slept in the big bed with my parents. And if Aunt Becky had anything to say about the situation, I never heard a word.

Our basement room was at the end of a short hallway and behind the boiler. Descending the stairs from the upstairs living room, looking straight ahead, you could see in our open door. But our room was only a small part of the basement.

At the bottom of the stairs, to the right, there was an irregularly shaped utility room where we did our laundry. We had an electric washing machine but no dryer; clothesline cord ran the length of the room, some twelve feet (about half the length of the house). In the winter, when it was too cold to hang laundry outdoors, we were forced to dodge wet shirts and socks and underwear on wash day and the day after.

The gray concrete floor dipped slightly in front of the washer, leading to a round grated drain. There was always a ten-gallon can, fitted with a homemade mesh bottom, positioned over the drain. Father grew bean sprouts in it. He lined the cans with alternating layers of burlap and small green beans, then watered them daily

until the beans sprouted. When the top layer of burlap rose from mid-level to the rim, Father peeled back the fabric and pulled the bean sprouts loose, packaging them in plastic bags to carry to the restaurant. In later years, after he got a driver's license and a car, Father grew extra bucketfuls, and the two of us would drive around selling them to other Chinese restaurants on his days off.

The rest of the basement, the largest part, was used as a play space. It was a big open area sharing a dividing wall with my parents' room and the downstairs hall. This play area was to the left of the stairs as you descended; walking downstairs, you could peek into the room through a cut-out window halfway down the wall. On the other side of the wall, there was a long table directly beneath the window. As I became older and braver, I started climbing into the playroom through the window, using this table as a step down to the floor. I risked the adults' censure doing this, but somehow it seemed worth it for the thrill of climbing through a wall.

But my first year in America, I didn't dare go into the playroom alone. It was a seemingly vast space, extending the full length of the house. The floors were a chilly white linoleum interrupted intermittently by red squares. The walls were unstained ply-wood, punctuated by one small window at the far end. Coming down the stairs to our room, day or night, I was afraid of the play-room's unlit corners.

Besides, there was no point in my going into the playroom alone, since I didn't have any toys. Everything there belonged to San: board games, Tonka trucks, Legos, crayons, Matchbox cars, comic books, a Snoopy record player. In the early evenings after supper that first winter, San would invite me to play downstairs. Together we built Lego villages, racing the smaller cars through our make-believe streets and destroying them with the larger ones. We played Archies records on the battery-powered turntable, and I sang along: *Sugar, sugar, you are my candy girl . . .* I played there happily, but only when I was with San.

The new room changed all that—it made me braver. Father
built the room on Tuesdays, his day off. After school, San and I
would clump down the stairs to help. We loaded San's toys into
big cardboard boxes from the restaurant. We flattened our palms
against the curly red ink design on the sides and pushed them
across the floor, puffing like choo-choo trains the whole way. We
made sure to clear the part of the room where the window was,
because the adults said that a proper room needed a window, and
we wanted Aunt Bik-Yuk to have a proper room. After San and I
finished, Father measured off one third of the playroom with a
hinged wooden ruler. He marked the spot on the walls and cut
wood for the new partition: two-by-fours for the supports, dark-
stained plywood for paneling. He laid the supports across the
floor and up the sides of the wall. On the far right, near the hall
and stairs, he made a frame for the door.

Lumber to supports to wall, the transformation was miracu-
lous. Where once there'd only been air—lonely, empty space—
now there was a wall. A room. Shelter for my aunt. I was awed by
this act of creation. By the labor of his hands, my father had irrev-
ocably changed the character of Aunt Becky's house. The play-
room would never be the same. It would no longer belong only to
San. Now it was mine, too. No matter how many toys San owned,
I had my father's wall. I belonged there.

I slowly grew bolder. By early spring I understood Mrs. Tate's
lessons without any help from San. I became more competitive in
school, and at home San and I started arguing about who knew
more. Down in the playroom one night, we got into a counting
contest.

"I can count to one hundred!" San declared. He was holding a
dark purple crayon, and, to prove his point, he wrote "100" in
inch-high numbers on the wall by the stairs.

"Oh yeah," I said, "I can count to one thousand." I picked up a

red crayon and made a circle next to the last zero. For good measure, I drew a smiley face inside of it.

"Well, I can count to ten thousand!" San made another zero, larger than the previous one. He put his own smiley face inside the zero.

"I can count to one hundred thousand!" I drew a very large circle, three times the size of San's. I left it hollow, but decorated the rim with petals.

"I can count to one million!" San added another oval, unembellished, twice the size of mine.

"Ten million!" I said, making my mark.

San scrawled another circle. "One hundred million!"

I didn't know what the next higher number would be, but I refused to concede. All I had to do was add a zero, I thought. If I could write it, I could count it. I scratched the crayon against the wall, "I can count to this number!"

San understood my tactic. He marked the wall next to me, "I can count to this one!" He squealed. I bumped him aside and upped the number. He dodged around me to write the next digit. I reached over him for my turn. We raced to see who could add circles fastest. We giggled, I spun two at once, he changed colors. I made a stick person out of mine, he drew rays and made a sun. We stopped abruptly. The number traveled three sides of the room, from the entryway by the stairs to the middle of the facing wall. The last zeros were almost as tall as we were. "Uh oh," San said.

"It's okay. We're decorating," I said. "It's *our* room."

San looked dubious.

"C'mon," I said. "You have to read this number if you want to win." I pointed to the "1" preceding all our zeros.

He accepted the challenge. "It's one-hundred-thousand-billion-trillion-jillion-million-zillion!" he read, tracing the number around the walls. He laughed.

"What if you had that much money?" I asked dreamily. "What would you do with so much money?"

"I would buy all the Archie comic books," he answered solemnly.

"I would . . ." I started and faltered. I didn't know what I would do. I tried again. "I would buy a yellow-haired doll." I thought for a minute. "I would buy a house and decorate all its walls." I looked at the crayon in my hand. I wrote on the wall again: ABCDEFGHIJK. I wrote the whole alphabet, thinking *ar-lu* as I got to that letter. San scribbled Z's in progressively larger zags below my alphabet. We started laughing again. I drew airplanes and clouds in the sky. I drew flowers and grass.

We were interrupted by a screech from the stairs. Aunt Becky's torso was framed in the window halfway down the stairs. The banister bisected the picture diagonally, but I could see that Aunt Becky's face was angry and shocked. "What are you children doing?" she screamed. The ceiling above us rumbled, and I knew that Mother was running to the basement door.

"Answer me! Answer me now!" Aunt Becky demanded.

San's eyes were huge. His mouth was open, but no words come out.

"We're decorating," I squeaked.

Mother's face appeared in the window behind Becky. "What is it?" she asked, alarmed.

"Look what the children have done," Becky said.

Mother's gaze jumped over us nervously. Briefly, she looked relieved. "Ah, Becky, you scared me to death," she said. "I didn't know what was wrong."

"Look at the walls!" Becky gasped.

Mother focused on the walls for the first time. Her expression changed to one of fury. "Yee, come here now!" she ordered. "How dare you scare us like that?"

I edged toward the stairs slightly, but I was too scared to move much—Mother's voice was poisonous, her face had contorted beyond recognition.

"Man Yee, do you hear me? Come here now!" Mother ran the

rest of the way down the stairs. Becky grabbed at her arm. "Slow down," she cautioned.

"You spank your son, I'll spank my daughter," Mother said. San and I burst out crying simultaneously.

"Ah, Ching, you're scaring San," Becky said.

"How else can we teach the children, if we don't hit them?" Mother spit over her shoulder. She seized my wrist and dragged me across the room. "Which hand do you write with, this one?" She slapped my right hand hard. "And don't think you can try writing with this one," she said, slapping my left hand.

I heard Becky telling San, "Show me your hands." I heard sharp stings of skin on skin. San howled. "Don't you ever write on the wall again!" she yelled.

Mother slapped at my arms and legs. She knocked me so hard I thought I would fall over. "What were you doing? Why did you do that? Didn't I teach you well?" she screamed.

"I was decorating," I sobbed, "I wasn't being bad."

"Don't talk back to me!" Mother yelled.

"Say you're sorry! Say you regret it!" Becky was ordering San. Her voice rang and echoed inside my head.

"Mama, I'm sorry, I didn't mean it," San snuffled immediately.

"That's enough then, I'm taking you upstairs," Becky said. "You can sit in your room for a while."

Mother was still hitting me. "Tell your aunt you're sorry!" she screamed. She spun me around to face Aunt Becky.

"I'm sorry! I'm sorry!" I said. Becky barely glanced at me. I could tell she thought the whole thing was my fault. San's tear-glinty eyes met mine as Aunt Becky led him upstairs. I thought that he blamed me, too.

Mother said, "You've been so bad, my arm hurts from hitting you!" She clutched her shoulder.

"I was making the wall pretty," I cried.

"Don't talk back to me!" Mother snapped. She paced the floor in a circle. "Silence! No more tears!" I tried to stop crying, but the

tears caught and jerked in my chest. They forced their way up my throat in sharp, hiccupy sobs. Mother crouched down at the other end of the room, in front of a cardboard box containing San's toys. I watched her rummage through the box. A blue and yellow dump truck clattered to the floor. A strip of orange rubber sprang over the box's square rim, one of the racetracks from a Matchbox cars set. It vibrated and stopped, poking stiffly in the air. "I told you to stop crying!" Mother screamed, grabbing the strip of orange rubber. Her voice shook. She stood. She held the racetrack in one hand. Then, with one quick move, she lashed it across my legs.

The raised edges bit into my flesh. I screamed. Another snap of rubber. Pain sliced into my bones. Heat in my lungs. My skin burned. *Snap! Snap! Snap!* Light flashed in my head, a blinding white, then black, then white again. *Snap!* I felt dizzy. My throat was sore. I heard my voice: a long hoarse scream. *Snap! Snap!* My body disappeared. My head hurt. All sensation was reduced to one point, a single knot of pain inside my head. *Snap! Snap! Snap!*

"Stop crying! Stop crying now!" Her voice was hysterical. *Snap!*

I closed my mouth over the tears in my throat, but they burst free. I screamed again. *Snap! Snap! Snap!* "I-I ca-ca-can't!" The syllables choked me. I coughed. My nose ran. *Snap!* The rubber dug into my legs.

From far away I heard Becky say, "You're scaring San." I didn't know who she was talking to. *Snap!* Through the ceiling I heard the baby howling. *Snap!* I was going to die. *Snap! Snap! Snap!* Little Brother wouldn't have anyone to play with. *Snap! Snap!* I couldn't stop screaming.

"Have you had enough? Have you learned?" Mother's hand paused, but her face was still contorted with fury.

I hiccuped. "Mo-o-o-ther! Mo-o-o-ther!" I wailed. Tears puffed my eyes to slits. Their salt stung my face. The lenses of my glasses were spotted with their residue.

Mother raised the racetrack. "Stop! Stop crying!"

"We-we were de-decor-decorating," I whispered. I gasped for breath, hiccuping again. "The b-b-base-m-ment b-belo-o-ongs to-to *u-us*," I choked out between tears.

Mother shook me by the shoulders. My head bobbed with the motion. "Yours?" Mother hissed. "What's yours? Nothing's yours. This house belongs to Aunt Becky, everything belongs to Aunt Becky, don't you forget it." She cracked the racetrack across my thighs again. "Shame!" she said. "You don't listen! You don't learn!"

She put me to bed afterwards. The house was silent. The baby was asleep. I lay in the crib gasping lingering sobs.

"I don't know what to do," Mother said. There were tears in her voice. "If you behave so badly, Aunt Becky will throw us out. We won't have a place to live. Your father won't have a job. Little daughter, you must learn to be mature. This isn't our house. That isn't your room. Those aren't your toys. Nothing belongs to us here. Aunt Becky doesn't even like having you near San—did you see the way that she looked at you? I had to show her we were sorry. I had to hit you hard. Please, Yee-daughter, learn to be good. You need to be mature."

I pressed my hand against the crib's slats. A thin red welt snaked across my wristbone. I wondered why everyone hated me so much.

Mother said, "We have to do everything we can to make it up to Aunt Becky. She might still throw us out, do you understand?"

I swallowed a sob. I didn't answer my mother.

"Do you understand?" Mother repeated. "You must learn to be mature."

I only wanted my mother to like me again. I gave her the answer she expected. "Yes, Mother," I said quietly, although I didn't understand. I didn't understand at all.

4

Jesus on the Beach

An exciting thing happened at school. McMeen had a new mascot, and our class was going to an assembly to see it. "What's a mascot?" we all asked.

Mrs. Tate said, "It's something that represents the students at McMeen, like the flag represents this country." She pointed at the American flag displayed beside the chalkboard. Automatically, I put my hand over my heart, the way I did every morning during the Pledge of Allegiance.

"McMeen's mascot is called a 'Meenie,'" Mrs. Tate continued. There was a shuffle of shoes scraping on the tiled floor as the class shifted in their seats. Kids turned and gave each other puzzled looks. I was glad that I wasn't the only one confused.

Janet raised her hand. "Mrs. Tate, my mom says it's bad to be mean."

Mrs. Tate chuckled. "Did everyone hear that?" she asked.

Thirty-one voices murmured *uh-huh*.

Mrs. Tate repeated, "It's bad to be mean. That's true. I don't want to see anyone being mean." She paused to let this message sink in. "This is a different kind of Meenie," she explained. "It's a joke, because 'Meenie' sounds like McMeen."

Hah, hah, hah! I laughed with the other kids, reacting to the word "joke."

Mrs. Tate held up her hands for us to be quiet. "Now let's go see what the Meenie looks like," she said. "Remember, the mascot is an example for this class; we're *all* Meenies." She lined the class up, single file, for the trip to the auditorium.

The Meenie was a three-foot-high papier-mâché figure, Muppet-like, carrying a spear in one hand and a big round shield in the other. On his head was a horned helmet. During the assembly, the principal explained that the Meenie was dressed as a Viking warrior, symbolizing our school spirit. He said that we should try to be like the Meenie, tough in spirit but kind of heart.

The sixth graders at the back of the auditorium started hooting. Soon everyone was clapping. I cheered along with the rest of my class. I didn't completely understand what the fuss was about, but I liked the happy noise. I decided the Meenie was a good thing. We were all Meenies. For once I didn't feel left out—I looked as much like the Meenie as the other kids did.

Coasting down the slide at recess I whispered to myself, "I'm a Meenie, I'm a Meenie." On the blacktop, kids charged at each other with imaginary spears. They defended themselves with invisible shields. Busy with the new game, they didn't have time to bother me. During art time, I hummed under my breath, "We're Meenies, we're Meenies, McMeen Meenies." I snipped uneven paper circles with my safety scissors and glued them to a plain white board. The other students at my worktable breathed the same tuneless words, in sync.

At the end of the week, Mrs. Tate said that we would be able to order t-shirts with the McMeen Meenie on them. "Everybody liked the Meenie so much that Mr. Myers decided to have t-shirts made," she explained.

The whole class said *Yay!* including me. This time I knew why I was cheering.

Mrs. Tate waited for us to calm down. "The t-shirts will be white, with navy blue letters that say 'McMeen Meenies,'" she said. "The teachers are hoping that everyone orders a t-shirt. That way, we can have McMeen Meenies day and wear the shirts at the same time, the kids, the teachers, even Mr. Myers."

"Like a school full of twins!" Amil Levine shouted, cracking up. Mrs. Tate didn't scold him, even though we weren't supposed to talk unless called on. We all started laughing.

"If we're twins, nobody can tell us apart," Janet explained to me, giggling.

I laughed even harder. I had an image of me playing four square without anyone slamming the ball against my body. "What if they mix us up?" I joked.

"Yeah, I'll look just like you!" Amil responded good-naturedly. "Or Mrs. Tate! Everybody will think I'm the teacher!"

We roared. Smiling, Mrs. Tate passed the order forms down the aisles. I grabbed mine eagerly. *Name*, I read. As soon as I got home, Mother and I would write "Elaine Mar" on the line. "I'm a Meenie, I'm a Meenie," I whispered. My bottom bounced in the chair.

Mrs. Tate said, "If your parents want to order t-shirts, it's also ten dollars for them. Don't forget to return the order forms by next Friday." The bell rang. "Have a good weekend, everyone!"

I leaped out of my seat. Mrs. Brown smiled at me. She said, "Aren't t-shirts a great idea? The Meenie is just the cutest thing in the world!"

I agreed and waved. "See you later, Mrs. Brown!"

She waved back. "Your English is really coming along," she complimented. Laughter bubbled in my chest. This had been the best week of school so far!

At the classroom door, San offered me his form. "Will you carry this home for me?" he asked. "It might get ruined at base-

ball." He had joined Little League and stayed after school for prac-
tice every day.

"Okay," I agreed readily.

"Be careful. Don't bend it or tear it or lose it," he warned.

I nodded solemnly. I understood how important a McMeen
Meenies t-shirt was.

I flung open the aluminum screen door and let it bang behind me.
"Mother! Mother!" I called. "Look what I have!" I shoved the
t-shirt order forms at her.

She laughed. "*Wah!* What happened? Did you win a prize at
school?"

"No, no," I said excitedly. The words tumbled over one
another. "Everyone's buying t-shirts with the school name on it!
We're all going to wear them on the same day!"

"Like a team," Mother said. "How fun!" She bent her head to
study the forms.

Grinning, I bobbed my head. I pointed at the order forms, "We
have to write on this paper. My name, and what size to buy."

Mother's head jerked up. "Buy?" she asked warily. "How much
do they cost?"

"Ten dollars."

She sighed. "Ah, Yee, your school must have gone crazy! Ten
dollars is too much money! We don't have ten dollars for a t-shirt."

"Mother," I pleaded. I wondered how to explain how much I
wanted this shirt, but I didn't have the vocabulary for it. I stared
at Mother mutely.

She said, "Yee-daughter, be mature. Your father has to work a
long time, many hours, to make ten dollars. How much money do
you think we have? We're not like the Americans, with their
English and their four-dollar-an-hour McDonald's jobs! Don't you
think your father would work at McDonald's if he could speak
English? Do you know? Your aunt pays him two hundred dollars

a month, that's all! Six days a week, twelve hours, thirteen hours each day, it doesn't matter—still two hundred dollars a month." She paused for breath. Her face was flushed, her eyes narrowed. She shook her head in disgust. "Ten dollars for a t-shirt!"

I didn't say anything. I knew that she was right—ten dollars was a lot of money. Nothing I owned cost that much. My shoes were two dollars, my socks fifty cents, my dresses three-fifty—on-sale. When we went shopping, I knew not to ask for anything that cost more than five dollars. But I had never wanted anything the way I wanted the McMeen Meenies t-shirt. It was magic, like Cinderella's glass slipper. It had the power to change my life.

"San will get one," I mumbled, eyes downcast.

"San gets whatever he wants," Mother agreed quietly. "Your aunt has more money than we do, and she gives him everything. But Yee-daughter, you'll understand later: It's not good to get everything you ask for."

She's crazy, I thought. I reached for the order forms. I wanted to hold them, just in case. Maybe by some magic they would be transformed into Meenies shirts. Maybe my fairy godmother would appear. I thought of Carmen and Mrs. Brown.

Mother was studying my face. She said, "If the money was for books, or paper and pencils, I would give it to you. If it was for something you really needed, I would provide it immediately. This is a t-shirt! You have plenty of clothes. I can't give you ten dollars for a t-shirt. It's not even a nice piece of clothing! It's underwear!"

I nodded, though I wanted to cry. No use arguing. No Meenies shirt.

"How about your snack?" Mother asked in a too-cheerful voice. "You're such a good girl! So clever and obedient! I know you won't mind not having the t-shirt."

But I didn't want to be good or clever or obedient. I didn't even want my snack. I wanted to be a McMeen Meenie.

*　　*　　*

On Monday morning I watched my classmates rush up to give Mrs. Tate their ten dollars. She put the money and the order forms in a big manila envelope. She wrote the children's names on a sheet of paper. "Don't forget, you have to order by Friday," she reminded the rest of us. I counted the children who hadn't lined up by the teacher's desk. I hoped that their mothers had decided that ten dollars was too expensive.

I couldn't concentrate on anything else the rest of the week. On Tuesday, I watched as another group of students crowded around Mrs. Tate's desk. I couldn't tell who was left, besides me. Mrs. Tate said, "Two more days, don't forget, or you won't have a McMeen Meenies shirt on Meenies day." I looked out the window. I pretended to be forgetful. I stared down at my desk and tried not to hear. San was silent in the seat next to me. He knew I wouldn't be getting a t-shirt.

Wednesday was the same, and so was Thursday. I wished the week would end quickly. I worked on blocking out my knowledge of English.

When I got home after school on Thursday, Aunt Becky's car was in the driveway. Aunt Becky was inside, sitting on the living room sofa, reading her mail. I mumbled her name, and she said *yeah* in a distracted way. She didn't look up. I slipped off my shoes and ran downstairs to find Mother.

"Did you say hello to your aunt?" my mother whispered.

I nodded without paying much attention. "Fee-fee-fee!" I said, letting the baby grab my fingers. He put them in his mouth. "Eeew!" I squealed. The baby laughed and grasped at my hair. I bounced out of his reach to change into playclothes.

Mother said, "Your snack's on the kitchen table. Eat quickly and come back downstairs. Don't get in your aunt's way."

I climbed up the stairs softly. The basement door was ajar, jutting out into the living room. I stepped into the sheltered "V" opening. The kitchen was to my left, the living room to my right. I knew I should hurry, as Mother said, but I wanted to spy on

Aunt Becky. I peered around the door, to my right. I gasped. Aunt Becky was standing directly in front of me.

She flicked her eyes over my face. "Why are you creeping around?" she asked.

I opened my mouth, but I couldn't think of an answer. I shrugged.

Becky's mouth pursed. "Do you understand your lessons at school?"

"I do," I answered automatically.

She nodded in a satisfied way. "You follow San, do as he does, and you'll learn." She started to turn down the hall to her room. She paused, reconsidering. "Have you ordered your t-shirt?" she asked, turning back. "Tomorrow's the last day, isn't it?"

I shifted my weight from foot to foot. I didn't want my aunt to know the truth; it wasn't Mother's fault that we didn't have any money. Aunt Becky watched me expectantly. The silence grew. She didn't leave. "I don't get a t-shirt," I finally said in a very small voice.

Aunt Becky looked surprised. "Why's that?"

"Mother says we don't have enough money," I whispered.

Becky twisted her mouth. She blinked. "Is everyone in your class buying a t-shirt?"

I nodded miserably.

Aunt Becky looked like she was thinking. "Come with me," she said. She held out her hand and began walking at the same time. I followed, keeping my hands stiffly at my sides. Not once did we actually touch.

I tiptoed down the hall behind her, waiting while she fiddled with the lock on her bedroom door. She pushed it open. The smell of liniment and tired muscles rushed out at me. I held my breath, afraid to disturb the air. Aunt Becky moved forward. "Come," she said, looking over her shoulder. She patted the blue sateen bedspread. "Sit here."

I padded in slowly. I'd never seen her room before. I darted

quick looks at the dresser, the table, the king-size bed, the cot against the wall. I carefully boosted myself onto the edge of the bed. Aunt Becky didn't speak to me. She set her purse on the dresser and turned her back to rummage in it. I stared down at my bare feet dangling off the bed.

Aunt Becky turned abruptly, holding out an envelope. "Give that to your teacher," she said.

"What's it for?" I asked. The words scraped against my throat.

"Your t-shirt, what else?" she answered roughly. "Tell the teacher you need extra small."

For a second it felt like my heart stopped completely. Then it raced, a million beats a minute. My head spun. I couldn't believe what I'd just heard. *My aunt was giving me money for a t-shirt.* I grasped the envelope greedily. I prepared to slide off the bed and run downstairs. But before I could make a move, I remembered my mother. I saw her alone in the basement, playing with my little brother. My hand twitched involuntarily. I set the envelope on the bed next to me. I wanted the t-shirt so much, but I couldn't take Aunt Becky's money. "I'm not allowed," I said.

Aunt Becky narrowed her eyes. "Who says you're not allowed?" she asked. "I gave it to you, and I say you're allowed."

I said haltingly, "Mother will know. And I'll get in trouble."

Aunt Becky pressed her lips together. She looked away from me. Then she said, "Take the money. Tell your mother . . . tell her that your teacher ordered an extra shirt by mistake, and she gave it to you." Aunt Becky picked up the envelope and stuck it back in my hands.

I stared at the envelope clutched tightly between my fingers. After a long silence, I whispered, "Thank you." When I looked up, Aunt Becky was smiling.

For the first time since coming to America, I felt genuinely grateful.

* * *

Mrs. Tate distributed the t-shirts in alphabetical order. *M, M, M,* I thought anxiously, *Mar, Mar.* I watched the kids drifting forward to get their t-shirts. I couldn't keep track, because I didn't know everybody's last names. Why couldn't I be an "A?" Then I'd be first. I counted the alphabet on my fingers, how many letters until M? I hadn't counted very far before Mrs. Tate called my name. I stumbled out of my chair and nearly tripped on my way to her desk.

"Extra small?" she read from the inside label.

Hand outstretched, I barely heard her. The air rushed in my ears as I walked back to my seat. I hugged the shirt to my chest. I was a McMeen Meenie.

I walked home slowly, crumpling the shirt into the smallest ball possible. I didn't want to show it to Mother. What if she made me give it back? I ambled up our driveway, climbed the single step by the door, and slipped inside.

"You're home," Mother said, looking up. She was bouncing Jeffery on the couch.

I greeted her quickly and headed for the stairs, trying to hide the wadded t-shirt behind my body. Too late. Mother saw.

"What's that?" she asked. She lifted the baby and followed me downstairs to our room.

I handed over my prize. "It's the t-shirt I told you about," I mumbled. "With the school name on it."

Mother shook out the shirt, holding it by the shoulders. "Where'd you get the money for this?"

I looked down at the floor. "My teacher ordered an extra one by mistake, and she gave it to me," I said in a rush. *Please, please don't make me return it,* I thought.

"Why did she give it to you?" Mother asked. But her voice was puzzled, not suspicious.

I didn't know what to say. Aunt Becky hadn't coached me for

this possibility. "It fit me," I improvised nervously. "It was the right size, so she gave it to me."

Mother placed the t-shirt on the bed. "How very lucky," she said earnestly. "We're very lucky the extra shirt came in the right size for you."

At that moment, I felt very lucky indeed. I reminded myself not to tell anyone where the t-shirt had come from, not even San. The secret was between my aunt and me.

The spring sky's blue curve stretched wider and clearer each afternoon. San still had Little League, and I continued to walk home alone, but suddenly I didn't mind: After months of walking by rote, clinging to Mother's directions, I became aware that my neighborhood's existence was immutable. The same houses would always lie along the same streets. The same streets would always lead to the same destinations. In permanence there was safety, in safety, magic. I knew I could never get lost in this little world on Jasmine Street.

Then, one day shortly before summer vacation, Mrs. Tate told us that President Nixon had done something bad. I didn't understand how this was possible. Father had said that being President meant you were boss over everyone, even your parents and the teachers in school. You had to be very smart to be President, and even then it was a hard job to get. So how could the President do something bad?

Mrs. Tate couldn't explain. She said that she was confused, too. I wondered what kind of place America was, where Presidents did bad things and teachers didn't have the answers. She told us what the bad thing was, but I didn't understand it. All I knew was that everyone was mad at the President. I felt sorry for him. When Mrs. Tate let us vote on what should happen to President Nixon, I raised my hand to give him a second chance. But right then, I decided it didn't matter that I wasn't born in America. Because

what was the point of having the most important job in the country, if you were only going to get in trouble and let a roomful of first graders vote to put you in jail?

First grade ended. Aunt Bik-Yuk, Cousin William, and Cousin Dani arrived from Hong Kong joining San's family, my own, and Uncle Wing, our boarder. Now Aunt Becky's house was jam-packed, eight adults, two six-year-olds, and the baby, hardly any room to breathe. Everywhere there was the odor of cigarette ash, everywhere the sound of a Toishanese voice, everywhere pots of Tiger Balm, discarded shoes, greyhound racing forms, and creased back issues of *Sing Tao*, the Chinese-language newspaper delivered sporadically from San Francisco.

We overflowed the house and the restaurant. There were so many of us that Mother didn't need to work at the restaurant anymore; she could stay home to take care of San, Jeffery, and me. "I'm a housewife," she declared happily. "I don't need to work."

"This is the good life," Cousin Dani agreed. "I'm signing up for classes at the college downtown. English and painting. I'm going to be an artist!"

Mother sighed. "Ah, that's well enough, paint a few pictures, have some fun. But you be careful—you're in your twenties already, not so young anymore! Soon you'll have to get serious, find a husband, and have some children. Otherwise..." Her voice trailed off. She shuddered. "If you wait too long, your female parts won't work anymore. You'll be a failure," she whispered.

Dani looked annoyed. "Don't you think I know these things?" she asked harshly. "I know my duty. I'm a good daughter. I'm doing my best. I'll be a better wife and mother if I study English and art. Besides—" she chuckled slyly "—I'll be able to take you shopping downtown. All the best stores. We won't have to wait for Aunt Becky, because *I'll* be able to speak English."

"It would be fun to see something of Denver," Mother murmured. Then she shook her head, clearing it of such foolish thoughts. "We shouldn't talk this way—we're lucky for what we have! What could I buy in the best stores? Nothing! Your Uncle Shing and I save every penny to send back home to my mother. How else could she live? I don't have time for the best stores! I don't have time for this talk!" She stood up abruptly. "Yee," she snapped, "what are you doing inside? I didn't bring you to America to sit around listening to adults talk! You go outside, play with the kids, Nancy or Joey, *someone*. Go learn English so you don't end up stupid like your mother!"

I stared up at her, stunned by this flurry of words—the mention of poverty, the reminder of Grandmother, the claim of stupidity. What could my mother mean? I opened my mouth, but no sound emerged; the words I wanted were beyond my grasp, questions and answers for adults only. I scrambled to my feet quickly, slipped on a pair of sandals, and disappeared out the door.

San had left the house hours ago, and I didn't bother looking for him. Automatically, I headed for Nancy's house, two doors down. Nancy was my first *gui* friend. She had red hair, freckled skin, and brown eyes. Best of all, she always did whatever I said, even though my English wasn't perfect. She didn't know any better, because she was one whole year younger than me.

I liked going to Nancy's house, because she had more Barbies than I'd ever seen in my entire life. Three different Barbies, their younger cousin Skip, Ken, a mobile home, a townhouse, and dozens of outfits with matching shoes. It was the Land of the Yellow-Haired Doll, and if I couldn't live there, at least I was allowed to visit every day.

If it were up to me, we would have played only at Nancy's house. But strangely, Nancy was fascinated by my family. She didn't mind waiting upstairs while I did calligraphy, she didn't

care that I didn't have any toys, and she liked going to the restaurant to drink Cokes and dig for wet sand. She came over to our house every day for lunch—and supper, too, when her parents let her. She sat with us at Aunt Becky's yellow formica table and gobbled bowls of white rice with soy sauce. Thinking that Nancy was afraid to try the accompaniments, Mother offered to make SpaghettiOs or a bologna sandwich. But Nancy said no, she just like white rice and soy sauce. At night, in our room, Mother told Father how strange the *gui* girl down the street was, always eating only rice when there were accompaniments. They laughed at her funny ways, and I had to agree—why eat plain rice when you could have chicken wings or a big bowl of egg-and-tomato soup?

Wednesday nights were the only time I wasn't allowed to play with Nancy, because she got on a bus at seven, to go to Bible hour. I didn't know what the Bible was, except something that people swore on—like I'd seen on *Perry Mason*. I couldn't imagine where that bus took Nancy every Wednesday night.

Finally, overcome by curiosity, I asked her, "What happens at Bible hour?"

We were sitting on her living room floor, dressing and undressing Barbies. Nancy didn't even look up to answer, "We listen to Bible stories about how Jesus died on the cross to save us from sin."

"Who's Jesus?"

"The son of God." Nancy recited automatically: "'For God so loved the world that he gave his only begotten son, so that whosoever believeth in him shall not perish but have everlasting life,' amen, John 3:16."

"Is that like the Pledge of Allegiance?" I asked. I only knew God from the part where we said, *one nation, under God, invisible, with liberty and justice for all*. I figured from this that God was a good thing, because liberty and justice were good, but I didn't know whether it meant that God was invisible or the nation was invisible. I wished it weren't summer, so I could ask Mrs. Tate.

"It's the Bible, which means God and truth," Nancy said,

combing Barbie hair. "At Bible hour we hear stories about how the world was created and how we can be saved."

Stories, I thought. I wanted to hear stories. "Can I come to Bible hour too?" I asked.

Nancy said, "Uh-huh."

Her mother, Mrs. Bulkey, said, "Yes, but you have to ask your mother."

"Mother!" The screen door rattled shut behind me. "Mother! Can I go to *church-ee* with Nancy to learn stories?" I didn't know the word for "church" in Chinese, so I improvised.

"So noisy!" Mother scolded, but mostly she looked surprised. She said, "Do you understand what you're asking?"

I nodded a *yes*. "I want to go hear stories with Nancy on Wednesday night. A bus comes to pick her up, and Nancy's mother says it's okay if I go, too."

Mother said, "Do you know what these stories are about?"

I bobbed my head. "Nancy says it's about how 'Jesus' dies on the cross," I answered, pronouncing *Jesus* in English.

"Do you know who Jesus is?" Mother said Jesus differently, like *Yeah-su*.

I didn't understand why she was being so picky. I only wanted to go listen to stories. "Nancy says that he's the son of 'God,'" I responded impatiently, using the English word for *God*.

But Mother didn't let up. She repeated the word back to me: "*God*. Do you know what *God* means?"

Why was she being so serious? She didn't mind when I went with the Bulkeys to watch fireworks on the Fourth of July. I hoped she wasn't going to accuse me of *having no sense of home*— a familiar Chinese criticism. I said, "*God's* the invisible person in the flag we say hello to in the mornings before class."

Mother laughed. "Crazy girl! You say the Pledge of Allegiance, that's an oath to the government!"

Confused, I asked, "What does that mean?"

"It means that you're promising to be loyal to the President of the United States. You say it when you become a citizen."

Now I was worried. I knew I wasn't a citizen. "Mother, does that mean I'm not allowed to say the Pledge of Allegiance anymore?"

Mother was quiet for a minute. She said, "You can say it if your teacher tells you to say it. But it doesn't mean the same thing, because you weren't born here. You'll just be saying it to get along with the others."

I was glad it was summer, with no Pledge of Allegiance in the mornings, because I didn't understand at all. I just knew that everything was different because I was born in Hong Kong. I reminded Mother about Wednesday nights: "Can I go with Nancy to listen to stories?"

Instead of answering, Mother said, "God is the supreme being, taking care of everyone and everything on earth."

"Like the President, who's boss over everyone?" I asked.

"Bigger than the President. God's invisible, like you said. A spirit. You can't see it." She paused to see if I'd absorbed this bit of information.

I nodded.

"*Yeah-su,* what you call the son of God, is the leader of Nancy's religion."

I crinkled my forehead. "What's religion?"

"'Religion' means a way of learning about God," Mother explained. "It's the reason Nancy goes to *church-ee*—a *gao-hong.* To learn about God."

I nodded again, but I was puzzled about the way Mother kept saying God in English. I wondered if God was like Snoopy, something American children had, but Chinese children didn't. "Is there God in Hong Kong?" I asked.

Mother said, "Crazy girl! Of course there is."

"What's our word for it?"

"*San-ai.*" Mother pronounced slowly.

"*San-ai,*" I said. "Why don't we go to church to learn about *san-ai?*"

Mother sighed. She took a long time to answer. "*Gui* churches are different from what we believe. Nancy goes to church to learn about Jesus and Christmas. It's not what we believe."

That didn't make any sense. "We celebrated Christmas!" I reminded her. "Aunt Becky bought a tree, and we decorated the windows, and there were presents!"

Mother said, "That was for your aunt. Your aunt celebrates Christmas because the *gui* do."

"Not for us?" I asked, puzzled. "Mother, I got presents. Remember? I got new clothes and the music box with the spinning dancer. The waitresses gave you perfume. They gave Father cigarettes. How can we get presents if we don't believe in Christmas?"

"We only believe in it for fun, not for real, like Nancy does."

I must have looked confused, because Mother continued, "Nancy believes in Christmas as Jesus's birthday. Jesus is the person closest to God for her, and that's why she celebrates Christmas."

"We don't believe in Jesus?" I asked.

Mother took a long time to answer. "We don't celebrate Christmas the way the *gui* do," she finally said.

"Do we believe in God?"

Mother started. "What a question!" she exclaimed. "We have a word for it, so we must believe."

"How do we believe in God but not Jesus? Nancy says he's the son of God. She says he tells the truth."

Mother explained slowly, "Not everybody believes that Jesus is the person closest to God. Do you know? Annie and Casey are Jewish. They don't believe in Jesus, but they have God. In this world, there are many different kinds of people. There are people like Nancy, and people like Annie and Casey, and people like us.

In India there are people who wear little dots on their foreheads."
At this she paused and gestured with one hand. She opened her
mouth to continue.

I interrupted, "Who's right? Nancy or Casey?"

Mother sighed. "Oh, Yee! How should I know? You ask Nancy,
she'll say she's right. You ask Casey, he'll say he's right. All over
the world, people celebrate God differently. They all think they're
right."

I scowled, more confused than ever. "But, *Mother*," I wailed,
"how can that *be*?"

"Think about it," Mother said. "Who's going to tell you that
they're not right? There's no point arguing about it. I always say,
I'm just one person, how can I decide for anyone but myself?"

I wondered if that meant I could go. "Mother?" I said impa-
tiently.

My mother smiled. "Little daughter, church, is that what you
want? You can go to church with Nancy if that's what you want."

I loved Bible hour.

The deliciousness of running across the lawn to Nancy's at
seven. The heavy air of dusk just falling, the grass dampening,
the heat rising from sidewalks. The knowledge that I was leaving
on an adventure of my own choosing, without my parents or
Nancy's. The noise of the bus, the children's excited hellos, their
enthusiasm over meeting me. The first tune I learned, which I ini-
tially took to be nonsense but later recognized as the books of the
New Testament, sung in order, loud and fast. The church room
where we sat, rapt, listening to stories about Jesus and Peter and
John and Judas. The stories. Stories about foreign lands. Stories
about love, friendship, and betrayal. Stories about right and
wrong.

Best of all, the bus ride home. The quiet chatter of tired chil-
dren, the bump of tires over worn asphalt, my reflection in the

window, the darkness of a Denver night held at bay. And the certainty of reward—the knowledge that no matter how far I had traveled in space or imagination, I was now returning home to Mother. What more could I want?

Mother was waiting with my supper when I returned the first night. It was after nine, and the others had already eaten. San was camped out in front of the TV. Jeffery slept—he was still at the stage where he slept and ate and pooped, with very little in between. I had Mother all to myself. In the kitchen she scooped a bowl of rice for me. She set out the dish of accompaniments that she'd saved. Then we sat together while I ate. The television droned from the living room. Crickets chirped in the back yard. The refrigerator hummed and clicked off again. My chopsticks rubbed together. I felt absolutely at peace.

"Did you have fun?" Mother asked.

I nodded. I told her about Bible hour—the story about Peter the fisherman; the kids on the bus; the competition over who could sing the loudest.

"Who won?" Mother asked.

"First the girls, but then the boys. I couldn't help very much, because I didn't know the words." I sighed in frustration.

"It was your first time," Mother consoled.

I nodded. "Mother, can I go again? I want to hear more stories, and the people at the church said they would give me a book for free, a Bible that has even more stories in it."

"You liked it?" She smiled. "If you like it, you can go every Wednesday. Church won't hurt."

"Mother?" I said, then hesitated. Nancy had invited me to church on Sunday morning. I wanted to go, but I was nervous about asking. Sunday mornings in our house were special, reserved for sleep. On Saturday nights the restaurant didn't close until midnight, and the adults stayed up until two or three when they got home. They laughed and smoked and watched old movies on TV, knowing that they could sleep late the next day,

the one afternoon that the restaurant didn't open for lunch. If I went to church, Mother would lose this luxury. I shoved rice into my mouth, not wanting to demand so much.

Mother filled the silence for me: "What is it? What do you want to ask?"

I shook my head nervously.

"I know you want something," she said. "Don't be afraid to ask."

I cleared my throat. I didn't meet her eyes. "Mother, may I go to church on Sundays, too?"

"Yes, you're allowed," she answered immediately.

"Mother, it starts early," I said awkwardly. "You have to wake me before nine."

"Don't worry," she said. "I'm a mother, I can do anything. If you need me to wake you, I can do that. If you want to go to church, you can go. Do you want to start this Sunday?"

I nodded gratefully.

From that point forward, I went to church every Sunday and Wednesday. I learned to sing the books of the New Testament. I learned to recite John 3:16 on command. I learned about God and Jesus and all the apostles: Peter, whom Jesus loved the best, and John, who loved Jesus the best. Judas the betrayer, Thomas the doubter. I learned about the Romans and the Jews who mocked the son of God. The more I learned, the more I wanted to know. I wished I could read. The world was full of stories, I realized suddenly, and the sooner I learned to read, the sooner I would discover these stories.

Although I was the only person in Aunt Becky's house who attended church, nobody remarked on my routine. My church-going was apparently no more extraordinary than Little League. When Father woke on Sundays, he would ask whether I'd been to church that morning. I would say yes. "Was it fun?" he would

ask, and I would answer yes again. Then Father would cough and trod upstairs to wash his face. On Wednesdays San watched the clock and reminded me about the bus for Bible hour. When I rushed out the door, he would promise to tell me what I missed on television. My family's conversations about church never extended beyond these levels.

Nancy's church was a Baptist congregation; it taught that the Bible was truth, and I believed it. Yet, strangely, this assertion did not change my belief in Mother's spirits. I don't think I ever connected the two. I fully believed that the Bible was truth, and I fully believed that Mother's teachings were truth.

My mother was always talking about the spirits. How we needed to eat this food, or that one, to respect them. How our bodies were important because their health reflected the state of our souls—the reason I wasn't allowed to squint or frown or make funny faces. My mother said these things so often that I didn't hear them anymore: It was like listening to her breathe. I simply did as she instructed—a bite of chicken on holy days, wear red for joy, eat rock sugar after a funeral, no potato chips allowed whenever she determined that I had too much hot *chi* (a mysterious Chinese word meaning energy, breath, and lifeforce, all at once). I did whatever she said, it was a part of being Chinese. There was no conflict. On Sundays and Wednesdays after church I told her about Jesus, and all the rest of the week she told me about the spirits. To me, church and Mother were like math and spelling, two different parts of truth.

Nancy liked church because of heaven. I liked Jesus. I liked the idea of a holy man who was foreign and misunderstood, wise and loving, ultimately revered.

I imagined Jesus on his travels, a carpenter like Father, spreading ideas that were new and frightening. In my mind, Jesus was a *gui*—partly due to the Sunday school illustrations, and partly

because *gui* was my definition of foreign. He had flowing sandy-blond hair and a beard; he wore rope sandals and a woven flax tunic. I pictured him walking alone for a long time, through towns where people called him names, threw rocks, or simply shunned him. I imagined him bowed in the darkness, on the edge of town, late at night, praying to God, asking, *Why, Father?* His face was bruised and his knees bloody. Looking up, he could see the town's lighted windows, the laughing shadows within. *Why, Father?* I thought he must have cried when there was no answer.

But finally he made it to the beach—the shores of Galilee, which looked a lot like the Hong Kong harbor—and there he began to make friends. I saw him waving, and the apostles running to join him. And soon Jesus wasn't alone any longer. He was surrounded by his new friends, laughing and dancing, spreading joy on the beach.

There I was, six years old, in the church schoolroom, learning about Jesus as truth, Jesus as history. My fists clenched and my chin jutted out, preparing to run to the party on the beach. Then the day's story ended, and I remembered where I was. Denver, 1973. Too late to meet Jesus on the beach.

5

Jook-sing *and* Jook-kok

In the fall I began second grade with a room full of new faces. Dawn, Janet, and San had been assigned to other classes. Mrs. Brown stayed at home with her son Jamie. Miss Tyler, my new teacher, did not look like Lois Lane; she was tall and thin, with cat's-eye glasses and big feet. But none of these changes mattered.

My second year at McMeen was no different than the first. *Chink eyes, what's the matter with your eyes, you're ugly, you stink.* Handfuls of sand and pebbles stinging my legs on the playground. Big rubber balls bounced against my body, softball pitches aimed at my head, shoves forcing me to the burr-covered field during runs between bases. I hobbled home every afternoon with scraped knees and dusty clothes.

"Why are you so clumsy?" Mother fretted. "Why are your clothes so dirty? Don't play so rough! You're a little girl, act like one! Be gentle, walk more slowly, keep your clothes clean!"

I didn't know how to answer, because I was equally confused. I spoke English, I played hopscotch, I owned a McMeen Meenies t-shirt. What could be wrong with me? I tried harder. I got one hundreds on spelling tests, I read better than anybody else in my class. Nobody cared. They pushed in front of me in line to the

drinking fountain. They pulled up the corners of their eyes mockingly. *Chink eyes, slant eyes, you're so ugly, why don't you go back to where you came from?*

At home I unzipped the garment bags in the back of my parents' closet. I ran my hands over the smooth lengths of the coats and dresses inside. I remembered when we bought them in Hong Kong, preparing for our life in America. *Things won't be so rotten there*, Mother had promised, *we won't worry about thieves.* But now Father's slacks were covered with flour and grease. His sport jackets smelled like onions and vinegar. Mother didn't wear dresses anymore. She said that her legs weren't pretty enough. And it didn't matter what I wore to school, the kids always told me I was ugly.

I, too, wondered why we didn't go back to where we came from.

"How dare you ask such a thing?" Mother scolded. She took away my Hong Kong photo album. She said I couldn't talk to Po-po anymore—not on Christmas, not on the lunar new year, *never*.

When I cried, she yelled, "Hush! You're a big girl, have some maturity! We live in America now, you need to stop thinking about the past if you want to succeed!" She took a deep breath and continued, her voice raspy, "The people in Hong Kong are begging to come to America! You should be grateful, look at all we have! Study hard, learn English, be the best at school, and everybody will like you. People always like the most clever girl."

She took away my calligraphy books and gave me a blank Big Chief notepad. "Write in English," she said. "Practice your penmanship, A, B, C, D. Do the curly kind of writing, too, I don't care if your school doesn't teach it until fourth grade! What kind of schools do they have in America, so soft on the students!"

If the schools here were so awful, why didn't we go back to Hong Kong, I wondered. I started writing in the notepad with a chubby blue pencil—capital A's the full height of the solid lines, lowercase letters just brushing the dotted middle line. Mother

was confusing me with her strange behavior. From the age of two or three, the moment I could hold a pen steady, she had taught me to write our ancestors' names. *This is how we respect their memory. Family is the most important thing,* she'd said. Why was she taking my books and brushes away? Why did she want me to write in a language she couldn't read?

I had no choice—I resigned myself to second grade. When the children taunted, *Slant eyes, go back to China!* I whispered, "I can't." And they stopped short, shocked by the sadness of my answer.

The days assumed a terrible flatness. I ducked balls in gym, I searched for a hopscotch partner at recess. In class we learned to add and subtract. We learned to measure using a ruler. I stopped remembering my multiplication tables.

A few months into the year, Miss Tyler said that I needed to go to a "speech correctionist." She had discovered that I couldn't hear the difference between "f" and "th" sounds. As a result, I said "bof" instead of "both," "firsty" instead of "thirsty." Miss Tyler excused me from class for thirty minutes each day for speech correction with Mrs. Schuster.

I was almost relieved to be singled out—finally, a tangible defect! I thought we'd discovered the reason the other children picked on me so much. There was hope. With the speech correctionist's help, I would learn to become like the other children. I would become likable. Gratefully I traipsed down the hall each day, pass in hand, to the small closet of Mrs. Schuster's office. I listened to tapes of half-articulated words. I read alphabet fragments out of a workbook. I practiced whispery "th's," blowing air through slack lips, tongue held between my teeth. I thanked God for giving me thirty minutes away from my classmates.

* * *

I wasn't completely friendless. Every day at lunch I sat with Donna McGrath, a spindly blonde girl who'd been in Mrs. Tate's class. Donna had delicate, papery skin that looked like sleep had not quite been scrubbed from it. Her hair was always tangled, once in a knot the size of my fist at the back of her head. "Did you get gum in your hair?" I asked, knowing the dangers of bubblegum.

Donna shook her head no. In her whispery voice she said that her grandmother, with whom she lived, had simply given up on combing the snarls out of her hair. I was mystified. I couldn't imagine Mother letting me leave the house with uncombed hair, since she viewed any messiness on my part as a reflection on her. I couldn't imagine *being* Donna, a child without the pride to comb out her own hair. In that moment, I understood Donna's vulnerability, the weakness that led the other children to pick on her as intently as they picked on me. And honestly, I didn't want to be friends with her either.

Except that I didn't have any choice. Donna and I ate together because we were of equal status. We couldn't contaminate each other with our lack of popularity. The other children laughed at us, pulled our hair, and threw things anyway. Our playing together didn't endanger us any further.

Donna and I were school friends but not "real" friends. I learned the distinction through eavesdropping and observation: The most popular kids maintained two levels of friendship, one in the schoolyard, and the other at home. In order to be a "real" friend, you had to be invited to somebody's house. This rule was absolute. It didn't matter if you played hopscotch together every day; until you were invited to someone's house after school, you weren't real friends. That's why San and Daniel were real friends, but Donna and I weren't. I didn't have any real friends, because neighbors and cousins didn't count—San and Nancy were stuck with me.

I decided that I wanted a "real" friend—even if it was only

tangle-haired Donna McGrath. One day after school, I asked Mother if Donna could come over to play.

Mother's answer was immediate: "Are you insane? How dare you ask such a thing? You know this house doesn't belong to us, how can you think about asking a *gui* girl over here?"

I wasn't sure what Mother was objecting to. After all, Nancy was a *gui*, and she came over almost every day; she'd even accompanied us to the restaurant. "My classmate's a good *gui*," I pleaded, automatically choosing the word "classmate"—in Chinese, the word "friend" is reserved only for the closest of relationships. "Very quiet, not rough like other *gui* girls," I continued. "She studies hard and gets good grades in school."

"No," Mother repeated.

"Daniel comes over all the time, and he's a *gui* boy," I argued.

Mother heaved a long, loud sigh. "Crazy girl! Have some maturity! Why don't you understand? Of course Daniel comes over, he's San's friend. San can invite anybody over, he's your Aunt Becky's *precious* son!"

I want to be precious, I thought, even though Mother spat the word with the force of a curse. I was tired of not being allowed to do anything, just because it wasn't our house. But I knew better than to argue with Mother when she got in a mood like this. If I said anything more, she would tell me that I was becoming "just like the *gui*." She would say that I had "no sense of home."

So Donna remained a school friend. At home I played with San or Nancy. San tended to avoid me in school, but he was nice enough at home. If he wasn't busy with Daniel, he would invite me to play board games, create obstacle courses in the basement, or just watch TV. Sometimes we talked about school, but only to debate whose teacher was nicer or what we had learned that day. We never discussed the name-calling and sand-throwing.

San himself called me "creepy" and "weird" in front of the other

children. I didn't really blame him. My school in Hong Kong had taught loyalty to family as a part of every subject. From earliest childhood, I understood that the characters for "woman" and "child" combined—the essence of family—created the word for "good." My reading texts were full of sentences such as "I protect my little brother from danger" and "I teach my brother right and wrong." My experience with American education was completely different. McMeen's children clearly demonstrated that younger siblings were to be avoided, as they could only harm your social status. Sherry Bailey's older sister walked home several steps ahead of her. Scott Mendelsberg didn't talk to his little brother at recess. I accepted San's abuse as part of this ethos, and, far from hating him for it, I sought to emulate him, in order to become more American myself.

Our school relationship was additionally complicated by our living situation. None of the children understood it. In our neighborhood, one set of parents lived with one set of children in one house. It was a fixed rule, like trimmed shrubbery and weed-free lawns. There was no excuse for my presence. In the cafeteria the little boys consoled San, "She's not even your sister, and you have to live with her?" I heard the disgust in their voices. I never stayed around to hear San's response.

Still, we ate our morning cereal and afternoon Twinkies together. We walked to and from school as a pair. Given a choice, I chose to play with him over Nancy. But I usually didn't have a choice. He had "real" friends, boys whose company he preferred to mine. I had Nancy and Barbie and Wednesday night Bible hour.

I continued to go to church twice a week. I liked the easy assertion that the Bible was truth. All I needed was to believe in God and Jesus, and I would be saved. Jesus loved me, even if nobody else did. I lay in bed talking to God every night before I fell asleep. I memorized the books of the New Testament.

Despite these efforts, I didn't appreciate Christmas any more my second year in America than I had the first. Immediately after Thanksgiving, we started singing Christmas songs at school— "The Little Drummer Boy," "Rudolph the Red-Nosed Reindeer," "Frosty the Snowman." I got confused and started thinking that *brrr-rum-pa-bum-bum* was the sound of a drum playing at a starved child's funeral. It wasn't a happy song, so I didn't want to sing it.

In any case, I didn't understand what any of this had to do with the birth of Christ.

I liked the Rudolf and Frosty television specials, but they never mentioned Jesus. There was not one trace of Galilee—no beaches, no flax robe, no long hair. When I asked Mother about the discrepancy, she said, "They're just cartoon stories, for fun. It's the way *gui* do things." *What about God?* I wanted to ask, but San shushed me, so I focused on the television in silence.

I asked Nancy how Santa Claus was related to Jesus. I thought that she might know, since she'd been going to Bible school longer than I had. But Nancy only looked confused by my question. She said that they weren't related at all. Jesus was the son of God. Santa Claus was a toymaker who lived at the North Pole. He brought children presents to celebrate Jesus's birthday.

I shrugged and went home, where I tried to read the tiny, incomprehensible words in my Gideon Bible, looking for an answer. Sunday school was no help, either. The teacher talked about Jesus, but not Santa Claus. Instead of explaining the significance of reindeer in Jesus's life, she told stories about the virgin birth, how God had come to Mary and told her he would put a baby in her stomach. Another mystery, the word "virgin." I raised my hand. "What does 'virgin' mean?"

The teacher said, "'Virgin' means that Mary stayed pure. It means that *God* put the infant Jesus in her womb."

What was so special about that? I wondered. Everybody knew that God and/or the spirits put babies in women's stomachs. The

spirits put me and my brother in Mother's stomach. How were Mary and Jesus any different? I inched my hand up, but the teacher shook her head at me. Oh well. I rested my chin in my hands and listened to the story about Jesus's birth in a manger.

In the end, I liked my second American Christmas for the same reason that I'd liked the first: presents, glitter, and a day off from work for the entire family—the only one we were ever assured. Early in December, San and I helped Aunt Becky tape sparkling Mylar snowflakes to the front window. We strung colored lights above cutouts of candy canes and Santa Claus. I was very proud of our work. Our window was the most colorful on the block—you could barely see through it.

A few days later, Becky came home from the restaurant early with a tree in the trunk of her red Chevrolet. We dragged the big, scratchy fir into a corner of the living room and covered it with tinsel strands and blinking lights. Boxes piled up around the tree's base. Most of them were for us children, brought to the restaurant by family friends paying respects with a bag of oranges and a little red envelope of cash for the adults. When school let out for winter break, I waited up anxiously each night, hoping that the adults would come home with more presents. I hoped that Carmen remembered that I wanted a yellow-haired doll.

No one in my family, not even Aunt Becky, played Santa Claus. Presents were given by one family to show respect for another, so the givers' real names were always prominently displayed. Parents didn't give gifts to their own children, because they had no need to respect us; they did their duty simply by feeding, housing, and clothing us. I understood this perfectly—all the years of my life, I'd been taught that the young respect the old, women respect men. I was only grateful to live in a house full of relatives who needed to show respect for my parents by buying me presents.

The best part of the holiday was Christmas Eve. We skipped supper that night. Instead, we snacked on a big pot of *fan jook*, a savory rice porridge flavored with pork bones. We would not eat a full meal until midnight, when the rest of the family came home from the restaurant. I ate little mouthfuls throughout the evening, running between the living room and the kitchen, where Aunt Bik-Yuk and my mother sat, chatting while they made sweet peanut dumplings for the Christmas meal.

I hovered near the table, watching them form the dough, stuff it with a mixture of peanuts and brown sugar, seal the open end, and roll the completed dumplings in sesame seeds. I knew that the dumplings needed to be deep-fried before serving, but I couldn't wait. I wanted a bite of the sweet peanut mixture *now*. I tried to look mournful.

"You don't need to look so sad," Mother said. "I know what you're doing, begging for sugar. Well, you won't get any!"

"I'm hungry," I whined piteously.

Cousin Dani sat at the table, blowing on spoonfuls of hot *jook*, gossiping between sips. She laughed, "How about a bowl of *jook* if you're hungry?"

I sighed and shook my head, preparing to run back to the living room.

"Not hungry, *wey sik*," Mother chuckled, meaning a particular type of hunger—the desire for a specific taste. In this case, peanuts and brown sugar.

I bobbed my head cheerfully, glad to have a word to describe my condition. "*Wey sik*," I agreed.

"Come here," Mother said, and she poked a few morsels of the sweet stuffing into my mouth. I closed my lips over her fingers gratefully, tasting the coarse grains of sugar, the rough whorls of my mother's skin. It was this motion, as much as the flavor itself, that sated my desire.

Then San ran into the kitchen. He leaned on the wall beneath the phone. "May I call the restaurant?" he asked.

Mother said, "What time is it?"

"Ten-something," he answered.

Mother blew out a breath. "Phew! So late already! Yes, yes, call and see if they can come home early. Maybe there's no business tonight!"

San lifted the receiver and started dialing. Christmas Eve was the only night we were allowed to wish for a lack of customers. If the dining room wasn't busy, Aunt Becky could close the kitchen early. The family would be reunited before midnight.

"Not yet. Soon. Mama says one more table," San reported. We waited and counted presents and waited some more. San called again. "They're going out the door! They're coming home!" he shrieked. We danced around the living room, laughing.

Mother said, "Settle down, are you crazy? We have neighbors!" But she wasn't really yelling; she was laughing, too.

The rest of the family was home before eleven. Aunt Becky, Uncle Andy, Father, Uncle Wing, Cousin William. They pried off their shoes, and the house filled with the smell of tired feet.

"Not too bad tonight," Aunt Becky laughed. "Just one table that came in late and took a long time to order!"

"The rotten bastards!" Uncle Andy cursed cheerfully. He coughed a hacking laugh and put a cigarette to his lips. "No more of that! Festive, festive, eh, children?"

Mother came out of the kitchen. She said, "I'm tired of working all night! Yat Shing, you come in here and chop the chicken!"

Father waved her off. "I haven't even had a chance to rest," he protested good-naturedly. "Let me drink a mouthful of *diu* first," he said, referring to the herb-steeped Hennessey reserved for special occasions.

Aunt Becky said, "An-dee Wong! You go help, go chop the chicken!"

Uncle Andy didn't move. Father poured cupfuls of Hennessey. He passed them to Uncle Andy and Cousin William. Uncle Wing shook his head.

"Sister Bik-Yuk, don't forget her," Aunt Becky said.

Father laughed, "How could I forget my older sister?" He poured.

"Wow," I whispered to Mother, "Aunt Bik-Yuk drinks *diu*?"

Aunt Bik-Yuk cackled, "Of course I drink *diu*! I'm an old woman, I can do anything I want!"

"Don't listen to her—she drank even when she was young," Father teased. "The truth is, she was raised rough, back in Toishan. She does things other women wouldn't think of!"

"All I do is drink a cup of *diu* every now and then," Aunt Bik-Yuk said, flashing her gold teeth.

Mother said, "Oh well, if Aunt Bik-Yuk drinks! Yat Shing, pour a small taste for me, too."

"Mother!" I exclaimed, horrified.

"Oh, daughter," she laughed. "One small taste, what can it hurt? Don't worry, your mother's not going to become a drunkard!" She raised the cup to her lips.

We laughed and teased this way for a long time. Eventually Father went into the kitchen to chop the chicken. Mother set her cup on the coffee table. I stuck my nose into its depths. The scent of whiskey and herbs burned my nostrils and throat. I recoiled. Why would anyone want to drink that? I looked up to say something, but Mother's face was flushed. She was too happy for me to interrupt. I hugged my little brother. I pulled him onto my lap and leaned against the black-lacquered trunk by the tree.

In the dining nook, Father and Aunt Becky were arranging dishes on the long table. "Beautiful, beautiful," Uncle Andy approved, showing up to watch, then ambling away. The voices in the living room got louder. More laughter. Uncle Wing finished his cigarette and lit another one. Cousin Dani slapped her brother's leg playfully.

"Nobody's watching the time!" San suddenly shrieked. He ran into the dining room. "Mama, Mama, it's time!"

"*Aiya!*" she laughed, "I almost forgot."

Father and Aunt Becky rushed back into the living room. "Look there, we have two minutes," she soothed San. We all silenced to watch the second hand go around. Once, so slowly! Then the final sweep, even slower, if possible. I jiggled in place. *Fivefourthreetwoone*, I counted in my head. *Fivefourthreetwoone*.

"MerryChristmasHappyNewYear! *Gung hee fat choy!*" we all cheered.

Aunt Becky distributed presents. She read the names on the cards—who the gift was for, who from. She took a paring knife and neatly slit the paper along box corners before passing the gift to its designated recipient. She was excruciatingly neat, and I wished she would hurry. I wished she would let us find our own presents, so that I could feel the thrill of discovery for myself: I longed to rip the brightly colored paper, to crumple it and toss it aside. I wanted to be selfish and excessive just this once. But I couldn't. The acceptance of gifts was a family ritual, with rules, like everything else.

Afterwards we ate. At least one bite of chicken, for luck, then I could have anything I wanted. Duck and fish and sautéed celery hearts. Sweet peanut dumplings and orange wedges. Christmas chocolates. The adults stayed upstairs to drink and smoke and talk. San and I went downstairs to play with our new toys. Carmen had given me a yellow-haired doll, but not the one I wanted. The doll had long, stiff ringlets and a velvet hat. She wore a turn-of-the-century lace-and-velvet dress. I had imagined a chubby blonde doll exactly like the one from Hong Kong. Before long, I lost interest in the new doll. I started playing with San's and Jeffery's toys instead. A jack-in-the-box and tubby PlaySkool people. Blocks and clanky metal trucks. Enough to occupy me long after the rest of the household had fallen asleep.

* * *

The following day's Christmas banquet was held at the Hip Sing Association, a Chinese-American social club. For the occasion, Mother hauled our good coats out of the garment bags in the back of the closet. She let me choose one piece of jewelry to wear, a gold-tone frog pin or a silver-mesh fish pendant, with a jaw that snapped open. "The fish, the fish!" I cried. The pendant was my favorite, both because of the hinged jaw and because Little Uncle had given it to me.

Mother opened the makeup case she'd brought from Hong Kong. She patted a tiny bit of powder onto her face, using the pack of blotting papers with the pretty English lady on the cover. She uncapped a tube of lipstick and dabbed it over her lips.

"Me too?" I asked, and she rubbed a dot on the center of my mouth.

"Do this," she said, rubbing her lips together.

I mashed my lips and wiggled my jaw. "It tastes funny," I complained.

"Don't eat it!" Mother laughed. "Here, do you want Hong Kong perfume or American perfume?" She had an amulet-sized bottle of Maya from Hong Kong and six-inch spray flasks of Ambush and Tabu, from the waitresses.

I couldn't decide. "Can I have both?" I asked.

"Crazy girl!" Mother said, but she touched my wrists with Maya and sprayed my chest with Ambush. She combed her hair and put on a fancy pantsuit.

"Why don't you wear the wig?" I asked. In Hong Kong, Mother had bought a wig, in case she needed to be dressed up but couldn't afford a perm.

"It's so hot wearing a wig," Mother complained, dressing the baby. "I can't bear it."

"Okay," I said, but secretly I thought she wasn't making enough of an effort for the party.

"Besides, it's only America," Mother continued. "Nobody takes care with their appearance here. It's not like Hong Kong."

Father came downstairs to dress, dispelling my mood. He put on a three-piece suit, vest and all. He squirted Brylcreem on his comb and smoothed his hair back, a big puff over his forehead, just like Jack Lord in *Hawaii Five-O*. *At least Father takes care with his appearance,* I thought. When he finished, Mother gathered our coats and we trooped upstairs to wait.

"Ten more minutes," Father promised, settling on the sofa.

I sat stiffly next to him, trying hard not to muss my clothes.

Father slowly opened a corrugated cardboard box. "My good shoes," he murmured. "Nice, huh?" He nodded in my direction. "Put on your shoes." He took his good shoes out of their box. "Mail order, how about that?" he chuckled. He carefully removed the tissue paper wadding and set the shoes on the floor. He eased his feet into the shoes, reading pages of *Sing Tao* the whole while.

"Hurry, hurry!" I said, bucking my Mary Janes.

"What's the rush?" he asked, delicately picking at the laces of one shoe and then the other. "Plenty of time." He tied the shoes.

Finally! We were out the door, the adults carrying bags of presents for people they'd yet to honor—John Flink, the white *gui* immigration lawyer, a few different Wong families who hadn't stopped by the restaurant. Finally! We were headed for the biggest party of the year.

If you weren't a member, you would have a hard time finding Hip Sing. The club was located along a strip of West Colfax Avenue best known to adult Denverites for its gay prostitutes. It occupied the second floor of a commercial building across the street from a used car dealership. The entryway was slightly recessed from the blank brick wall on either side. Like most private clubs, it was nondescript, a single wood door with a trio of Chinese characters over the lintel. The door was always locked; visitors buzzed to gain entry.

As a child, I didn't notice the seediness of the neighborhood. I never wondered about the business on the ground floor. For me,

Hip Sing and Denver didn't exist on the same plane. West Colfax was just an address. Once I walked through Hip Sing's door, America disappeared, and I was transported to another land.

On the other side, there was a narrow staircase, not more than eight inches wider than the door. The walls met the stairs' edges, so there was nowhere to go but up. At the top, we faced a diamond-shaped window set in the wall, ten inches square, for the uniformed police guard to check out newcomers. There was a second door to our left. This was left open during the first two or three hours of a big party; otherwise, it too was locked.

Objectively speaking, Hip Sing was absolutely charmless. So much foot traffic had traversed its linoleum floors that no amount of washing could erase the streak marks. The walls were a muddy yellow plaster that may have been white in an earlier incarnation. Acoustic tile covered the ceiling, interspersed with long fluorescent tubes that cast gray shadows. Against this backdrop, the guests were vibrant, belying the image of the inscrutable Oriental. We Cantonese celebrated from the gut, quick to laughter and to anger, almost melodramatic in our passions.

Nowhere was this more apparent than in the crush of bodies inside. Although everyone stood jammed together, the adults conversed in shouts. Every comment was an exclamation: "Happy New Year! How are you! I haven't seen you in a long time!" I knocked against the adults' legs along with the other children, chasing the boys in their Garanimals suits, the girls in their indestructible nylon skirts and lacy Woolworth's blouses. Everywhere there was the snap of Coke cans being opened, the ripe odors of cigarettes, dime store perfume, dirty hair, and Seagram's 7.

The women wore their best polyester pantsuits or the occasional dress, reeking of mothballs from storage. Knee-high, flesh-colored nylons poked out from under hemlines. The women carried stiff leather purses stocked with Kleenex and special-occasion lipstick. They aired out the one good coat, whose acrylic fur trim was inevitably years out of fashion. Home perms frizzed their hair.

The men clustered to smoke and drink, sighing over bad luck at the greyhound track. They pointed out their children proudly, although they couldn't remember ages. "Third grade. Yes, he's in third grade now," they'd say uncertainly. They dressed in vested suits or clean, pressed pants and thin white shirts. I could see the outlines of their tank tops underneath. Their shoes, for once, weren't splattered with grease.

I ran giddily. No matter what language I spoke, someone understood. No one mocked my eyes or pulled the elastics out of my hair. "That's your daughter? That one?" the adults asked my parents. "So pretty!" they said. "Was she born here?"

"No," Father chuckled proudly. "She's a *jook-kok*—" meaning a Chinese-American child born in the old country—"Yee and her mother came from Hong Kong a year and a half ago."

"So fortunate!" the adults exclaimed. Some of the men sighed, dreaming of the day their families would join them. They sipped at their teacups of whiskey.

"How old is she?" someone asked.

"Seven years old," Father answered certainly. "She was born on a special day, do you know? October first, Chinese National Day, in 1966, the beginning of Mao's Cultural Revolution." The adults nodded solemnly. They drank some more. "Yee, do you know?" Father called out to me. "You were born on a special day for the Chinese, an important day for the Chinese!"

"Yes, Father," I muttered, rolling my eyes.

"And he has a son, too," Aunt Becky contributed to the conversation. "A little *jook-sing*—" meaning a Chinese-American child born in the U.S. Mother bounced Jeffery.

"Ah, a fat little boy!" the adults exclaimed, praising the baby's chubbiness, which was a traditional sign of prosperity. "The ancestors at home would be proud!"

Gradually we drifted to claim spots at the long fold-out tables. Mother poured me tea and Coke, and I suffered through the extended formal toasts. "What are they saying?" I complained.

Mother pointed at the red banners covering the walls. Black calligraphy ran in long columns down each one. "They're reading those names," she said. "They're thanking everyone."

Then the meal: We ate bird's nest soup, crunching on the curly, translucent mushrooms known only as "white fungus." We ate roast chicken and duck, heavy mounds of boiled rice, thin sliced abalone in oyster sauce, broccoli, baby corn, bok choy, straw mushrooms, shrimp with water chestnuts. The adults' faces were intent, sweat beaded their brows. They sipped at whiskey between courses. "Don't wash down your food with Coke or water," Mother cautioned. "Eat slowly, taste every bite—people work hard to give you food, and you must respect it."

After the last course, the servers passed out toothpicks and quartered oranges. We leaned back in our seats and conversations resumed. The more devout families went to bow before the altar at the back of the room, set up on a small podium about six inches high. There was a Buddha, a whole roasted chicken, a bowl of oranges, burning sticks of incense. Even families who went to Christian churches regularly paused to pray at this altar. Mother said that we didn't need to kowtow, because we were girls. But she sent Jeffery with San and Father. I watched as Father stood silently in front of the altar for a few moments, holding the wiggling baby in his arms. I wondered what he was thinking. I recited John 3:16 to myself, confused about the distinction between American and Chinese gods. I was glad that girls didn't have to approach the altar; I wouldn't have known how to pray.

After the dishes were cleared, Hip Sing set up for a Chinese-language movie. Not everyone watched: A few families went home immediately after the meal. The rest had to decide between the movie and gambling.

It was almost as if the decision were made based on gender alone. Most of the men gambled, and most of the women watched the movie. The women turned their chairs to face the front of the room. A Hip Sing officer set up a broad white screen, blocking the

lone window. Someone dimmed the lights, and with the click-click-click of the projector, we saw a Hong Kong melodrama, where the heroine sobbed on a windswept beach, the music swelled, and the entire story was told in flashback.

Of course, some women gambled, and some men never did. The adults commented on both behaviors. Women who gambled regularly were branded "wild" and "excessive." Men who never did were praised as being "responsible." Father compromised: He watched over the shoulders of the gamblers. While Mother was busy with the movie, he sneaked in a few sets of dominoes, but he withdrew before the movie's end, guarding against Mother's sharp-eyed criticism.

I sat with Mother and Jeffery until I grew bored with the movie—about five minutes. Then I ran to find San and the other children our age, Nicky and Angie Yee, Susie and Spencer Wong. We talked Uncle Andy, a Hip Sing officer, into letting us play in the small office off the foyer. We crowded around the desk to gossip about classmates at our respective schools. We flipped through channels on the ancient black-and-white TV. We arm-wrestled and played card games. We rarely acknowledged the difference between this play group and the ones outside of Hip Sing: We were, for once, surrounded by children who were Chinese.

We knew the movie was over by the sound of voices in the foyer. *A wonderful banquet, see you again next year, thank the spirits for our health, where are those children?* Someone rattled the doorknob. We crept out regretfully, Nicky and Angie to go home with their parents, Susie, Spencer, San, and I to find our various family members in the big, now-empty main room or clustered around the gambling tables.

I saw that Aunt Bik-Yuk had joined the gamblers. "A good movie, now I can do what I want, I'm an old woman," she cackled, placing her money. Uncle Andy was several hours deep in dominoes. Father and Aunt Becky had retired to watching. I joined Mother in the main room, where she was commiserating

with the other gamblers' wives. *So rotten,* they murmured, their eyes narrowed, their faces pinched. *For once, I'd like to get home before sunrise . . . he won't listen . . . he could lose everything . . .* Their voices trailed off. They stared out the single, dark window.

At Hip Sing, gambling was serious business. One hundred men or more congregated in a cramped, fluorescent-lighted room to play at dominoes or mah-jongg. Dominoes was more popular. The men stood two or three deep at the two tables, playing some variation unknown to Americans. The more experienced never even turned their tiles over; they curled their fingers under, reading the dots like Braille and betting accordingly, their eyes squinting as they sucked on everlasting packs of Camels.

But at least you could walk away from dominoes. In mah-jongg, you were in it for the long haul, playing sets that lasted hours. These weren't friendly games. In one night, your business could be destroyed, your life savings lost. *Please quit,* the wives begged, standing in the doorway. *You have children, think about them.*

But the men only waved their families away. They said, *Call a taxi,* or, *Catch a ride home with Mrs. Yee.*

The wives left with their children, pleading, *Please come home by sunrise.*

I personally didn't understand these dramas. I loved to hang around as late as possible, waiting for the gamblers to act out their superstitions: To ensure continued luck, they gave token amounts of their winnings to small children. It was a Chinese custom. So I chased San through the empty banquet rooms long past midnight, frenetic with the energy of too many Cokes, waiting for one dollar bills sealed inside little red envelopes printed with gold lettering. I never noticed whether Father placed any bets, whether Mother stood in the doorway, begging him to stop.

6

Cindy Fisher

I thought that all of America looked like Jasmine Street, but I was wrong. In the fall of 1974, the year I went into third grade, busing came to Denver. By court order, McMeen students were required to spend afternoons at Smith, a school in a primarily black neighborhood. The Smith students, meanwhile, spent *their* afternoons at McMeen. On half-days everyone stayed at their "home school." Kindergarten classes and minority students—including me—weren't bused. Every day after lunch, I watched my classmates—Donna McGrath, Sherry Bailey, Scott Mendelsburg, everyone—board the big yellow buses for Smith. I stayed behind, along with San, a handful of black students, and other assorted "minorities." For half an hour we had nothing to do but wait for the Smith kids.

It was very boring.

Mrs. Moore, my third grade teacher, didn't have an explanation for why busing worked this way. "We're all learning as we go along," she murmured early one morning. "Negroes, Chinese, Japanese, what a wonderful opportunity for our students." Then her eyes lit up. She called my name. "Elaine, dear, would you like to tell the class about Hong Kong?"

My face flushed hot. I shrugged.

"For Social Studies, dear," she encouraged gently. "To give us an idea about the different cultures in the world." Her pink-lipsticked smile broadened slightly, a smear of color on the indistinct oval of her face.

Mrs. Moore was a little dumpling of a woman, short and round, with stiffly curled white hair, rhinestone glasses, and skin that looked as warm and pliable as bread dough. She smiled continually, in the vague and unassuming way of a television grandmother. For this reason, I could never determine what she was thinking. For instance, did I have the option of refusing her request, when she had asked in front of the entire class?

I stood up nervously, my mind a blank. What did I remember about Hong Kong? Grandmother, Little Uncle, Moy-moy and her chamberpot. It all seemed so long ago. "There were a lot of flowers," I began. "Flowers everywhere. My uncle used to take pictures of me. You can see the flowers in every picture."

Silence.

"And in the park, you can stand on the swings, not like the playground here, where we have to sit, and teachers yell at you if you try to stand . . ."

Mrs. Moore interrupted. "Tell us more about your *culture*, dear."

"Culture?" I repeated. The word felt funny coming out of my mouth. I wasn't sure what it meant.

"Yes, dear. Tell us what it's like being Chinese."

I stared at Mrs. Moore. What was it like being Chinese? I thought about that as often as I thought about having ten fingers and ten toes—which was to say, not at all.

"Um, I like it, I guess."

To my surprise, the other kids started laughing. I didn't understand the joke, but I joined in right away, remembering what the teachers always said: *They're not laughing* at *you, they're laughing* with *you.*

"Shhhh . . ." Mrs. Moore shushed gently, trying not to laugh herself. The pink lipstick curved and dipped, curved and dipped. When the class finally quieted, she said, "No, dear, I mean, tell us what Chinese people *do* in Hong Kong."

"We go to the park," I repeated. "And sometimes the zoo, if it's a special occasion."

Mrs. Moore's smile did not waver. "What I mean is . . ." Her voice drifted off and started up again. "Dear, why don't you tell us how you celebrate the Chinese New Year?"

"We go to Hip Sing," I answered immediately.

"And where is that?"

"Somewhere downtown. My dad has to drive us, and we get to wear our nicest clothes. My mother lets me wear perfume . . ."

Mrs. Moore sighed audibly. "Elaine, let's tell the class *when* the Chinese New Year is. Class, did you know that Chinese people have a different new year from the rest of us?"

"Except for Dean!" someone shouted.

"Children," she admonished weakly.

"No way!" Dean shouted back. "I'm not Chinese!"

"What are you, then? You sure *look* Chinese!"

"Idunno," Dean answered, all one syllable in his throat. "Maybe Japanese, I guess. At least my parents are. Or grandparents, or something. *I* don't know. *I* was born here."

"Children," Mrs. Moore repeated.

"Mrs. Moore, how do you say Dean's last name?" another boy asked innocently.

Her smiled brightened. "Fukihara," she said, pronouncing the "u" like the double "o" in "hoot."

The boy giggled. "No, I think it's Fuc—"

Mrs. Moore cut him off quickly. "The Chinese New Year," she reminded the class.

No one paid attention. The kids were laughing and jostling Dean in his seat. He pushed back, giggling. Still standing, I played with the pleats in my skirt. I wished that the kids would

joke with me the same way they did with Dean. But they only called me "Martian" instead of "Mar," and I didn't think that was funny at all. Of course, I didn't think the joke about Dean's name was funny, either—I didn't really understand it—but I laughed anyway, extra loud, just to fit in.

"That's enough, class. The Chinese New Year," Mrs. Moore said again. The twitters subsided slowly. I grinned at my teacher. She said, "Elaine, when is the Chinese New Year?"

"I don't know," I answered blithely. "My mother always tells me, and then I have to eat chicken, for good luck."

Mrs. Moore looked encouraged. "Chicken! What else does your family do for Chinese New Year?"

"We set off firecrackers, and there's a dragon dance."

Wow! I heard the kids gasp. My heartbeat quickened.

"We have dragon dances all the time, almost every weekend," I lied.

Another simultaneous intake of breath—*ooooh!* Thirty sets of eyes were on me, wide and admiring. It was the most positive response I'd ever gotten from my classmates. I milked it for all it was worth.

I said, "The dragon head is six feet tall and really scary. It has big mean eyes and whiskers everywhere. The mouth opens and closes, and it has teeth, so the dragon can bite people. Only special people are allowed to dance under the dragon head. The rest of the dancers have to carry the body, and that's only cloth, with sparkles sewn into it. But it's really long—it stretches all the way down the block, so nobody can pass when the dragon's dancing."

The class waited. Their mouths hung open. I tried to think of something else to say. Something scary and exotic.

"The dragon dances on top of lit firecrackers. *POW! POW! POW!*" I screamed.

Mrs. Moore winced. "Elaine, dear. . . ."

"*POW! POW! POW!*"

"Elaine. . . ."

I finally took the hint. "It's so loud you can't even stand it, you have to close your ears," I whispered. I put my hands over my ears to demonstrate. I raised my voice again. "And there are cymbals. *Clang! Clang! Clang!*" I slammed imaginary cymbals together. "And . . ." I paused, wracking my brains for more details. "Um, then we have a banquet, where we eat chicken and duck . . ."

"And rice?" someone asked hopefully.

"And rice," I confirmed.

"*Fried* rice? And dragon meat?"

"Well, no," I said, scorn creeping into my voice. Only the *gui* ate fried rice. And whoever heard of dragon meat?

In front of me, thirty pairs of shoulders sagged.

"But we have movies," I said quickly. "Chinese opera. More cymbals. *Clang! Clang! Clang!*" I banged my hands together. "And funny singing. Like this, '*oyoyo!*'" I yodeled.

The eyes were bright and expectant again.

"*Oyoyo! Oyoyo!*" I sang.

Mrs. Moore said, "Elaine, dear . . ."

I clamped my lips shut. The kids laughed. I started giggling.

"Anything else, dear?" Mrs. Moore asked.

I grinned. "Oh, yeah. Um, the singers' hair is all piled up on top of their heads, and they wear these long robes! Even the men have long hair and robes. Big poufy lumps on top of their heads and long ponytails behind." I pantomimed hair with my hands.

The kids snickered. *Men in ponytails! Sissies!* They collapsed on their desks laughing. *Chinese men are sissies!*

"Swordfights!" I shouted. "They have swordfights!" I clenched my hand around an imaginary sword and slashed it through the air.

Silence. Their eyes were on me again.

"Kung fu?" someone asked excitedly. "Do they do kung fu?"

"Uh-huh!" I agreed happily.

"Do you know kung fu?"

"Um . . ." I played with the frilly collar on my blouse. Mother

would kill me if I said yes and then ended up ripping my clothes demonstrating fake kung fu kicks. "Not very well," I mumbled, staring at my desk.

I heard the deflated sighs. *Aw, c'mon, show us . . . Hiiiiiya! Ah so, Masta Wong . . . Hiiiiiya! Ancient Chinese secret. . . .*

Then Mrs. Moore's voice: "Everyone, let's thank Elaine for her presentation." She started clapping.

I looked up quickly. "Firecrackers and dragon dances every weekend," I reminded the class.

Everyone clapped. I told myself to start watching kung fu movies.

That fall, it became fashionable to be Chinese.

I made friends with the popular girls in my grade—Kim and Claire and Sherry, smiling white *gui* girls who were fascinated by my minority status. "How can you be a minority? You're not black," Kim repeated every morning before school.

We were crouched on the playground blacktop, in the middle of a game of jacks. A small rubber ball bounced in the circle formed by our knees. I scooped up the remaining pair of jacks and caught the ball. "Threes," I called, scattering the jacks. I threw the ball into the air. "I'm Chinese, that's a minority," I said without looking up. I was accustomed to both rituals, the jacks game and this discussion. I closed my hand over three spindly metal asterisks. "We have dragon dances every weekend."

"But your skin's the same color as mine," Kim protested automatically. "Wait, it's my turn—your hand touched that one." She pointed at a stray jack.

I passed her the ball. Kim scooped the jacks up off the blacktop, cradling them in the open cup of her hand. I added the six I'd been holding. I said, "I know, but I'm supposed to be yellow."

Kim looked puzzled. "What am I on? Threes or fours?"

"Threes."

Kim threw the jacks. "*I* want to be a minority," she confided. "Then I wouldn't have to go to Smith."

"It's no big deal," I shrugged. I watched Kim slide her hand across the blacktop. The ball took an extra hop.

"Double bounce!" Kim and I shouted together. She groaned.

I shook my head wisely. "I knew you wouldn't get those three! They're too far apart. What's Smith like, anyway?"

Kim relinquished the ball and jacks. "Smith's okay. It's just a school."

With one quick hand movement, I scattered the jacks. "Hmmm," I exhaled, considering my options. Kim bent over the game pieces on the ground in front of us.

"You can do this four here, and then these here," Kim suggested, drawing circles in the air above the jacks.

"I'm still on threes," I reminded her. "I missed last time, remember?"

Kim shrugged. "That's okay. You can go on to fours if you want."

I bounced the ball. I was happy—in the mornings, at least.

The afternoons were a different matter. I couldn't get anyone from Smith to like me. I didn't know why. I tried hard to be likable, cheerfully inventing stories about my family—dragon dances, kung fu practice, the bitter powders we swallowed for strength. But no one cared. They called me dirty, mocking my habit of wearing one outfit for the entire week. "Are you too poor to buy more clothes?" they cackled.

I have plenty of clothes, I thought, *a whole drawerful.* I went home and asked my mother why I couldn't wear a different outfit every day. The next day I returned to school with her explanation: "It's 'cause my mother doesn't want me putting dirty clothes in with the clean ones," I said. "I can't just wear something once and then put it back in the drawer."

"Wash it, then," they snapped back, not a trace of sympathy in their voices.

I chose not to answer, for how could I explain that we only had one washer for eleven people, that Mother considered more than one load a week wasteful, and that *she*, ultimately, chose my clothes at the beginning of each week? I would be called poor, dirty, and—worst yet—childish, just a baby dependent on my mother.

In the end, I blamed my troubles on Cindy Fisher.

Cindy was a black girl who lived in my neighborhood. She was the tallest, meanest child in the third grade, known not only for making threats like "I'm gonna kick your booty, motherfucker," but also for following through on them. She would fight you before school, after school, or during recess, whether or not adults were present—unlike other bullies, she didn't seem to care about getting caught. Cindy was *always* in the principal's office, and at least twice a year she actually got suspended from school, three-day absences that the rest of us savored like long weekends. Everyone was afraid of Cindy: The older grades were afraid of her. Boys were afraid of her. Probably even the teachers were afraid of her—I used to overhear them in the halls, whispering hopefully, "Another suspension this year, and she'll get expelled for sure." But the promised expulsion never came. Cindy remained at McMeen. The rest of us continued to track her movements with gloomy satisfaction.

My first two years at McMeen, I wasn't important enough for Cindy to threaten. Certainly, she would nudge me here, shove me there, call me a name if I happened to cross her path. But she didn't go out of her way to be mean to me. I wasn't worth the effort—too many others picking on me already, too small and meek to fight back. I only knew her by reputation, by the black eyes and bruises she gave the other kids.

In the third grade, things changed. Cindy noticed me. She was in a different homeroom that year, but we had gym at the same time. There were two gym teachers at McMeen, Mr. Wicks and Mr. Hardee. They taught separate classes in the same room, a parquet-floored, high-ceilinged gymnasium with an accordion-pleat partition down the middle. On the first day of each semester and during fitness tests, the partition was in place. Every other day of the year, it lay flat against one wall, the panels stacked snug as cards in a deck—removing all barriers between me and Cindy Fisher.

In the third grade, gym was an afternoon class. There were sixty-some students in Mr. Wicks's and Mr. Hardee's two classes combined. Three of these students were not black—me, Dean Fukihara, and Theresa Espinosa, a white girl whose father had raised enough of a fuss that the school agreed not to bus her to Smith.

In the third grade, gym was the last class of the day. When the first dismissal bell rang, the local children were asked to remain seated on the gym floor. The students from Smith lined up for their buses home. When the final bell rang, they filed out of the room, leaving the neighborhood children alone in the gym. There were six of us—me, Dean, Theresa, Cindy, and two other black students.

Cindy Fisher noticed.

The strangest thing was that she didn't beat us up right away—Dean, Theresa, and me, one after the other. She ignored us. She would only speak to the children from Smith. She gathered in tight little circles with the girls, laughing uproariously, her back to me. Her most threatening action was this: Every so often she twisted around to shoot a look in my direction, held it long enough to ensure that I saw, and turned away again. I was mystified.

"Is she going to beat us up?" I asked Theresa. We huddled together in our own corner of the gym.

"I don't know," she whispered in reply. "They do that to me all the time."

I didn't ask who. I was pretty sure that she meant the circle of girls gathered around Cindy—they were in the same homeroom as Theresa. I shrugged and watched.

The mystery continued. For over a week Cindy behaved as if I did not exist. She looked over my head if I stood in front of her. She stumbled into me whenever she needed to pass—almost absentmindedly, without any real force, without threatening or swearing. I felt something akin to disappointment. This was not the behavior I expected from Cindy. I was too puzzled to feel relieved.

Then she changed again. Theresa and I were heading out the gym door one afternoon when Cindy stepped in front of us. "White bitch," she said, blocking the exit.

We stepped back inside. It was long after the last bell, and the gym was empty except for us three. I looked down instinctively, afraid to challenge Cindy. Even in a fight of two against one, I thought that she would win. But Theresa said, "Get out of our way."

In response, Cindy closed the distance between them. Only inches of air separated their two bodies. Cindy bent over Theresa's head. "You white *bitch*," she growled. "Think you're too good to go to school in a *black* neighborhood."

Theresa stiffened. She stepped back just far enough to look into Cindy's eyes comfortably. "My dad's a sheriff," she warned.

Cindy scoffed. "Huh! Your dad's a pussy. I can kick his butt any day."

"Don't you dare say that about my father!" Theresa screamed. Spittle flew out of her mouth.

"Say *what*?" Cindy taunted.

Theresa scowled. "Say anything. Don't you dare say anything about my father."

"What are you going to do about it?"

Theresa didn't answer. She stared into Cindy's eyes, face frozen, scowl intact.

"What are you going to do about it?" Cindy repeated.

Theresa didn't move.

"Huh? What are you going to do about it?"

I blinked. My heart beat like a crazed jackhammer. My palms were slippery. I was so terrified that I could barely breathe, but I wasn't going to run away. I was going to stay right here, next to Theresa. You didn't run away when your friend was in trouble. Everybody knew that. It was a rule. Even if you couldn't do anything to help, even if you could only watch while she got beat up, you didn't run away. Running was the lowest form of cowardice, worse than getting beaten up, worse than anything.

"What are you going to do about it?" Cindy asked again. She gave Theresa a quick shove with the tips of her fingers. Theresa stumbled backward. "What are you going to do about it, bitch?"

I heard a click at the back of the gym.

Shove. "White pussy bitch." Shove. Theresa stumbled again.

Behind us, the floorboards creaked.

"What are you going to do about it?"

"*My father . . .*"

Shove.

"*My father is a sheriff!*"

Shove.

Another noise at the back of the gym. I turned my head. At the far end of the room, a silver-haired figure fiddled with the door to the wire-and-glass-enclosed teachers' office. "Mr. Wicks!" I screamed.

Suddenly Cindy was pressed against my back. "You shut up, asshole-bitch-mama's-girl, you wanna get me in trouble?"

"Mr. Wicks!"

The figure did not respond.

"Shut up!" Cindy pushed against me. I stumbled forward.

"Mr. Wicks!" Theresa this time.

Cindy spun around. "Shut up!"

"Mr. Wicks!" Theresa and I shouted together, our voices over-lapping. "Mr. Wicks!"

He slid his keys into his windbreaker pocket.

"Mr. Wicks!"

"Shut up!"

"Mr. Wicks! Mr. Wicks!"

Finally he turned. His face was red and annoyed-looking. "What's going on? What's all the racket?" he asked, striding toward us slowly.

My mouth snapped shut. I thought it was obvious—Cindy, two smaller girls, and a lot of yelling. What did he think was going on?

"Nothing, Mr. Wicks," Cindy answered innocently. "I was just playin', me an' my friends." She smiled.

Mr. Wicks adjusted his glasses. "Uh-huh. Yeah, well, go play at home. It's after school hours." He fiddled with the silver whistle hanging from the cord around his neck.

I watched in horror. He couldn't possibly believe Cindy, I thought. He must have heard us arguing with her.

"Go on," he growled.

Not even a trip to the principal's office? Not even a warning? My mouth hung open.

He pointed at me. "You, get out of here, stop hanging around. This isn't your home."

Cindy snickered. She strolled out the door. "Good-bye, Mr. Wicks," she called back sweetly. "See you tomorrow."

Theresa and I exchanged a look. "Mr. Wicks," we protested simultaneously.

"GEE-zus Christ! What am I, your babysitter? It's after school hours! Get off of McMeen property, what are you waiting for?"

Without another word, I walked out the door. "I hate him," I told Theresa as soon as we were safely past the teachers' parking lot. "I'm glad he's not *my* gym teacher."

"I wish he'd never come to McMeen," Theresa said.

"Yeah!" I agreed enthusiastically. "That woman teacher we had last year was much better. She didn't scream all the time."

"Mr. Wicks likes Cindy because she's good at gym," Theresa confided. "He says that she *takes it seriously*."

"That's stupid," I said. "Everybody knows that the only reason we have gym is so our teachers can go sit in the lounge and talk about us." We crossed the street. I started to turn right. "Well, see you tomorrow . . ."

Theresa stopped me. "Where do you live?" she asked.

"On Jasmine."

"Walk this way," Theresa suggested, motioning to the left. "I live on Ivy, between Kentucky and Exposition."

I considered her invitation. Ivy was two blocks over from Jasmine, on the other side of Jersey, so I'd be going out of my way. On the other hand, Theresa had the best pink book bag. It had pictures of ballerinas on it, and there was a secret compartment in the bottom, for toe shoes. Walking with Theresa meant walking with the book bag. I felt honored even to be asked.

"Come on, it's only another block," Theresa wheedled.

"Okay." I turned left. We walked.

"It just goes to show that my dad's right about Those People," Theresa said in an adult-sounding voice.

"What people?" I asked.

"You know," she whispered. "Minorities."

I felt sick to my stomach. "I'm a minority," I told her quietly, ready to cry.

Theresa gave me a puzzled look. "No you're not."

"Yes I am," I said. "I'm Chinese."

"Oh, that's all! That's not a minority," Theresa assured me. "My dad says that Orientals are *hard-working* and *believe in education*, so they're not minorities. Negroes are minorities."

"But . . ." I began uncertainly.

"Nope," Theresa sniffed, cutting off the thought. "My dad told

me, and he knows everything. Do you want to come over some-
time? I'll show you my ballet shoes."

"You have real ballet shoes?" I breathed.

"Uh-huh. I take ballet lessons."

"Oh, wow."

"Uh-huh. So do you want to come over?"

I thought for a minute. "Is it okay with your dad?"

"Sure. I keep telling you, you're not a minority."

I smiled. "Okay, I'll ask my mom then."

Cindy didn't give up. She waited for us outside the gym door after
school every day. "Don't look at her," Theresa advised. "Pretend
she's not there."

I did my best. I stared straight ahead, not allowing my head to
turn in the least, so that I wouldn't catch even the smallest
glimpse of her. I spoke to Theresa extra loud and laughed extra
hard, to let Cindy know I didn't care.

Cindy followed us regularly, cursing, "The bitch and the baby,
scared of me? Yeah, I know you can hear. Why are you walking so
fast?"

Sometimes she'd creep so close that her toes caught the back of
our shoes, yanking them off our heels. I always tried to walk on,
my shoes flopping behind me, but Theresa would stop. "Stop giv-
ing us 'flat tires!'" she yelled, bending down to fix her shoe. I
pulled the back of my loafers up with an index finger.

"Ya scared of me? Huh? Ya scared of me?" Cindy asked.

"No!" Theresa insisted, pulling me forward by the arm.

"Then why won't you fight me, huh? Why don't we settle it
right now?" Cindy called after us.

"Don't look back," Theresa whispered. "That's what my dad
says. He says she's just looking for a fight, so don't give it to her."

I nodded quickly. I desperately wanted to cry, but I wasn't
going to do it in front of Theresa. I wondered if she was ever

scared. I wished that my father was a sheriff. If my father was a sheriff, I wouldn't be scared, either. If my father was a sheriff, he could put Cindy in jail.

"Come on," Theresa said. "Walk me all the way. Your mom won't mind if you're a little late. I'll let you hold my ballet shoes."

I nodded mutely. I walked Theresa to her door every day, even when I didn't go in to look at her ballet shoes. I'd discovered that Cindy tended to disappear after we crossed Kentucky. Instead of following us down Ivy, she would turn right, headed toward Jersey, Jasmine, and the streets that followed. It was the same direction I would turn if I didn't walk Theresa all the way home. The choice was simple. I walked Theresa home.

One day, in the middle of gym class, Theresa's father showed up wearing his sheriff's uniform, silver badge and all. There was a collective intake of breath, then silence, as he came through the double doors connecting the gym to the school building. He waited by the doors expectantly.

"Just a minute," Mr. Hardee said to our class softly, one hand raised in a "pause" signal. I stood with my hands on my hips, mid-calisthenics twist, as he went to greet Mr. Espinosa.

Across the room, for no apparent reason, Mr. Wicks blew his whistle. Immediately everyone burst out laughing. We resumed our frenzied calisthenics. He blew the whistle again. "Everyone against the walls," he barked. "I'll be right back." He stalked off to join Mr. Hardee and Mr. Espinosa.

I moved toward the wall, looking for Theresa, but other kids had already sat down on either side of her. I frowned. "Here, you can sit next to me," someone said.

I turned. "Thanks, Vicky." I squeezed into the space she'd made.

"Aw, I don't want her next to me," the girl on the other side complained.

A boy leaned forward. "Leave her alone, Denise!"

"Oooh, Terry, is she your girlfriend? Do you like her?" Denise taunted.

"Just shut up, Denise, she didn't do anything to you," Terry answered.

Denise said, "She did so. She's here, isn't she? I don't want her next to me—she scratches her booty."

"That means you've been watching it, huh, Denise?" Terry retorted. "Whatchu doin' watching that girl's butt? 'Sides, you're the one with the big fat booty."

"Yeah, you know you like it!" Denise said.

Mr. Wicks blew his whistle before Terry could reply. "Down there, be quiet!" he yelled, pointing in our direction.

"Sorry," I whispered to Vicky.

"It's okay," she whispered back.

I leaned forward to sneak a look at Terry. He grinned.

"Theresa! Cindy! Up here now!" Mr. Wicks held the office door open. Mr. Hardee and Mr. Espinosa waited beside him.

Theresa scrambled to her feet. She ran across the floor and hugged her father. They walked into the office together. Cindy sauntered toward the open door slowly.

"Oooh, she is gonna get it!"

"No fair, Mr. Wicks, leave her alone!"

"She ain't done nuthin'!"

"That white girl . . ."

"Don't say 'ain't.' Makes you sound uneducated."

"What do you care?"

Screeeeeee! The whistle sounded again. "This doesn't concern the class," Mr. Wicks said. "Come on, Cindy," he urged quietly, sounding surprisingly gentle.

She dragged out her steps further. Everyone waited. Mr. Wicks didn't rush her. He didn't blow the whistle again. Cindy finally reached the office door. Mr. Wicks ducked his head to look her in

the face. He rested one hand lightly on her shoulder. With a quick rolling motion, she tossed it off. Mr. Wicks didn't protest. He followed her into the office and shut the door, leaving Mr. Hardee to teach the two classes alone.

Mr. Hardee cleared his throat. He walked out onto the center of the gym floor. "Okay, everyone in rows of five for jumping jacks!" he said.

We lined up silently, Denise stood in front of me, Vicky behind. Denise didn't complain.

"One, two, three, four," Mr. Hardee counted.

I jumped at an angle, twisting my head to see into the office at the far end of the gym. I couldn't see anything but the top of Mr. Espinosa's head, a flash of dark hair bobbing up and down.

"Everyone, eyes up front," Mr. Hardee ordered.

I averted my eyes. I watched Denise turn to face Mr. Hardee. We jumped, arms and legs snapping open and shut.

They were still inside when the second bell rang. I wondered whether I should wait. I stood in the middle of the floor alone, looking toward the office.

"What's wrong, Elaine?" Mr. Hardee asked.

"Theresa and I usually walk home together," I told him.

He cupped my shoulder in one hand. "She's going to be a while," he said. "Why don't you go on without her?"

I looked up into his face. He was all gray-and-tan—eyes, hair, and skin—worn soft like an old stuffed bunny. "Will everything be okay?" I asked.

He nodded. "We're taking care of everything. Go on home, all right?"

I walked toward the door. "See you tomorrow."

"See you tomorrow," he said.

*　　*　　*

I thought that maybe Cindy would get suspended, but she was in school the next day. For the rest of the week, however, she steered clear of Theresa and me.

"What happened?" I asked Theresa on the way home.

"My father showed her who's boss," she gloated. "He's a sheriff, you know."

"Is he going to put her in jail?" I asked, awed.

"No." Theresa sniffed disdainfully. "He says that she's not worth it. She's just some Stupid Piece of Trash trying to act big, but she won't get anywhere. He says not to worry about her anymore."

"Wow," I breathed. I looked over my shoulder, just in case. No Cindy.

The following week, during gym, I was walking across the school field when I felt a shove on my back. I tripped and fell. Burrs dug into my knees. I yelped. "Stop it, Cindy, we're on the same team!" I got up slowly, brushing the sand off my skirt, picking the burrs out of my skin.

"'Stop it, Cindy,'" she mocked. "Where's your friend, slant eyes?"

"Don't call me that!" I said angrily. "Leave me alone, or . . . or else!"

"'Don't call me that!' Or else what? You'll go tell your friend's fat white father?" She laughed.

Ignore her. That was Theresa's advice. I turned abruptly and continued walking toward the diamond ball field. We'd been divided into four teams for two games of kickball. By chance, Cindy and I had ended up on the same team. Theresa was on one of the teams playing on the other field.

Cindy's voice followed me: "What's wrong, yellowface, your parents don't speak-ee no Engrish-ee, no can help-ee you?"

I kept on walking. *Ignore her. Ignore her,* I thought.

"Little yellow people, I'll beat them all up, your whole family.

'Pleas-ee, Cindy-san, don't kill-ee me!' And then what can you do? Tell that bitch Theresa's father?"

I blinked rapidly. My wet eyelashes left spots on my glasses. "Leave me alone, you . . . you . . . you . . ." I stuttered. "Shithead" was the worst word I could think of, but I didn't dare say it.

"What'd you call me?" Cindy demanded.

My feet stopped. Oh God, did I say that out loud? I turned to face Cindy. She didn't look mad enough for me to have said it out loud. "Nothing," I said. "I didn't call you anything."

"Liar. I *heard* you," she replied.

"I didn't call you anything," I insisted.

Cindy was carrying the kickball. She hurled it at me. I fell to the ground again.

I waited behind the fence for my turn to kick. Denise sidled up beside me. "What'd you call Cindy?" she demanded.

I tried to edge away, but there were too many people standing around. "Nothing," I said.

Denise said, "I *know* you don't want to be messin' with me. So don't lie. Tell me what you called her."

"I didn't call her anything," I repeated.

Denise smirked. "What, did you say it in Chinese?"

"*No.* I told you. I didn't call her anything."

"Why you want to go messin' with my friend, anyway?"

Friend? I wondered. Cindy didn't used to have friends. Aloud, I said, "I didn't."

"That's not what I hear," Denise answered. "I hear you been messin' with her, you and that daddy-girl-rich-white-bitch-friend a yours."

"*Cindy* did it," I protested nervously. "Theresa and I didn't do anything. It was all Cindy."

Denise leaned into me. She was at least a full head taller. "Oooh, you just want her to get in trouble, don't you?"

I inched to the side, until Denise was no longer touching me. I didn't know how to answer. The truth was, I *did* want to get Cindy in trouble. I wanted to get her expelled. But I knew better than to say so. Instead, I waved at home plate "It's my turn. Out there."

"How about this?" Denise offered snidely. "You kick that ball hard, don't get yourself out, and I won't beat your yellow butt."

I kept my mouth shut. I was miserable at this game, and Denise knew it. I took a deep breath and walked out to the plate. In my head, there was a fantasy where I suddenly became good at gym. I kicked home runs and caught all the outs. And Cindy, who was our team captain, told everyone to leave me alone, I was the school's best player. Maybe today it would happen for real. But no, one, two, three, I kicked and missed, another out. I slinked back behind the fence. At least Denise wouldn't kill me before the game was over—she liked kickball too much.

Things got worse as the weeks passed. McMeen afternoons happened in a weird parallel universe, like the one in San's *Superman* comic books, where everything was reversed—Superman was a villain, and Lex Luthor a hero. So it was with Cindy. Back in the first and second grade, before busing started, being tormented by her used to elicit all sorts of sympathy. You got so much attention that popularity was practically ensured. But now she had friends, and if she hated you, they did, too. Actively.

Theresa coped by hissing, "*My father!*" whenever Cindy crept too close. And Cindy would shove me instead. After a while, I became afraid to stand next to Theresa—I didn't want to jeopardize her. In my mind, *I* was the reason Cindy hated Theresa in the first place. If not for me, Cindy would leave Theresa alone. I was sure that Theresa would figure this out eventually. Then she would tell her father, and Mr. Espinosa would put *me* in jail. I would never be allowed to hold Theresa's pink toe shoes again. Preparing for the inevitable, I disassociated myself from Theresa

slowly—I didn't sit next to her in gym class every afternoon, I didn't walk home with her every day. If she invited me to play at her house, I refused every other offer. Theresa seemed confused by my actions, but she didn't press me for an explanation. Nor did she leap to my defense against Cindy and her friends. I, over the course of the year, became increasingly miserable.

It was bad enough in Mrs. Moore's classroom, when Cindy was not present, and her friends only shoved and kicked in passing, if they had nothing better to do. It was awful when Cindy was around to remind them. If our two classes had bathroom break together, I didn't dare leave Mrs. Moore's side. I stayed in the hall, afraid to go pee. I was terrified of what might happen to me in the lavatory, where there was no adult supervision.

Gym was even worse. Using various games as cover, Cindy and her friends continued to torment me. I was knocked down constantly. Kids stole my glasses and made me chase after them. In kickball, Cindy's friends threw the ball at me even if I wasn't running bases or standing at the plate to kick. I was scared all the time, but I didn't dare tell anyone. What could I say? Cindy was right about my parents—they couldn't come to school for a conference the way Theresa's father did.

7

Middle Kingdom, Beautiful Land

Their voices bounced off the gymnasium walls:

Come on, Lori, you can do it! Loooriiii!
Faster, Toby, she's right behind you!
Hurry! Hurry!
Come onnnn! Move those leggggs!

Sixty fourth-graders, shrieking with excitement. I couldn't hear my teammates in the frenzy, but it didn't matter. I reached backward and tagged Sydney's hand. Her turn. I'd finished my relay length, a crawling "crab walk" backward across the gym. I let my knees and shoulders sag; my butt hit the floor. The crab walk was a killer, forcing the body into an unnatural, inverted arch, stomach to the ceiling, hands and feet on the floor. It was also my favorite: No one else was any good at it, so I always stood a chance to win. It was my secret weapon, like left-handed arm wrestling, privately cultivated in Aunt Becky's basement.

I scrambled to my feet and brushed the dust off my butt. As soon as I stood, a flurry of hands landed on my shoulders, clapping lightly in congratulation. *Way to go, Elaine! All right! You put us way ahead!*

I grinned. Gym was a morning class this year. Cindy Fisher was

on another team. No one was threatening me. I might even win a race. I clapped my hands happily, mimicking the teammates at my side.

"Come on, Sydney!" they shouted.

"Come on, Sydney!" I echoed.

Across the gym, Sydney faltered, regained her balance, and ambled on. My breath caught. I watched my lead slip away. A full body length between Sydney and the nearest competitor, half a body length, less . . . The shouting intensified. I leaned forward. A cheer rose in my throat.

"*Fai nai!*" I screamed. *Faster!*

My voice shrilled the Toishanese syllables, out of sync with my classmates.

For an instant, the incongruity didn't register. In my excitement, I forgot the boundaries between languages. Then the other voices came rushing at me, and I realized my mistake. My mouth clamped shut. I froze, startled into stillness. Time continued around me: Rows of smudge-faced children cheered for teammates scuttling across the floor. Bodies plopped down to race the next relay length. Mr. Hardee played with the whistle slung over his golf shirt, preparing to announce the winners. Mr. Wicks crossed his arms, on the lookout for cheaters.

Air swirled over my body. I inhaled the musty odors of dust and children's sweat. My head unlocked and swiveled. Quick glances left and right. Had anybody heard?

Come on, you can do it!

Go! GO!

All right, Scott!

In the next row, Sherry's blonde ringlets bobbed against her throat, vibrating with the force of her shouts. My own teammates, Mark, Kim, Cary, and Stephen, strained forward, mouths open, knees bent, torsos bouncing excitedly. No one was paying attention to me.

Limp with relief, I nearly fell over. I couldn't believe I'd made

such a stupid mistake—screaming Chinese in the middle of gym class! I was just lucky that no one had heard. Even among the McMeen students—the white kids—I needed to be careful. My status depended entirely on their approval. Break a rule, and I might get beat up.

I was proud of how American I'd become: I answered to "Elaine" first and only spoke Chinese when absolutely necessary, with my adult relatives. Even this was embarrassing, and publicly, I sometimes tried to talk to my parents in English. I genuinely believed that they could understand if they only tried harder. After all, I had done it.

More than anything, I wanted to obscure my foreignness, that combination of ethnicity and poverty. I would have given anything to slip into the ordinary. But my parents foiled all attempts. They turned me into an object of ridicule. Mother chose my clothes for me, cotton dresses and skirts sewn out of restaurant flour sacks, acrylic sweaters from K Mart, and—the best of the lot—hand-me-downs donated by Diana, a waitress's daughter. During the fall and winter chill, Mother sent me to school in taupe nylon stockings and knee socks beneath my skirts. I cringed when classmates touched my gauzy, discolored legs curiously. *If only I could be normal and wear Levi's*, I wished. I wanted stiff, new jeans badly, but I never bothered to ask. I already knew the answer—*too expensive*.

With each grade, my glasses became thicker and uglier. My father compounded the handicap by making me wear a blue metal chain that attached to the earpieces. "A good idea," he remarked, loving gadgets. "Your glasses won't break if they fall off." At the optician's, I agreed, thinking myself special for having this sparkling eyeglass accessory. Then I wore the chain to school, and the other kids laughed. They pointed to Mrs. Bishop, the least popular teacher at McMeen: Around her neck, attached to her

eyeglass frames, there was a similar chain. An old woman's chain, to keep half-moon reading glasses on her bosom.

I looked like witchy Mrs. Bishop, with her cracked yellow fingernails and long, flaccid teats, when I wanted to be like Mrs. Harper, my fourth grade teacher. Her frosted blonde coif, mascaraed blue eyes, and narrow nose epitomized *American*. Every night, while San watched TV, I stared at my nose in the bathroom mirror. I pinched my nostrils shut, molding the desired face.

Mrs. Harper proved that mothers could be cool. She didn't dress like she had a teenage son; she wore clingy knits that showed off her figure. One day she brought a K.C. and the Sunshine Band record to school. She sang, "That's the way, uh-huh, uh-huh, I like it, uh-huh, uh-huh," over and over, snapping her fingers to the beat. "They're not saying anything, but it's really catchy," she laughed, never explaining what the song had to do with our lessons. I wanted to listen to her forever.

My mother had stopped styling her hair. She dressed in the same clothes every day; they were years old and sometimes didn't match. After my brother's birth, she developed a low, poofy belly, as if the baby had never left her body at all. Admiring Mrs. Harper's slenderness, I asked Mother why she was so fat. Repeatedly. Mother said that she kept the weight for my sake. "If I weren't fat, how would you know you were thin?" she retorted.

The dialogue epitomized our relationship. We were entering a long period of mutual struggle over our identities. I believed that she reflected poorly on me, and vice versa. I thought she should become more stylish—a code for "American." She dreamed of a dutiful Chinese daughter with my face, inhabiting my body.

I had a dreadful power over my mother, one that grew with each word in my American vocabulary. As I gained fluency in English, I took on greater responsibility for my family, and parent and child roles became murky. Mother spoke and read virtually no English. She needed my help to buy groceries, interpret the news, and complete all manner of forms. I filled out our "alien

registration" cards. I wrote out bank deposit slips. I showed Mother where to sign my report cards.

She continued to sign Father's name. I threatened legal action: "That's forgery! It's not your name."

Mother explained again, "You always sign the man's name. It's the only one with meaning."

A deep frustration set in. I was sickened by her statement's implication for my future. I hated her helplessness, believing it unique to her alone. I knew it couldn't be ingrained to my gender, because I fulfilled such essential tasks already. I was the American voice of the family, the connection between our basement room and the outside world. I'd accepted a hollow name, an empty construct, and created an identity with it in four short years. "Elaine" was adored by teachers, got A's in everything except penmanship, and watched *The Brady Bunch* faithfully every day after school. I didn't ask for these challenges, yet I responded and excelled. How dare Mother tell me that I would eventually amount to nothing? I had trouble respecting her. I grew increasingly willful, violating the most sacred of cultural tenets: absolute fealty to family and elders.

At home, San and I almost always spoke English, isolating Mother from our conversations. She was our primary caretaker, alone with San, Jeff, and me most of the week, relieved of duty by Aunt Bik-Yuk only on weekends. When we spoke Chinese, I defied Mother subtly. I no longer called San "Big Cousin." I didn't call Jeffery "Little Brother." San and Jeff went by their birth names. I went by Elaine around kids, Yee around adults. Mother protested our practice. "It's not polite," she admonished. We wore her down through simple disobedience. A lot of the time, she just didn't know what we were saying. She retreated into silence, a subversive anger.

She used to laugh at the way I said "Mother" so formally, not "Mama, Mommy, Mom." Now there was something malevolent about my precociousness. My independence sapped her strength.

She'd always devoted her energies to nurturance—her success depended on my neediness.

Watching San and me bat words back and forth across the dinner table, Mother asked us to translate. We grudgingly shared our inane gossip: Was my teacher better, or his? What happened on Saturday morning cartoons the previous week? Since Mother had nothing to add, and we asked nothing of her, the conversation gradually shifted back to English.

In this atmosphere, English became Jeff's imperfect first language; he struggled with pronunciations, but he had far more difficulty with Chinese syntax. English was slowly robbing Mother of her last pleasure. Jeff's complacence was all that salvaged her parental identity. But he was naturally drawn to a child's word, and ours operated according to a special kind of secret language. It excluded our parents but not our neighbors; it defied my mother but not passersby at the supermarket. It was a code for power, moving us closer to the majority culture, further marginalizing our parents and memories of our past.

Our household existed in parallel worlds. San and I read the *Rocky Mountain News*. We gathered information for school reports from the *Encyclopedia Britannica*. Before bed we watched the ten o'clock news on Channel Nine.

Our adult relatives kept us company in front of the TV. Sometimes they asked about the weather report, but otherwise remained uninterested. For news, they subscribed to *Sing Tao*, a Chinese-language newspaper published in San Francisco. It came by mail sporadically, like information by lottery. Sometimes we received one issue a day, sometimes none for three or four days, then a whole pile at once. The adults anticipated deliveries like they did their one day of rest, or the Hong Kong vacation dreamed of but never taken. When they arrived home from work each night, they greeted us with only perfunctory cheer before searching the room with darting eyes. "Any newspapers today?" they asked. They grew restless and morose if days passed with-

out a delivery. They brightened immediately when more arrived.

Eight adults shared one subscription. They parceled out papers without regard for date or continuity. They didn't fight if one person had hoarded issues from the night before, but disapproval was implicit and obvious. Only Uncle Wing was bold enough not to fetch those issues at once. Then, no matter how late it was—and frequently it was past midnight—they sat up reading on the sofa or at the dining room table or in their bedrooms with the door open. The air grew hazy with swirls of blue as my father smoked his Winstons, Uncle Andy his unfiltered Camels, and Uncle Wing his Lucky Strikes. The smell of home. The smell of childhood.

I don't know what news *Sing Tao* reported. All the photos seemed specific to Chinatowns or China itself. Each night after I translated the local newscast for my mother, I motioned at the unfolded newspaper on the coffee table. "What does that say?" I asked. I knew that it wouldn't have the latest Bronco scores, but I wondered whether it discussed the upcoming elections.

Mother said, "It tells all the Chinese in Denver, in America, about your misbehavior! Everybody in Denver knows that you don't keep your clothes clean. They know you don't listen to your mother. I'm so ashamed that I'm afraid to go out in public!" The information about me varied, but it was always the bad, never the good. Mother believed that praise was immodest and would spoil me.

Her words made me nervous. I flipped through *Sing Tao* furtively, looking for my picture and name. Although they never appeared, I couldn't be sure Mother was lying. Perhaps I'd looked on the wrong page, I thought, or perhaps I'd missed an issue. The old shyness settled in my bones and ossified my voice box. I watched guests covertly, studying their gestures for evidence of my badness. If I couldn't hear a conversation, I assumed that it criticized me. An ambiguous comment was a negative one. I acquired a paranoia that never quite left.

Mother tested my Chinese with columns of *Sing Tao* text. The impromptu quizzes terrified me. My Chinese literacy was fading as my English improved. It was as if the new words were shoving the old ones out of my head. Under pressure, I teased my mother by picking out the easiest characters and reading, "One, two, three . . . see? I can do it!" These words were represented with straight lines, one for each count. Mother shook her head, but my joke affected her, and she laughed.

My reprieve was brief; I couldn't silence her criticisms. Appalled by my "B" penmanship grades, Mother monitored my after-school writing exercises more vigilantly. She examined the pages of English script closely, although she couldn't read any of it. "So sloppy," she muttered. "So few pages. Why don't you work harder?" I bent my head closer to the page, concentrating on the curves of my letters. I understood what was at stake: When you're Chinese, a penmanship grade is serious, since the culture judges intelligence as much by the shape of the written word as by the choice of the words themselves.

Although I resented the hour these exercises consumed, I never tried to dodge it, nor even scribble "I hate Mother" in my Big Chief tablets. I filled the pages with the fantasy version of my life. My real mother was an American woman Father could not marry. She would find me and reveal my true name, the one I hadn't learned yet. I would grow up beautiful and raise my children kindly. I pressed the pencil so hard the words appeared on the other side of the page, raised and reversed, like engraving plates.

Increasingly, I recognized the power of English. With it, I could defend my brother in ways my parents could not do for me. When neighborhood kids teased Jeff, I intervened, staring them down threateningly—or worse yet, ringing doorbells to speak to their parents. At home, unlike school, I was brave. I could boss the neighborhood children around, and they would listen, because

they were younger. They didn't see me at school, in gym class. They didn't realize how unpopular and powerless I was.

One afternoon while San was at Daniel's, I led my brother and three of our neighbors into Aunt Becky's basement to help me prepare a surprise for Mother. "We're going to mop the floor," I announced, filling a bucket at the laundry room sink.

Jeffery, Joey, Brian, and Nancy watched me doubtfully. Joey shuffled his feet. Nancy sucked on her two middle fingers.

"It's easy," I assured them. "First we get the floor wet, then we mix in laundry detergent, then we wipe it up." To demonstrate, I dumped a bucket of water on the floor. "Come on, you gotta help."

Joey and Nancy each claimed a container and marched up to the sink. Jeffery was only three years old, and Brian four. They were too small to reach the sink, so we passed them full buckets to empty onto the floor. "Boy, will San be sorry he missed this," I chortled. "My mom's really gonna be surprised!"

Through the wall I could hear the basement door open. Mother's voice tumbled down the stairs at me: "Yee! Why do I hear water running? What's happening down there?"

I ran to the foot of the stairs. "We're doing something," I answered ambiguously.

Mother frowned. She started down the stairs.

"Wait!" I called up at her, "We're not ready yet."

She descended despite my protests, following the sound of activity into the laundry room, where she stopped short. An inch of water lapped at her feet. In Chinese, she shrieked, "Are you all insane?" She snatched the buckets from Joey and Nancy's hands. Joey started sniveling; he tried to hide behind his little brother, Brian. Nancy stuck her two middle fingers into her mouth.

Mother turned off the faucet, then spun around to look at me. In a deadly voice, she said, "Tell them to go home."

I opened my mouth. Without waiting for my words, Nancy, Joey, and Brian hustled out of the room and up the stairs.

"We were cleaning . . ." I began. But Mother pushed me aside.

"Go upstairs," she said sternly.

"I was *helping*," I insisted.

"Silence!" she screamed.

Jeffery started crying.

Mother glared at him. "Hush up! What are you crying for?" She turned to me. "How dare you make work for me? You should be setting a good example for your brother, teaching him right from wrong, not doing this!" She waved at the floor helplessly.

In the next instant, her open hand made contact with my shoulder. I stumbled slightly and turned to face her again. Mother flailed at my arms, shoulders, and thighs. She always chose these body parts, never the buttocks. She never pulled me over her lap or held me still for her punishments. She struck at me as I stood facing her, as if we were two equals engaged in combat.

After hitting me, she wouldn't let me help her clean. She sent Jeff and me upstairs instead. In tears, hurt that Mother hadn't appreciated out efforts, I talked my brother into running away. Without packing, we snuck out, me on foot and Jeff on his "Green Machine" riding toy. We only made it half a block, to the first corner. I stood there considering the possibilities. We had nowhere to go and nothing to eat.

"I should have taken some bananas," I cried. "But it doesn't matter. We're orphans now. We can never go back. She'll be sorry. She doesn't have children anymore."

Jeffery nodded, sobbing. We stalled there, on the corner of Jasmine and Exposition. Cars passed but didn't stop. Exposition was a "big" street, meaning that traffic actually ran on it, unlike Jasmine, our own silent street. Crossing Exposition was a big deal. So we didn't move, waiting for rescue.

It seemed like hours passed before Mother came after us, but it was probably only a few minutes. On the way home, I got another lecture: "Children don't leave their parents. Older sisters should set a good example for their little brothers. Why don't you obey me?"

My mother believed that these actions were necessary to teach me obedience. If I asked why she yelled at me, she would reply that she wasn't "yelling," she was "instructing." I suppose that's why she whipped me, too.

I don't recall the first time my mother hit me. Pain was a natural, constant part of my childhood. When I was smaller, she only hit me with her hands. Then, our first year in America, she discovered San's Matchbox racetracks. They came in three shapes—U-curves, S-curves, and two-foot-long straightaways. Mother quickly learned that they could inflict a lot of pain without much effort on her part. She used the straight ones to whip me.

I worked on becoming stronger than my mother. I resisted her orders, and she whipped me more. Between the ages of nine and thirteen, there were periods when she hit me daily. She disciplined me for increasingly minor infractions. Then she tried to humiliate me by whipping me outside, in front of my friends.

One day early in the fall that I turned ten, Mother punished me for refusing to come inside when she called. Jeff, San, and I had been playing outdoors all afternoon, and the sun was setting. Standing at the front door, Mother called for us to come in. I ignored her and instructed San and Jeff to do the same. We continued chasing each other across the lawn. Several minutes later, Mother called again. "No!" I shouted back at her.

We argued through the door for the better part of the hour. The sky had paled into dusk by the time Mother charged outside.

I immediately saw the orange rubber racetrack.

There was a maple tree in our front yard, young enough for its branches to reach children, sturdy enough to support our weight. When we played tag, the maple was home base, a safety zone. I wrapped my arms around the trunk. Following my example, Jeff grabbed onto my shirt.

"How dare you disobey?" Mother raged, her eyes red and watery. "You come inside when I call!"

"No!" I screamed.

Mother's chest heaved. Her voice was ragged when she spoke. "Where did you learn to disobey like this?"

I met her eyes. I didn't have an answer, and she didn't expect one. She motioned Jeff aside. He started crying. We all knew that she wanted a clear shot at me.

Once she had me isolated, Mother whipped my legs until I howled. I twisted and danced to avoid her. I opened my lungs' bellows and screamed. But I wouldn't follow her into the house. I didn't care if she killed me on the front lawn. I knew her vulnerabilities. If she killed me out there, I would still win. I would win as long as I didn't follow her.

When she sapped her strength—or her frustration—she retreated to the house. Jeff stayed by my side, crying. The next instant, he was gone, inside with San and my mother. I stood in the yard, as immovable as the maple, gulping my own grief. Joey, Brian, and Nancy crept forward. They'd witnessed the entire incident. They'd watched at a distance, staring white-faced, unblinking. Now they gathered around me. They traced the narrow welts like calligraphy on my legs, whispering, "Look what Elaine's mother did to her."

I didn't care. In Chinese, "Mar" means horse. I was proud that my mother hadn't broken me.

That same fall, Mother began working at the restaurant again. She went in two days a week, Friday and Saturday, trading places with Aunt Bik-Yuk, who couldn't handle the pace of those busy evenings. Aunt Bik-Yuk was forty-eight—three years older than my father, eight years older than Aunt Becky. She had raised two children, William and Dani, who were now in their twenties. She didn't seem interested in taking care of any more kids.

On her days home, Aunt Bik-Yuk liked to putter in the garden, read *Sing Tao*, and talk for hours on the phone. Sometimes she became so involved in these conversations that she forgot to feed

us. "Another few minutes," she'd murmur, waving us away if we tried to remind her.

Around nine at night, Jeffery would start crying and complaining that his stomach hurt. San and I would get him a package of Ding Dongs out of the bread box. "Shhh," we'd whisper, glancing up at the clock. "She's been talking for over two and a half hours—another thirty minutes, and she'll break the old record!" Jeffery eventually learned to eat supper with Brian and Joey Eto next door. San and I continued to forage for Ding Dongs and Twinkies, fascinated by Aunt Bik-Yuk's telephone stamina.

One Saturday night our parents returned home after midnight to find us still watching the clock. San and I ran to greet them: "Auntie! Uncle! Mother! Father!"

Jeffery bounced off the sofa. "They made me throw up!" he whined.

"No! Uh-uh! Did not!" San and I protested.

"Where's your aunt?" Mother asked.

San said, "We were chasing Fee and he threw up on his own!"

"*I* cleaned it up," I announced proudly.

"Where's your aunt?" Mother repeated.

Jeffery burst into tears. "They're always picking on me!"

"No! Are not! Uh-uh! Baby! Baby! Can't catch us!" San and I danced around the living room.

"Silence! Be quiet this instant!" Aunt Becky's voice stopped us in mid-jig. "Where is your aunt?" she demanded.

San and I exchanged a look. We grinned. "On the telephone," he answered blithely.

I checked the clock. "Five and a half hours!" I laughed. "A new record!"

Mother's eyes froze. "Have you eaten?" she asked tersely.

Jeffery wiped his eyes. "I ate at Brian's," he sniffled, "a piece of steak . . . but . . . but that was a long time ago! This afternoon!"

In the background I heard Aunt Bik-Yuk murmur a good-bye. A click as she hung up the phone.

San said, "We gave him cupcakes."

Jeffery whimpered, "I threw up!"

I sang, "Choc-late cup-cakes! Choc-late cup-cakes! Yum! Yum!"

Mother shook her head. She walked past us into the kitchen, muttering, "This can't go on . . ."

San and I looked at each other and shrugged. Father picked up my brother. "What are you crying for?" he asked, his voice deliberately cheerful. "Huh? There's nothing to cry about. Why don't we go downstairs, wouldn't you like that? Huh? Let's go downstairs." He carried my brother away.

Uncle Andy grabbed a pile of newspapers. He spoke to no one in particular: "I'm not paying attention to this . . . I don't have time for this . . . a cigarette, read the paper, that's what I need . . ." His voice drifted off. Fishing in his shirt pocket for a cigarette, he shuffled off down the hall.

Aunt Becky had disappeared into the kitchen. Half-sentences from an argument floated to the living room:

". . . children starving!"

"I was just about to . . ."

". . . lucky it's a local call . . . the amount of time you spend . . ."

"Not my fault!"

"What if there was an emergency? Can't reach you . . . busy signal . . ."

"After midnight . . . no one's eaten . . ."

". . . no harm done!"

I could hear Aunt Bik-Yuk's nervous chuckle, Mother's low, worried muttering, Aunt Becky's high, shrill scolding. San grabbed the *TV Guide*. He said, "I'm not hungry, are you?"

I shook my head. "Uh-uh."

My cousin bent over the magazine. "Good. Let's see if there's a Jerry Lewis movie on."

I agreed. Neither of us understood what the fuss was about.

* * *

Aunt Bik-Yuk made an effort to shorten her phone conversations. She instructed San, Jeff, and me to alert her when we got hungry. She set aside half-an-hour, seven to seven-thirty, to cook our meals, telephone-free. But slowly this half-hour crept forward, slowly it shortened. Before long, it had disappeared altogether. Aunt Bik-Yuk ended up cooking lopsided, her head at an angle to secure the phone between jaw and shoulder. She made sure we were fed before our parents got home, but only by the smallest margin—some nights Aunt Becky's car pulled into the driveway before I could swallow my last bite. Hearing the engine rev, then die, Aunt Bik-Yuk would quickly slam down the phone, run into the living room to collect our bowls, and rush to the kitchen sink to wash up.

"Heh-heh-heh, I didn't know it was so late," she would say. "It must have been a quiet night at the restaurant, everyone home so soon."

San and I still didn't understand. We thought Aunt Bik-Yuk's phone habit was a big joke, and tried to trick her into even longer conversations—we lied about the time, we pretended not to be hungry. A few more hours, we thought, and Aunt Bik-Yuk could be famous; she could be in the *Guinness Book of World Records*.

I reported Aunt Bik-Yuk's new totals to my mother with glee: Four hours one time. Three the next. Only one on another night, because Jeffery fell down and required comforting. Mother was not amused. She said I had become a little monkey without any discipline: "You should be ashamed, making fun of your aunt like this!"

I giggled, "But Mother, it's funny! She likes talking on the telephone more than anything. She doesn't even have to pee when she talks on the phone! Not once in five and a half hours . . ."

"That's enough," Mother interrupted quickly. Her mouth twisted, trying to stay stern. She coughed and changed the subject: "What about your own responsibilities?" she scolded. "I

know you don't write for an hour on Fridays and Saturdays. You're too busy running up and down the street like a *gui* boy! You should be ashamed of yourself—girls don't act like that! Girls are quiet, they walk with itty-bitty steps. I don't know what's wrong with you."

She turned to a pile of clothes on her bed and selected a red plaid jumper. She pointed to the seam my father had just resewn. "*Look* at this! You know Diana, Violet's daughter? *She* doesn't act like this. *Her* clothes are never dirty or torn."

I shrugged. Diana was a teenager; she curled her hair and wore blue eye shadow. I *wished* I could do these things, but Mother wouldn't let me. I didn't know how Mother could compare us. I mumbled, "Maybe she does. We don't see her very often. Maybe when we're not around, Diana messes up her clothes . . ."

"Oh, Yee!" Mother exclaimed, exasperated. "Always so clever, what am I going to do? If only you were as obedient as you are clever . . ." She folded my jumper and handed it to me. "Put this away. Try to be more obedient. Because if you're not, I'll have to take you to work with me—your Aunt Bik-Yuk's too old to be running after you all the time."

Like Aunt Bik-Yuk with the telephone, I did *try*. Half an hour in my parents' room after school on Fridays, writing, *I have nothing to say. This is very boring.* No more roller-skating in the basement playroom. No more chasing my brother until he threw up on the living room rug.

But then I founded a secret club in the garage, and celebrated by spray-painting the name "Bulldogs" in orange on some old curtains. Then I kidnapped Nancy's Barbies for a week. Then I accidentally kicked Aunt Bik-Yuk on the way to bed one night. And put gum in her hair when I got yelled at.

So, in the end, I was sent to work with my mother every weekend.

*　　　*　　　*

When I first came to America, I loved visiting the restaurant. It was a treat, a rare glimpse of the world beyond Jasmine Street. Sitting on the back stoop at Casey's Palace, I witnessed dramas more complex than a Hong Kong soap opera: skinny teenagers jumping into a beat-up Nova, their swearing, short-changed waitresses close behind; Annie and Violet leaning against the door jamb, sipping margaritas and discussing facelifts; cocktail waitresses kissing customers in the parking lot; the owners' teenage daughter sobbing by the side of the building while her father screamed at Bucket, the bartender, inside. As a visitor, I was able to experience this world without actually being a part of it. I remained detached, a little girl waiting for a ride home.

Once I started working at the restaurant, my perspective changed. The restaurant began to affect me in a deeper way. Its sights and sounds, its scent, its very essence seemed to become a part of me. My sleep and hunger patterns adapted around the restaurant's hours. I started to confuse the aroma of soy sauce with my own sweat. I loved and hated the restaurant for this intrusion—although these emotions, like those involving my family, remained largely unacknowledged and unexplored. In the fourth grade, I only knew that the restaurant was my punishment for misbehaving.

Every Friday after school I waited at home for Aunt Becky. She'd drive up with foil-wrapped hamburgers for us kids, a kiss for San, a warning glance for Aunt Bik-Yuk. Then, minutes before *The Brady Bunch* ended at four, we would leave for the restaurant, stopping to run errands along the way—to King Soopers if there was a sale, to Safeway other times. Pushing the shopping cart down supermarket aisles, I came to anticipate Aunt Becky's movements: produce first, meat and poultry next, dairy on the way out. If she paused to buy a bag of oranges, I knew our list was short—no need for chickens. If she told me to grab a few bundles

of scallions, I knew that business had been good, and we needed everything—bok choy, potatoes, a few tubs of sour cream, every chicken in the store.

On Saturdays, my parents and I left for work early, to open up. Aunt Becky and Uncle Andy slept late. Jeffery snorted baby snores from my parents' bed. Aunt Bik-Yuk groaned and rolled over when Mother poked her head in to whisper good-bye. Only San was awake when we left, seated in front of the Saturday morning cartoons with the volume turned low. He mumbled good-bye, pretending he wasn't holding Snoopy, his battered stuffed dog. Father drove slowly in our new mustard-colored Buick LeSabre. He didn't get his license until I was in the third grade, and he always operated the car with the meticulousness of a new convert.

The twenty-minute trip down Monaco Parkway to Casey's Palace showed me a different part of America, one where people lived in big fancy houses and drove shiny new cars. The change from Jasmine Street to the wealthier neighborhoods was gradual. First we passed McMeen, a softball field, squat apartment complexes where I imagined young singles living. Further down, on our left, there was the public pool at Cook Park and a K Mart. About two blocks later, at the intersection of Monaco and Yale, the strip malls disappeared. The area became more residential. Two- and three-story houses lined both sides of the street. Polished foreign cars were parked out front. Intersections no longer occurred in a strict grid pattern, as in our neighborhood. Here, the roads sprouting off of Monaco curved, so I couldn't see past the corner. There were signs reading No Thru Traffic. I guessed that there were fancier houses beyond, hidden like castles in a fairy tale. I craned my head, hoping for a glimpse.

I had a designated seat in my father's car, the right rear. Every Saturday morning I rolled the window down until it caught, leaving five inches of child safety barrier poking up. I wanted to stick my head out the window, above this silly barrier, but Mother told me that passing cars amputated protruding body parts. (She

claimed it was in *Sing Tao*.) So I settled for curling the first joint of every finger over the edge of the glass barrier. I pressed my chin against it, too, so that only my lip stuck out. I rode this way every Saturday morning, watching the big houses zip by, imagining the lives inside.

We got to the restaurant sometime between ten and ten-thirty. We walked in the side door, waving at the day-shift bartender, craning our necks to count the number of customers seated at the bar. "Wah! Three drunks so early!" Mother might comment. On other occasions, she would make a disgusted noise, saying, "No one at all! Ronnie looks so bored! Why does Casey bother hiring anyone for this shift?" From her voice, I didn't know which was worse, to have a lot of drunks or none at all.

My parents let me read on the back stoop while they started setting up. The first thing Father always did was brew a fresh pot of coffee. "So strange," Mother would mutter, watching him. "Chinese don't drink coffee! Whoever heard of such a thing?"

"Aw, don't make such a fuss!" Father would grumble, waving her away.

After his first cup of coffee, Father began preparing food for the steam table: fried rice, sweet and sour sauce, brown gravy, mashed potatoes whipped from boxed flakes, wonton broth, and soup of the day. Six tureens in all. At night, a banana-scented white cream sauce, the topping for sesame chicken, replaced the mashed potatoes. Other than that, only the soup varied—New England clam chowder on Fridays, chicken noodle on Saturdays, egg drop on Sundays.

As soon as the mashed potatoes were ready, I rushed inside. Standing at the steam table, I scooped an unnaturally white ball into a soup cup and ladled gravy over it. I quickly ate off the top third and poured more gravy in. I beat the mixture with a spoon until the potatoes were no longer stiff and white. I was trying to achieve the perfect limp, beige paste, which I consumed in slow, tiny spoonfuls. Week after week I experimented with potato to

gravy ratios, until the final concoction was more gravy than potato.

Once I finished my potatoes, it was time to work. At that age, I was assigned the dishes. I put on a full-length white apron, looping a half-knot in the halter to shorten its length. I pushed through the single swinging door that opened into the restaurant's public regions.

On the other side, everything was dark brown or deep red. The dining room was corralled off with double thicknesses of plywood to form walkways along its perimeter. Straight ahead, a carpeted hall led to the bar. Four doors ran down the right wall: basement, men's room, women's room, and parking lot. On the opposite side, the blank panels stopped about four feet up, replaced by thin wood lace that ended a foot from the ceiling. The punched-out pattern of spears and arches was so regular that it could only have been mass-manufactured. Irrationally, I loved this design; I liked to stare at it until the shapes resolved themselves into the exaggerated eyebrows, eyes, and mouth of a clown.

Immediately to my left was another hall, perpendicular to the first. It doubled as a service area, where waitresses called orders through a window to the kitchen. It was the limbo between kitchen and dining room, separated from customers by plywood panels painted a sticky-looking brown. We taped work schedules and copies of lunch and dinner menus on the waitstaff side of the wall. The waitresses added horoscopes and comics clipped from the *Denver Post* and *Rocky Mountain News*. Lighter patches of brown, where tape had pulled off, dotted the wall like heat rash.

There were two entrances to the dining room along this wall, one on either end of the service hall. A three-tiered metal cart parked near each doorway, gray plastic tubs bunked on the shelves. Busboys placed dirty dishes in these bins, filling the top one first and moving downward. We usually put a small basin of soapy water in the top bin, for silverware, but the waitstaff frequently forgot (or were too busy) to use it.

To get the dirty dishes, I pulled the top tray out about six inches and propped an empty tub between it and the wall. When I lifted the full tray, the empty one slid down to take its place. Then, holding the full tub between my body and the cart's edge, I removed the silverware from its presoak and set the basin in the empty top tray.

I returned to the kitchen, backing through the swinging door. The tray's hard plastic handles pressed uncomfortably against my fingertips, and I clenched my hands, struggling not to drop the dishes. A fully loaded tray could weigh over thirty pounds, so sometimes the busboys helped me. But usually I got around the problem by emptying the tubs frequently or redistributing the dishes among bins before lifting them.

Back in the dishwashing station, I set the tub on a stainless steel counter next to the sink. Inside the tub, plates and saucers clanked. Red and brown sauces covered everything. I chose a dish, scraped, and rinsed. Again and again, until I was left with the leftover food at the bottom of the tub. I shoveled the slop into the garbage can with my fingers. The vinegar sting of sweet and sour burned my nose. Wet food puckered my skin. I wished for a weekend at home.

One day Mother carried in a half-full dishtub for me. A platter of egg foo yung balanced on top, two hard, round omelets unsullied by cigarette ash or coffee runoff. She removed it from the tub and walked away. I wasn't curious enough to question her. I started washing the other dishes, dumping cold rice lumps in the trash, dividing spoons, forks, and knives into their individual bins, rinsing the plates and stacking them in the sanitizer rack. When the tub was empty, I nozzled it off and returned it to the service corridor. There was a lull in the lunch rush, so I came back empty-handed. I sat outside to read my book.

Mother's voice broke my concentration: "Do you want some? It's pretty good." When I looked up, I realized that she was eating

the leftover egg foo yung. I was surprised and a little disgusted. I must have made a face, because Mother said, "Don't worry, it was clean. Cold, but I fixed that with some fresh gravy." She cut into an omelet with the side of a serving spoon. "Do you want some?" she offered again.

I opened my mouth like a baby bird. My family never ate the same food as the customers, and I was curious. Whenever I asked my parents about the menu items, they told me that the dishes were no good—crazy *gui* food. I never questioned their judgment, only wondered why people would pay money for bad food. Here was my opportunity to find out.

The egg foo yung was a shock. It turned out to be cold and oily, hard with bits of ham and bean sprouts. Only the gravy made it palatable. I wouldn't have eaten it under any other circumstances. But tasting it behind the kitchen, I ingested magic. I suddenly understood how it felt to sit in the dining room, to command rather than serve.

After that day I staked out the dishtubs for leftovers. I watched the waitstaff clear tables. I grabbed tubs as soon as the plates landed. Back at the dishwashing station, I examined my booty: Fried rice, who cared? I could have as much of that as I wanted. Sweet and sour pork, gross, no wonder they threw it away. Moo goo gai pan, I liked that, but part of it had spilled. I wondered how dirty the bottom of the tub was. I looked up. Nobody was watching. I picked a few pieces of chicken out of the spilled mess and ate them.

Sometimes I ate the congealed fried nuggets of sweet and sour pork anyway. Sometimes I rinsed off blatantly dirty food and consumed it. We all did some version of this. The waitresses picked off the platters' edges before delivering orders. They held back parts of leftovers packaged to go. When we served surf-'n'-turf, my father parceled out the shell of the lobster tail, heavily dipped in butter. The recipient gnawed at the minuscule pebbles of meat caught in the recesses.

A weird camaraderie developed between the kitchen and the waitstaff, transcending language and ethnicity. If a customer left something good—steak cubes or the open mouths of shrimp circlets split lengthwise—we shared it. The waitresses and my family couldn't afford to buy these luxury items for ourselves, so we became vultures, bottom feeders. It was torture, dishing out extravagances we couldn't have.

Only the busboys were immune. A seemingly endless procession of all-American boys staffed the restaurant. It was a bizarre circumstance that these boys ended up working for us, because their own families were so much wealthier. They came from the neighborhoods surrounding the restaurant, "new money" families who insisted that their children work for pocket money. These boys would start out as dishwashers one summer, be promoted to busboys by the next, and eventually move away when they finished high school.

The summer I was ten, on the cusp of adolescence, I noticed that they were kids—older than me by just four or five years. I immediately began to adore them. I loved their shaggy blond heads, the handsomeness of their adolescent good health, their rough-and-tumble affection for each other. Most of all, I adored them for taking the time to tease me as if I fit in. Whenever they caught me reading out on the back stoop, they quizzed me about the book, asking increasingly ridiculous questions until I put it down to chase them around the parking lot. They fetched me Cokes from the bar. Sometimes they let me sit behind them on their brand-new mopeds, and we zoomed around the block until the end of their breaks. To this day, I can remember their individual names—Gary, David, Danny, Mike, Gunnar, Terry—but not one detail about who did what.

Only Danny remains distinct in my mind. We used to schedule two dishwashers on Fridays and Saturdays, one on the other

nights. One Friday night business was unexpectedly slow, so Danny agreed to let the other dishwasher leave early. Not long after, we got a sudden surge of customers, and Danny had trouble keeping up. From my perch outside, I heard my family yelling at him for more plates; we had run out of everything. Without thinking, I put down my book and went to help Danny through the rush. *It'll be just a few minutes, maybe an hour*, I thought. But business never slowed; we ended up working together for the rest of the night. Before he went home, Danny asked Becky for that night's wages—Mondays being the usual payday. He found me outside and shoved some bills in my hand. I stared at him, open-mouthed. Nobody had ever expressed appreciation for my labor before, much less paid me for it. I would have walked across the backs of alligators in sulfur swamps on the hottest day of hell for him.

The restaurant boys became surrogate brothers. Mother approved of them, even though they were white. She didn't understand their religion, but she was careful to serve them fish on Friday nights. She was as proud as their own mothers when they quit working for us to attend one or another of the state universities. When the boys came back to visit during their summer vacations, Father would ask about their studies in a mixture of pantomime and English: "Terry, you go business or teaching?" Or he would reminisce, laughing so hard he could barely stand: "Gunnar, you new shoe on car!" (Recalling the time that Gunnar lost a new pair of shoes when he drove off with them on the roof of his Jeep.)

Every year we assumed that the oldest boys would leave us for college. I had never known people like them before. They led me to believe that in time I too would go. I relished this dream of freedom, the belief that I would eventually become *normal*, as American as the restaurant boys.

These boys were my anchor when Nancy and I fought, when she banned me from church, when her family moved away. They flirted with me when the boys in school didn't. In their company,

I forgot that I was lonely. More than Nancy Drew, more than *The Brady Bunch* and *Father Knows Best*, they were my education on the meaning of childhood in this country.

The restaurant became my preferred home. The native term for China means "middle kingdom," an equally accurate description of Casey's Palace. It was a country where my family and the rest of America coexisted. It forced my parents to form relationships with non-Chinese. There, I didn't feel like the solitary mediator between two worlds, isolated by my dual affinities. I was not constricted by responsibility to my parents. I was not obliged to observe rather than participate, translate rather than speak. The restaurant was the one place where I expressed myself. My nerves felt refreshingly raw.

I spent every weekend at the restaurant for the next two years. For two years I scraped dishes, read on the back stoop, and chased busboys around the parking lot.

Then, with the abruptness of a fall, my childhood ended.

It happened the winter I was in the sixth grade. I came home one day to find Mother seated stiffly on the living room sofa, staring blankly ahead. When she looked at me, her eyes remained unfocused.

I greeted her: "Mother." I started toward the kitchen to get my snack.

She said, "We have to move. Your father doesn't have a job anymore."

I stopped. She must be joking. "What happened to the restaurant?" I asked.

"Your father and Uncle Andy had a fight. That Uncle Andy! He hit your father with a spatula! You should see the mark on his neck! He could have died!"

This didn't make any sense. I asked again, "Mother, what are you talking about?"

"We're leaving. We're moving. Your father doesn't have a job. Go pack."

My stomach clenched. I couldn't eat a snack if I tried. Very quietly, I went downstairs. I lay down on my cot and howled. I didn't get up for supper that night. I hadn't cried that hard since my father left Hong Kong.

8

Aurora

I refused to leave. Did my parents hate me, or was it their duty to ruin my life? They had no idea how hard moving was, the excruciating *blankness* I experienced. The terror of sensation without words, being caught between languages with no way to explain how I felt—this is what I remembered about immigration. It was like devolution, being stripped of all control until I was a soft pink slug that could only curl in on itself for protection.

I was afraid that moving would erase my identity. Aunt Becky's house, Casey's Palace, McMeen Elementary School. They were landmarks of the self, grounding me at those times when I needed to look up and assess where—and who—I was.

But Mother said that we had no choice—Aunt Becky was kicking us out. A fight with Uncle Andy was serious, worse than any disagreement with the women of the family. Even though Aunt Becky handled all practical matters around the house and restaurant, Uncle Andy was still the official head of the family: He was eldest, he was male. Aunt Becky had to take his side.

I wondered where Father was going to get another job. He relied on the goodwill of other Chinese immigrants for jobs, because he didn't have the language skills to negotiate with

American employers. But since coming to America, he'd lived with my aunt. Everyone he knew, he'd met through her. I was sure that all their friends would support her. My father was a changed man. He didn't laugh at everything the way he used to. He didn't sew the buttons back on my clothes or tend the bean sprouts in the laundry room. He moped around with red eyes and a cigarette dangling from his lips.

"What are we going to do?" Mother kept asking. "How will we manage?"

Father snapped, "Will you shut up? How can anyone think with you talking?"

Sometimes he went to Hip Sing. "Why?" I asked my mother. "Is there a party?"

Mother answered, "No. He's hoping to meet someone who can give him a job." She turned away, silencing any further questions.

One night I was getting ready for bed when I heard him returning. I ran from the bathroom to greet him. "Father?" I whispered anxiously, watching him kick off his shoes by the front door. But instead of laughing a reply, he shook his head, his face pinched as if ready to cry. Mother quickly shooed me off to bed, admonishing, "School tomorrow."

I crept around the open basement door, letting my feet thump on the stairs. Mother yelled, "Yee! Not so loud! Are you crazy?" My feet silenced. My parents resumed their conversation, not knowing how I waited on the third step, ears strained for news about our future.

"How did it go?" Mother asked.

Father breathed a long, shaky sigh. "Nothing yet. I sat at Hip Sing all day. You know how that goes—people come by, have a cup of coffee, a bowl of soup, talk a little. Everyone knows I'm looking for a job, no one's heard of anything . . ."

"And a place to live?"

"No, nothing there, either." His voice broke. He coughed. There was the sound of a lighter striking, the scent of tobacco smoke.

Mother said, "I don't know what we're going to do . . ."

Father said, "I don't either."

Their desperation was palpable even at a distance. I couldn't stand their frailty. Very quietly, I snuck down the stairs into bed. I hoped my parents didn't hear.

After a few weeks, Father found a job in northwest Denver, at a restaurant called Dahlia Lounge. I knew it well. Back when we used to sell home-grown bean sprouts, Father and I drove to Dahlia Lounge twice a week, delivering their orders. It was a small, divey place, more bar than restaurant, but the cooks had always been nice to me. They used to give me pieces of apple pie. So I was glad he would be working there, even if it wasn't Casey's Palace.

We still needed a place to live. There weren't many options in Aunt Becky's part of town. Everywhere we looked, the rent was too expensive, or the landlord didn't allow children. Finally, Aunt Bik-Yuk suggested Aurora, a city outside of Denver, about half an hour from McMeen. Her telephone friend, Grandmother Wong, rented a house there, only seventy-five dollars a month. Grandmother Wong said that the house next door was available for the same price.

We drove out the next day. Jeffery cried the whole way, beginning to understand our situation. "I don't want to move," he sobbed. "If we live in Aurora, I won't be able to see Brian. He's my best friend!"

"Shh, shh," Mother soothed, "what about John? You remember him, from Hip Sing. His family lives in Aurora, next to the house we're looking at."

"He's too *little*," Jeffery wailed. "He's only three! I'm five!"

Mother said, "Little Fee, I think John's four."

"He's still too little," Jeff insisted.

I had my own concerns. "Mother," I whispered, "if we live in

Aurora, where will I go to school? I want to stay at McMeen."

"You can transfer," she assured me. Her voice was deliberately cheerful. "Remember? Auntie Wong has three children your age. You can go to school with them."

I stared out the window. I didn't want to transfer. If I lost McMeen, then I'd lost everything—Jasmine Street, the restaurant, my hard-won sense of security. I didn't deceive myself into believing that I'd become popular at McMeen, but at least I knew how to survive there. I'd made it through three years of busing. I'd identified the bullies and the "cool" kids. I knew which classmates to turn to when the teasing got rough. I had a niche: I was never an insider, but I wasn't completely isolated, either. I sat on the fringes, politely sniffing the popular girls' bottles of Love's Baby Soft perfume and listening to debates on the merits of Shaun Cassidy versus Parker Stevenson.

I knew that these moments, more than any words on any spelling list, defined the true American language. Communication relied on cultural cues I was only beginning to understand. I watched McMeen's children: In the sixth grade, about half their families were divorced. I pretended that my parents had separated. I avoided mentioning them in the same sentence. I said things like, "I spent the weekend with my father"—neglecting to mention that my mother had been present as well. I noticed that a lot of kids chewed their fingernails. For a week I tried it myself, lapsing when I forgot that it was supposed to be a habit. When the girls gathered to compare notes on their crushes, I faked infatuation. Although I had no interest in the boys, I compiled my own list, based on the top two or three choices from everyone else's.

I didn't know whether the kids at another school would have the same language. I was afraid to find out. I was afraid that the blankness would return and I would lose all that I'd worked for. I had no way to explain these fears to my family. Terror manifested as stubbornness. I repeated blindly, "I want to stay at McMeen."

Mother shook her head. My insistence went against all that I'd

been taught about family. Duty and obedience were the foundation of our value system. "You have no sense of maturity," she scolded in a low, mean voice. "This is what comes of living in America, children disobeying their parents—"

Father cut her off: "Shut up! Fussfussfuss, talktalktalk, that's all you women ever do!"

Mother glared at me. "See what you've done?"

"Shut up!" Father roared again. We all silenced.

We parked in front of the Wongs' house. The younger generation—Auntie Wong, Uncle Wong, and their four children—lived in a conventional house facing the street. It was approximately the same size and style as Aunt Becky's. Grandmother Wong lived in a smaller house in their back alley. The house we'd come to see was in the back as well.

We ran the Wongs' bell. "Ah, so good to see you!" Auntie Wong greeted. Mother gave her a bag of oranges. Auntie Wong responded on cue, "Too kind! This wasn't necessary!" She set the bag in the kitchen and called out to her three older children: "Marina! Peter! Laura! You watch Jeah-Fee and John. I have an errand to run."

I followed the adults out of the house, automatically understanding that I wasn't allowed to play. My parents had brought me to translate, not to visit. Auntie Wong led us down the street. "The landlady's a nice person," she said. "A *gui*, but very fair."

The landlady was a heavy-set, white-haired woman in her fifties. She smiled at my parents. "I've heard about you," she said, jingling her key ring. "I sure hope this house works. The Wongs are such nice people. I'm always happy to meet their friends."

I was too nervous to say anything.

We walked into the alley, stopping in front of a small white house. The landlady unlocked the door. I exhaled in shock. Walking in the door, without straining my eyes, I could see into

every corner of the house. It was tiny, no larger than Aunt Becky's living room and dining nook combined. There was one bedroom, a bathroom, kitchenette, and living room, all flush to one another, no halls. The walls were yellowing. The floor didn't look quite clean. In the bedroom, there was a sagging queen-sized bed. It nearly filled the room, leaving no space for dresser or night stand, no space for doors to open or people to walk through. In the kitchen, there was a chipped formica table and two greasy-looking chairs. The toilet bowl was rust-stained. The whole house smelled like mildew.

I retreated out the door. It was no better outside. There was no yard, only a concrete area shaded by the roof's overhang. The landlady called it a covered porch, but I knew it was a carport. I was certain that the house had been converted from a garage.

Mother opened the door. "Yee, come here, help me." I went back inside. Mother said, "Ask the woman if the rent covers utilities."

I did. The answer was yes.

"Ask if she'll leave us this furniture."

I wrinkled my nose. I wanted to gag, but I did as I was told. Again the answer was yes.

Mother breathed out in relief. "The refrigerator, too?"

Yes.

"So lucky!" Mother murmured. "What would we do if we had to buy furniture? We could never afford it!"

Father cleared his throat. "We can live here, then?"

Mother said harshly, "What else can we do? What other choice do with have?"

My father didn't answer.

Mother continued, "It'll work, on a temporary basis. Fee can sleep with us in the bed, it's big enough. We'll put Yee's cot in the living room."

I started to protest, "Mother . . ."

She hushed me, "Wait a minute, I'm thinking." She turned to

my father. "For seventy-five dollars, we can make do, isn't that right? We'll look for a bigger place later, when we have time."

Father wore the pinched expression that had become so familiar lately. His eyes were red, his lips pressed tight. For a minute, I thought he was going to cry. "Yes," he answered roughly, "we'll make do."

Mother continued, "Until we know where we'll be living permanently, we shouldn't change Yee's school address. We'll use the old address. Becky won't mind. She can't begrudge us the one favor, not when it's a child we're talking about. A child and school, families pull together for that."

Father coughed. "I'm sure she won't mind."

"Where will I live?" I whispered, panicked. Suddenly I wasn't so sure that I wanted to stay at McMeen.

Mother said, "I'll find someone to take you in." She hesitated. "Auntie Louie, perhaps. Do you remember her from Hip Sing? The one with two little boys Fee's age. They live in the apartments near Target, walking distance to McMeen. Maybe we can ask her."

"If we offer them something," Father suggested, not looking at me.

"When will I come home?" I asked, nearly choking on my words. I didn't want to leave McMeen, but I didn't want to leave my parents, either. How could I live with strangers?

Mother said, "Your father gets Tuesdays off. He'll pick you up after school and bring you home for the night, drop you at school Wednesday morning. And he'll ask his boss for a few hours on Friday afternoon to go get you, so you can spend the weekend here. Monday morning, he drives you back to school."

I bit my lip, fighting back tears.

Mother closed her eyes. "Yee-daughter, there's no point in crying. We can't change the situation. We make do, that's all. O-kay?" Her voice sounded tired.

Very quietly, I said yes.

Mother said, "That's good. Be mature. Take good care of your brother. Never fight with him this way." She looked pointedly at my father.

He didn't speak. Keeping his eyes averted, he fumbled for his wallet. He slowly counted out our first month's rent.

We moved in the middle of February, three weeks after Father and Uncle Andy fought. Before leaving, I helped San write Valentine's Day cards for the kids in our class. I read all his comic books. I looked up everything I could think of in his encyclopedias—epilepsy, Egypt, Down Syndrome, dogs, penicillin, pasta, psychosis, schizophrenia, antibiotics, asthma, the Bermuda Triangle.

I visited Mrs. Brown and the Etos. I walked by Nancy's house, remembering her Barbies and the church bus. "Good-bye," I whispered, suddenly glad that she'd moved.

For our last meal, Mother cooked beef bone soup, San's favorite. We ate in silence. My father was red-eyed. Jeffery pouted. San looked like he was going to cry. Sniffling, Mother urged San to have a third helping. She said, "It might be a while before you have this soup again." San nodded and held out his bowl.

The next morning, before Andy and Becky awoke, Father loaded our things into the car. Blankets, clothing, matching brown and pink teddy bears, half a dozen Nancy Drew mysteries, my cot, a twelve-inch black-and-white TV, a box of dishes we'd brought from Hong Kong. We barely filled the car. "Easier this way," Mother said brightly. "Who needs a lot of things?"

Father turned the ignition. "We'll borrow some chairs from Auntie Wong."

"We have Yee's cot," Mother added. "So who needs a sofa? We'll have a place to sit during the day."

Father said, "A TV, that's luxury! See how lucky we are?"

I sat silently in the back seat, watching all that I knew of America disappear.

* * *

The houses seemed smaller in Aurora; the yards dustier; the boulevards, with their constant flow of traffic, closer. I gritted my teeth, willing myself not to cry. Jeffery was sniffling in the front seat. My parents were absolutely quiet.

The street signs rolled by. The car turned left, into an alley. Another half-block, and we'd arrived. We pulled up next to the seventy-five-dollar house, the Buick fitting neatly into the space our landlady had called a "covered porch." We were barely out of the car before the Wongs came running through their back yard to greet us.

"You made it! So fortunate!" Uncle Wong exclaimed.

"You're too kind," Mother responded. "How did you know . . ."

Auntie Wong said, "We were watching from the back windows. We thought you would need help unloading."

Father flushed. "There's no need; we don't have much," he mumbled, gesturing at the car.

"Oh, everybody needs a helping hand," Auntie Wong said. She laughed suddenly and turned to her children. "Where are our manners? Peter, Marina, Laura, John, say hello! Help Uncle and Auntie Mar!"

The children rushed forward. Minutes later, boxes cluttered our living room, clothing, blankets, and teddy bears everywhere. "Too kind, too kind," Mother kept saying. "I should offer you a chair, something to eat." She looked helplessly into the kitchen, where the landlady's two chairs seemed to grow dirtier by the minute.

Auntie Wong waved her aside. "Ah, no need! You get settled first." She squinted at the screen door. My father and Uncle Wong were outside, leaning against the Buick, talking too softly for us to hear. The Wong children and my brother were beyond her vision, having returned to the Wongs' house.

Auntie Wong smiled at my mother. "Come over for supper," she

invited. "You have so much to do here—I know you won't have time to cook."

"Too kind," Mother said again. Her voice was hoarse.

Auntie Wong touched my mother's arm, an unexpectedly familiar gesture. She said, "Don't be polite. I mean it."

Mother nodded. Her eyes glistened.

"Good!" Auntie Wong moved across the room briskly. She started out the door. "Marina will come get you when supper's ready." Her tone was overly cheerful, compensating for the previous intimacy.

The door clicked shut. I heard Auntie and Uncle Wong say good-bye to my father. There was a brief silence, then the slam of a car door, the roar of its engine. I opened the screen door. "Father?" I called.

Behind me, Mother said, "He needs to get to work."

I turned. "He didn't say good-bye," I choked out forlornly. My chest hurt. I missed the father who used to laugh and tease.

Mother said, "Don't you worry about him—we don't have time for it." She shoved a box in my direction. "Be a good girl and help me unpack."

I got to work: Dishes in the kitchen cabinets, clothes in the front closet, my cot in the living room. Mother scrubbed the floors. I wiped down the counters. By dusk we'd finished; there was only the trash to take out. I stacked the empty boxes.

"No," Mother said suddenly. She pushed me aside. I dropped the boxes. Mother knelt down beside them.

I watched her dig through the wadded-up newspapers and crinkled plastic bags. Confusion churned in my stomach. "Mother, what is it?"

She didn't answer, only continued to sort through the debris inside the boxes. "Where are they?" she muttered. "Where did I put them?"

I watched her anxiously. "Mother, what? Tell me, what? I'll help you look."

Mother sat back on her heels. Her eyes were moist. "Don't worry, Yee," she answered softly. "It's nothing important, nothing for a child to worry about."

My breath caught in panic. In the last three weeks, I'd learned that *everything* was important, *everything* was worth worrying about. "Mother, tell me. *Tell me.* What is it?"

She wiped her brow with the back of one hand. "Yee, I told you—it's nothing important." She paused. "Just . . . the lucky figurines. Remember? We brought them from Hong Kong." She looked into an empty box sadly. "Such a long day," she mumbled. "So many changes . . . so tired . . ." Her voice faded away.

The figurines. A small, tangible loss. Something we could remedy. I felt my body relax. I grabbed a nearby box. "Mother, don't worry, we'll find them. They're here somewhere."

My mother did not answer me. And though I searched for the rest of the week, I did not find them.

On Sunday night, Mother packed my pajamas and a change of clothes in a brown paper bag. "Go get your school things," she said. "Paper, pencils, library books. Remember to behave yourself, and don't spend any time alone with Mr. Louie, that's the most important thing. If you walk into a room, and he's the only one there, you leave. Do you understand me?"

I gathered my things. "Yes, Mother."

For reasons unclear to me, the Louies had agreed to house me during the school week. Their apartment was a twenty-minute walk from McMeen, just beyond Denver's city limits, in a town called Glendale.

"Don't let anyone know where you're living," Mother cautioned. "If anyone asks, tell them you still live with Aunt Becky. What we're doing is illegal. We could be put in jail."

"Yes, Mother." My head hurt with the abundance of details: Help the Louies with housework. Never raise my voice. Eat spar-

ingly. Be kind to the two little boys. Don't tell anyone where I live.
Don't stay in a room alone with Mr. Louie, and never, ever, let him
touch me.

"If anything happens, you tell me," Mother instructed. "If Mr.
Louie messes with you, if he touches you in any way, you let me
know, do you understand?"

"Yes, Mother."

"Repeat it back to me."

"Don't stay in a room alone with Mr. Louie. Don't let him touch
me. If he messes with me, I tell you."

"Good. Tell me again."

"*Mother*," I groaned, but she insisted. I repeated the three sen-
tences for nearly an hour.

By the time I met Mr. Louie, I was convinced that he was a per-
vert. I was so scared that I couldn't look him in the eye, much less
sit in a room alone with him. At supper, I was horrified to find
myself across the table from him. I was so repulsed by his oily lips
and sweaty forehead that I could barely eat. I was too busy won-
dering, *What does he do to little girls?*

Mrs. Louie gave me a worried look. "Don't you like the food?"

"Oh, yes, I do," I answered politely. I couldn't take my eyes off
Mr. Louie's fat, oily lips. Jiggly bits of boiled cow's blood slith-
ered between them. Mr. Louie sighed with contentment. I nearly
retched.

"It's cow's blood," Mrs. Louie explained, misunderstanding my
fascination. "Only for adults. Men, not women or girls. It helps
their spirit."

"Uh-huh." *What does he do to little girls?*

"Do you want some? I suppose we could give you a taste. It
wouldn't hurt."

I shook my head. *What does he do to little girls?*

"Eat up, then."

"Yes, thank you." I swallowed a mouthful of rice. *What does he
do to little girls?* I wondered if all men were evil, or just Mr. Louie.

*　　　*　　　*

The Louies lived in a two-bedroom apartment. I shared a room with the Louies' young sons, Stanley and Jason, ages four and six. There wasn't any furniture in their room, only two mattresses on the floor. Jason and Stanley shared one, while I slept on the other by myself. To the boys, I was a curiosity, and they hounded me relentlessly, following me around the apartment, jabbering, "What are you doing? What are you doing?" Whenever I tried to read, they snatched the books out of my hands. I was miserable.

One day I discovered that I fit on the top shelf of the boys' closet. For a week I hid there with the lights on and the door closed, reading. I would sneak into the closet right after supper and not emerge until bedtime. No one knew where I was. No one looked for me. I was safe until I became careless and climbed down while the boys were in the bedroom. They thought I was playing hide-and-seek, and became more rambunctious than ever.

I tried spending time away from the Louies' apartment. After school, I went to the public library, nearly a mile in the other direction. The walk back was long, but I didn't mind. I didn't mind walking two miles in the dark. I didn't mind anything, as long as it meant less time inside the Louies' apartment. I knew I was being ungrateful, but I didn't care.

After a while, I realized that I could go home with San. The adults worked, so the house was empty during the day. Nobody would know that I'd been there. Without premeditation, almost by instinct, I fell into step beside my cousin after school one day. San didn't question my presence. He, too, seemed to forget that I shouldn't be there. We walked and talked and fell silent and talked again, swinging our book bags the entire way. It felt so natural, I half-expected to find Mother inside, waiting with our afternoon snack. Then San unlocked the door, and I was jolted back to reality. The house was empty. I walked through the living

room silently, touching the old familiar things, sofas and tables and Buddhas I hadn't seen for over six weeks. It was like waking up inside my own dream. Objects seemed unnaturally vivid.

San didn't notice my disorientation. He made himself a snack and turned on the TV. I crept downstairs to my parents' old room. It was eerie—familiar yet alien. There were no traces of my family. The bed was stripped, the nightstand empty. A thin film of dust covered the bureau surface. I opened a drawer. There, in a row, looking forlorn, were our lucky figurines. Mother had forgotten to pack them. Acting on impulse, I shoved them into my book bag. I didn't care if Aunt Becky called me a thief. She'd made my family unhappy enough. She had no right to keep our figurines, too.

My face burned. I was trembling. I wanted to break the bureau mirror and write on the walls. I wanted to rip holes in the mattress. I nearly choked on my anger. I ran out of the room before I could do any damage.

I wrapped the figurines in paper so they wouldn't break. In Aurora the following weekend, I hid them in one of Mother's dress purses. Then I sat on the cot-couch and clicked noisily through channels on our TV.

"Stop that," Mother scolded. She was sitting on her bed, reading an old newspaper. "You'll break it, and then what will we do? We have enough troubles as it is, no money, no furniture—"

I interrupted, "But Mother, there's nothing to *do*."

"Read a book."

"Nooo," I whined. "I want to play cards. Mother, let's play gin. Where are the cards?"

She laughed, an unexpected and welcome sound. "Crazy girl! How would I know? Everything's turned around since the move. I don't know where anything is."

I stood up. "Mother, come help me look," I coaxed.

"Oh, you crazy child, what am I going to do with you?" She rose slowly off the bed. "In the sixth grade, almost grown up, and you're still interested in silly card games." She shuffled out of the bedroom.

I darted to the closet and began poking around the upper shelves. Mother's face appeared in the doorway. "What are you doing?" she asked. "The cards wouldn't be up there!"

"You said you didn't know," I pointed out. "They could be anywhere." I held up a pair of shoes. "Mother, look at these!"

"Yee, are you insane? Those aren't playing cards."

"Yes, Mother, I know. I'm only admiring them. They're such pretty shoes. Why don't you wear them more often?"

She laughed. "Why would I wear them? Am I a queen? Where would I go in such nice shoes? You know they're only for parties."

I shrugged. "You should wear them more. They're pretty." I reached up again. "How about these?" I handed her two purses. "You should carry these purses, not let them go to waste."

"They're for parties," she repeated, shaking her head. She reached around me to put them away. Then she got a puzzled look. "How peculiar," she mumbled. "There's something in here."

She gave me the empty purse to hold. She unzipped the other one. "What's this?" She removed a paper-wrapped object, unraveled the paper. Her face changed. Her eyes were moist, her skin seemed to glow. "Your father," she whispered. "Your father must have packed them without telling me."

I didn't correct her. She looked too happy, too proud of my father.

My parents hadn't stopped fighting since we moved to Aurora. Every time Mother asked a question, Father yelled, "Talktalk-talktalk, that's all women ever do! Why won't you shut up?" If Father complained about the long drive to work, Mother muttered, "You should have thought of that before you fought with

Andy Wong." And if Mother needed help, she asked me, not Father.

One Saturday morning, Mother dragged me out of bed to help her carry home a coffee table from the Salvation Army store. "What about Father?" I mumbled, getting dressed. "Can't he help?"

Mother waved dismissively. "Oh, him! Wake him up, and we'll have all sorts of trouble. He'll fuss loud enough for the whole neighborhood to hear, who needs that? Let him sleep. Fee's at Auntie Wong's house, playing with John, so it's just the two of us. Come on, quickly!"

"What's the rush?"

Mother charged out the front door. She answered me over her shoulder, "We don't want someone else to take it."

I laughed, "It must be a special table."

Mother retorted, "Special nothing, it's free." She described how she'd been walking by the Salvation Army store when she noticed a pile of furniture in its parking lot. "It must be trash day," she mused. "But the things people throw away! The *gui* are so wasteful. Some of the furniture can still be used, it's hardly broken at all . . ."

As soon as Mother began talking, I knew she meant the donation dropoff spot outside the store. It was clearly marked with big red letters on a white sign. If she could read English, she would know this, too. I wanted to tell her, but I couldn't find the words. She sounded so excited. The truth would only make her unhappy. How could I point out how far we'd fallen? I knew we were picking through the trash or stealing from the Salvation Army, depending on how you looked at it. I wasn't sure which was worse. Wordlessly, I helped carry the coffee table home.

We continued to furnish the seventy-five-dollar house this way. Usually I was the one to help Mother carry home her finds, the

chairs, lamps, and dishes that people left by the Salvation Army store. On rare occasions, she required stronger arms and awoke my father, who would follow her out of the house grumbling, not cheered by the prospect of a free sofa.

I barely recognized my father these days. He only came home to sleep. He always woke up in a bad mood. Since the fight with Andy, he'd gotten in the habit of visiting Hip Sing. He liked to go once a week, usually after work on Sundays. "I'm going for a cup of tea, see how everyone's doing," he'd say, looking up at the clock. "Only ten o'clock now. I'll be home by midnight. Don't worry."

The first time, I asked, "Is there a party? I want to go, too!"

"Naw!" Father said. "I'm going to take care of some business, adult stuff. You won't have any fun."

I persisted: "Maybe Angie will be there."

"Naw! There won't be any children. You stay home, get to bed. I'll drive you to school in the morning."

"Okay," I agreed, watching him leave. As soon as the car pulled out, I asked Mother, "Why's he going? Who's going to be there?"

She scowled. "Rotten gamblers, that's who! Staying there day and night, playing mah-jongg and dominoes!"

"Not Father!" I breathed. "He doesn't gamble, remember? He only watches—I've seen him at parties, and I know he only watches."

"Who's to know?" Mother sighed. "Uncle Gok-Gong will be there—he cooks rice porridge for the rotten gamblers. So maybe your father's going to keep him company. Who knows? Don't worry about your father—it won't do any good. Go to bed."

I crawled into my cot, the next morning Mother woke me, and Father drove me to school. Over time, Father came home later and later. He would say midnight, but he wouldn't show up until four or five o'clock. In the morning I'd hear him grumbling when Mother woke him to drive me to school.

"If you didn't stay out until daybreak, you wouldn't be so

tired," Mother scolded furiously. "I don't care what you do, you're a grown man. It's your daughter's education I'm worried about. You have responsibilities, you know."

"Be quiet!" Father retorted, his voice heavy with sleep. There was a click, the sound of a cigarette being lit. The scent of Winstons floated over my cot. "Talktalktalktalktalk! Can't even smoke in peace."

Then one night Father didn't come home at all. I felt his absence as soon as I awoke. Our house was so small that he couldn't have slipped in without my knowledge. Any human presence there was palpable, each new body pressing the air tighter around my skin. I sat up and reached for my glasses.

"You don't need to look," Mother said. "He's not here." Her face was pale. There were lines around her eyes.

"School," I croaked. "What should I do?"

Mother snorted. "You can hope he comes to his senses. You can hope he'll come home in time to drive you."

"He'll come home," I said.

I dressed hurriedly. He would come home, of course he would. He would never let us down. He knew that my education was important. He'd be home soon. Mother folded my cot. I gathered my books. I sat on the Salvation Army sofa. I waited. It was eight-fifteen. If he came home now, we could make it to McMeen with fifteen minutes to spare. I could sit against the side of the building and read. He'd be home any second, I knew he would. It was eight-twenty, eight-twenty-five, eight-thirty. If he came home now, we'd make it just in time. I stared at the door. *Please, Father, come home. Please.* Eight-thirty-five, eight-forty. Now I'd get a tardy slip. I strained my ears for the sound of our car. The wind rattled our door. Across the alley, a rooster crowed. It was eight-forty-five. Eight-forty-six. Eight-forty-seven. Eight-forty-eight. No Father.

Mother called Hip Sing. Yes, he was there. Yes, he was on his way, leaving now. It was eight-fifty-five, nine o'clock, nine-

fifteen. Mother called again. Her face tensed. I could hear Father's voice radiating from the earpiece, shrill, angry. Mother's eyes were moist. I turned away. There was a silence. Mother handed me the phone.

"Father?"

The voice that answered was hoarse, hardly recognizable. "Yee? You be good, I'll be home soon."

I wanted to believe him. I whispered, "Okay."

"Bye-bye," he said. "I have to go now. You be good."

"Bye-bye." I hung up the phone. I had a sick feeling inside my stomach. For the first time, I realized that I did not believe my father.

I waited another hour before changing out of my school clothes. It was a rainy day, and we had nowhere to go, so I climbed into bed with my mother and Jeffery. She showed him simple addition flashcards while I read.

We ate lunch, we played cards, we watched TV. Mother called the Louies to let them know where I was. "No, he's never done this before," I heard her say. "He's not a rotten gambler, I won't let him . . . I don't know, talking, drinking tea, who knows . . . rotten . . . hanging around, gambling until dawn . . . so wild, so excessive . . ."

I turned up the volume on the TV. I knew my mother was wrong. My father was not a rotten gambler. He wasn't wild or excessive. He'd be home soon.

We ate supper. "Call Dahlia Lounge," Mother said. "See if he made it to work."

I called. When Father came to the phone, I said his name tentatively. "Father? You're there?"

"Yes, where else would I be?" he snapped. "What do you want?"

"I . . . Mother said . . ." I gave up and passed her the phone.

"So you're there," she said. She sounded sarcastic, and I flinched in surprise, upset by her tone. "Are you coming home tonight? . . .

I'm asking, what's wrong with asking? . . . I'll save you noodles . . . Yee has school tomorrow, don't forget." She hung up.

"Is he okay?" I asked.

My mother's face was red and harried-looking. "O-kay? Even if he's not o-kay, he has to be o-kay, what choice do we have?" She exhaled loudly. "You just be thankful your father still has a job. You be thankful he didn't forget to go to work after sitting at Hip Sing all night."

I stared at her silently, too confused to formulate a response. My family had never acted this way before—Father fighting with Uncle Andy, Aunt Becky kicking us out of the house, Mother picking up furniture off the side of the road, me living with perverts and noisy little boys, Father staying out all night, Mother yelling at him . . . I couldn't make sense of it, not even in little bits.

I twisted noodles around my chopsticks. There was nothing I could do but wait. Eat and wait. My life was completely out of control.

I was lying in my cot when Father's car pulled up. Mother and Jeff were sitting on the sofa, their legs touching the side of my bed. On TV, a rerun of *M*A*S*H* played. At the sound of our Buick, I started to sit up, but Mother stopped me. "Wait a minute," she said, "I'm going to the kitchen."

It didn't make sense—what did her going to the kitchen have to do with me sitting up? For once I didn't ask. I did as she asked. I lay there, limp, complacent, waiting.

Father walked in, shoulders slumped from lack of sleep, hair still Brylcreemed in place. "What are you doing?" he asked me softly.

I heard Mother puttering in the kitchen. Suddenly, for no discernible reason, I felt very scared. "TV," I whispered.

Father nodded. He took off his shoes and went into the

kitchen. He slid into a chair. Mother served him a bowl of noodle soup. He slurped it down. For a long time, nobody spoke. I could see Mother's eyes following Father's motions. I could see Father's head bent over the soup. Their presence felt impossibly heavy, pinning me to the cot with a force greater than gravity. I was helpless. My whole life depended on their movements.

Mother said, "Yee has to go to school tomorrow."

Father didn't look up. He slurped soup from a big china spoon. His lack of response stretched, elongated like a shadow through the house. I thought I was going to cry. I held my breath, counted seconds. Finally, Father nodded. He finished his soup, smoked a cigarette, and went to bed. The next day, he drove me to school.

Father went to Hip Sing three, four times a week. He couldn't seem to help himself. Around eleven o'clock on Friday night, he started fidgeting. He went outside to tinker with the car. He would take off from there, a natural progression, like the final sliver of a cake shaved off crumb by crumb, gone before you noticed what was happening. Inside, we heard the engine turn over, and Mother's mouth would tighten. "So mean," she'd whisper, "So wrong." It wasn't happening, I told myself, he'll come home soon.

If he held out Friday night, he'd go on Saturday, or on Sunday. We came to expect it without acknowledging his behavior. "Don't stay out too late," Mother told him as he stepped out for air.

He jerked his head around. His face contorted, somewhere between anger and tears. "What are you talking about?" he thundered.

Mother said softly, "I know where you're going."

He brushed her off with a gesture of his hand. "You're so meddlesome! Talktalktalktalktalk! That's all you do, talktalktalktalktalk! Leave me alone. I know what I'm doing. Keep silent!" He disappeared out the door, out of the driveway—to Hip Sing.

Mother stood in the living room, gazing out the door after him.

On Sunday nights, Mother said, "Don't expect to go to school." I couldn't respond; my voice was locked tightly in my throat. I went to bed early, although I knew she was right.

I began checking out extra books before the weekend. Sometimes I arrived in Aurora with a stack of four or five. I was missing a lot of school, maybe half a dozen Mondays, maybe more. Still I would awake pretending that Father was on his way home. I'd wait until ten before changing and climbing into my parents' bed to read. We no longer bothered calling Hip Sing.

I always wrote myself the same note: "Please excuse Elaine's absence. She was sick." Mother signed Father's name to it, explaining that her own name wouldn't count—she was a woman. My teacher, Ms. Nicholson, never questioned these absences.

I crawled deeper inside myself. I started reading library books during classtime. Once, I was so engrossed in my book that I didn't notice the other students leaving at the end of math class. I looked up at chapter's end to find myself surrounded by a whole different roomful of sixth graders. Ms. Nicholson was going over their homework. The child who usually sat in my chair for his math session had found an empty desk. No one paid attention to me, even when I hurriedly pushed back my chair and scooted out of the room.

9

Pocket Money

Aunt Becky's house haunted my imagination.

When the sixth grade ended, I moved to Aurora full-time. Every night I unfolded my cot in the living room and fell asleep next to the sofa where I'd been sitting only minutes before. By 5:00 A.M. I was startled into consciousness by the sound of roosters crowing as they awoke in their cages on Grandmother Wong's porch next door. I hovered between sleep and wakefulness until full daylight broke. I was never fully rested. I felt vague and incomplete, as if in the wings of a stage show, awaiting my cue.

I wasn't unhappy. Father was spending more time at home. He and Mother fought less. Jeff had stopped crying for Brian. We spent summer evenings with the Wongs, often sharing meals in their dining nook. I traipsed freely between their house and ours, not pausing to knock before entering. Father uncoiled the plumber's snake from his car trunk to clear their drains on his days off. On weekends Mother played mah-jongg at a table on their screened-in porch.

But these familiarities only heightened my sense of unreality. I felt like we'd slipped from one extended family into another,

with only a change in setting. I called Auntie Wong by the same familial term as Aunt Becky, although she wasn't a blood relative. Marina, the oldest child, shared my Chinese name, Yee. Lying on my cot at night, I wondered whether my identity was as mutable as these details. If I never entered Aunt Becky's house again, if I never touched the crayon marks on the playroom wall, if I never scraped my palm against the maple in the front yard, screaming "home base," what would happen to the girl who had lived there?

I longed to locate home as a place, rooted in soil like childhood safety markers. I wondered whether this trait was peculiar to immigrants. Or did everyone imprint, like ducklings, on the first landmark where they learned to say "I," realizing the self as individual? Did everyone burn the image of *home* on their retinas at that moment, terrified by their ability to walk away? Suddenly I understood Father's attraction to Hip Sing. It was his guidepost, as Aunt Becky's house was mine.

In mid-June, four months after moving to the seventy-five-dollar house, my parents resumed our housing search. On Father's days off, while Jeff played at the Wongs', my parents and I drove through our old neighborhood, looking for "VACANCY" signs. Each time we saw one, Father pulled over, and I got out to ask the standard questions: How much was the rent? How many bedrooms? Furnished or unfurnished? More often than not, I returned to the car with one simple message: No children allowed.

I dreaded the ride back to Aurora. Father would stare glumly ahead, smoking his way through a pack of Winstons. Mother would complain about the meanness of the world, always ending with the same refrain: "It would be so much easier if we didn't have children. We could live wherever we wanted. We could do whatever we wanted." Sometimes she turned to look at me as she said this.

I never knew how to respond. There I was, eleven years old, sitting in my designated seat, my head resting on the seatback, stewing in the silence of anger, confusion, and sorrow. I wanted more than anything to make things right, but I couldn't do the one thing my mother seemed to be asking—I could not disappear.

After weeks of unsuccessful searching, the Louies gave us a tip: A two-bedroom apartment was available in the building next to theirs. Children were welcome.

We took it immediately.

We moved in August, with the help of a friend of Father's from Hip Sing. Borrowing the friend's van, we loaded up our Salvation Army furniture and left the seventy-five-dollar house. Auntie Wong gave Mother a grocery bag filled with homemade Chinese dumplings. Grandmother Wong wished us luck in her whispery voice. Uncle Wong and the children shouted and waved as we drove away.

Father guided the Buick out of the alley and onto the main thoroughfare. He checked the rearview mirror for his friend's van. I rolled down my window and stuck my lip over the child safety barrier, glad to be leaving Aurora.

From the front of the car I heard Mother's voice. Its sound was distorted by the wind rushing in my ears. I sat back to listen more closely. "The Wongs are good people," she was saying. "They've helped us a lot." She choked out the syllables, her voice clouded by tears. I was shocked by my mother's show of emotion—we hadn't lived in Aurora very long, and I didn't recall her crying when we moved from Jasmine Street.

Our new apartment was three times the size of the house in Aurora. For the first time I had my own room (although my parents claimed my closet for general storage). We didn't have much furniture. I slept on my fold-out cot, my parents and Jeff slept on a mattress donated by Father's friend. The friend also gave us a

card table and two chairs. We set these up next to the sofa for meals.

After a week or so, my parents splurged and bought us beds. These were followed by a wood veneer dining table and six red chairs, the backs shaped like tulips. I bounced on my bed excitedly, too happy to ask how we could afford new furniture. I found out later that evening: Mother had gotten a job. Father's boss, Uncle Richard, was opening a new restaurant, closer to our part of town. He'd agreed to let both my parents work there, starting in September.

"We're very fortunate," Mother emphasized. "Your father won't have to drive so far, and we need the money." She paused to look me in the eye. "Yee, you must be very mature now; it's up to you to take care of Jeffery. You must set a good example for your little brother."

I shrugged. Jeffery chirped, "I'll behave." I tweaked his nose. He tickled me.

Mother sighed, "What did I just say?"

I groaned, "Mother! We're just playing!"

"Uh-huh. Just playing," Jeffery agreed.

Mother was not appeased. She said seriously, "You'll see—you need to be more mature now."

I rolled my eyes. So Mother was going to work and I'd be left alone with my little brother, so what? I leaned against Jeffery playfully. Giggling, he fell down. Mother shook her head.

In September, my brother and I went to school in two different districts: He started kindergarten at Holly Hills Elementary, in the Cherry Creek school system, where we were both zoned to go. I stubbornly persisted in using Aunt Becky's mailing address, in order to attend Hill Junior High with San and my elementary school classmates. I still harbored a fantasy of appearing normal to my white, all-American schoolmates, and I believed that I

could prove it—through time, through mimicry, through force of will and sheer desire. Now that I lived in a single-family household beyond the vision of San's friends, my fantasy seemed possible at last.

When I'd lived at San's, there had been embarrassing questions to answer: *Why don't you have your own room? Why do you sleep on a cot in the corner of the basement? Why don't your parents buy their own house?* The boys used to tease me in a way that I optimistically construed as flirtatious, even though, deep down, I knew they were just being mean. But I didn't have to worry about their mockery any longer. The word had spread that I didn't live with San anymore, and I was never, ever going to invite anyone to our apartment, so no one at school would know about our secondhand furniture, the fringed acrylic slipcovers from K Mart, the weird way Mother had of arranging our dining room chairs along the walls, as if we were perpetually waiting to see the principal. I hoped that the kids would imagine me in one of the houses on the Denver-Glendale border, the two-tiered ones with sloping lawns and basketball hoops over the garage. The houses where cool kids like Troy and Cary spent their afternoons, smacking pebbled rubber basketballs against the pavement of clean driveways.

It was only logical: Traveling along Exposition from Jasmine Street to the Glendale line, the houses became progressively larger. As far as I knew, Troy and Cary had never gone beyond their row of houses, past the vacant lot and wood-shingled apartment complex that divided Denver from Glendale. They'd never seen our building with its meager front stoop, the dusty patch of yard on either side, the clumps of crabgrass sprouting at random intervals. Why *wouldn't* they imagine larger and grander houses beyond the vacant lot? Why *wouldn't* they think that I lived as they did? If only I dressed the part, I knew I could deceive them into believing that I was cool. No longer in need of San. American.

I wheedled money out of my father to buy slick teen maga-
zines. I examined the pages for hints on transforming my face into
the all-American ones then in vogue—Cheryl Tiegs, Christie
Brinkley, and, of course, Farrah Fawcett. I hacked at my hair with
Mother's sewing shears. Not owning a curling iron, I tried to set
my hair in wings by twisting it up in barrettes overnight. When
Mother saw the new coif, she asked why hair covered half my
face. She handed me bobby pins, which I palmed silently, only to
toss them when she wasn't looking.

I was angry, lonely, and depressed. In the mornings I waited at
the school bus stop with kids I knew from McMeen. The previous
year, when I'd lived with the Louies, we'd walked home together
every day. We'd teased and gossiped, a cordial relationship, if not
a close one. But between the sixth and seventh grade, they'd dis-
covered the power of racism and testosterone. Suddenly these
innocuous boys with feathered hair attacked me in packs. They
picked at my clothes and my hair and my face, waiting for me to
crumble. When I brushed off the comments, their rancor intensi-
fied, until I was caught between tears and pity at the boys' ludi-
crous malice.

Troy, beautiful cool Troy, spearheaded the exchange that stays
with me most clearly. He began with the usual insults—my hair
was dirty, my clothes recycled from two years before, my nose too
flat to hold up my glasses. I retorted that he was a little on the
heavy side, and his hair, while cut to feather, only poufed like a
mushroom cap on his head.

He growled, "What do you know? You can't even see clearly,
that's why you have such thick glasses."

I fired back, "I can see *because* of my thick glasses."

When he laughed, I should have steeled myself against the
sound's venom. Instead I was caught off guard. He held one hand
against his forehead, the other against his waist, palms parallel to
the sidewalk. "What do you see with your squinty eyes?" he
asked, indicating the space in between. "Do you see this much? I

bet you only see about half what we see, because of your eyes. What's it like, seeing half a picture?"

I was stunned. Tears prickled my throat. I coughed. I said, "That's the dumbest thing I've ever heard. Don't you know anything about biology at all?"

Then I ran home, past the big houses and the vacant lot and the wood-shingled apartment complex, Troy's jeers chasing me the entire way.

I retreated to my room. Jeff wanted to tell me about kindergarten, but I only wanted to sleep. I started napping every day after school, leaving Jeff in front of the twelve-inch black-and-white TV. I rarely had the energy to play with him. I was angered by his smallest transgressions, from breaking a mug to watching too much television to refusing to bathe. Once I spanked him with a hairbrush. Another time I locked him out of the apartment, screaming that he didn't belong to our family anymore. I didn't want to do these things, but I couldn't seem to stop myself. My actions and emotions were beyond my control.

Living in the Glendale apartment, I felt impoverished as I never had before. For the first time, there was no extended family to mask our circumstances. I couldn't dash upstairs to watch *The Brady Bunch* on Aunt Becky's cabinet TV. I couldn't run across the alley to Auntie Wong's when I wanted to escape our Salvation Army furniture. I was stuck with the moldy smell of our rental carpet, the rusty water stains on the bathroom ceiling, the asphalt parking lots and dun-colored buildings outside. I missed the feel of grass and warm sidewalks beneath my feet.

One day, in a rare waking moment, I decided to take Jeff for a visit to Jasmine Street. Holding hands, we crossed the Denver border, passed Troy and Cary's block, passed alphabetical street signs until we were back at Aunt Becky's house. San and his friends were playing touch football in the front yard. Joey

zigzagged across the lawn, trying to ruin the game. Brian's toy sol-
diers fought a war on the Etos' stoop. Jeff and I had been absent
for almost a year, but nothing had changed. I let go of my
brother's hand. We'd come home.

We went to San's house several times a week, always returning
to Glendale before nightfall. I cautioned Jeff against telling our
parents about these visits—I knew that Aunt Becky's house was
forbidden territory. I felt guilty for our implicit betrayal and the
silent lies, but these trips were necessary. I relished the freedom
Jasmine Street provided. While Jeff played at Brian's, I hung out
in San's living room. I watched TV, I read the newspaper. If
prompted, I would actually talk to San and his friends. But com-
pany was not what I wanted. A strange heaviness had taken over
my body. Movement and speech, even consciousness, seemed
unbearably difficult. I only wanted to lie in silence.

One day, after walking Jeff to the Etos' door, I decided to
return home, rather than stay at San's. I told Jeff I would be back
for him, then left to nap for the rest of the afternoon. This became
our new pattern. Two or three times a week, I took Jeff to Brian's,
came home, napped, and returned to get him before nightfall.
Then the days grew shorter and it got cold. Sometimes snow cov-
ered the sidewalks. I grew too tired to make two trips a day. So I
stopped going. I sat by the window watching the sky turn black.
Then I crawled back into bed. When Jeffery called to ask when I
was coming, I told him to wait at San's. I said, "Mom and Dad will
pick you up after work."

I was too tired to fear my parents' response. I slept until I heard
their voices in the hall, and awoke only long enough to tell them
where Jeff was. If they reacted, I didn't notice—I was asleep by
the time I finished speaking.

Perhaps my parents already suspected our activities, perhaps
Jeff had told. In any case, they never did ask me about our visits
to Jasmine Street; they simply accepted the nights that I crept out
of bed with the news that Jeff needed a ride. After a while, they

even let my brother spend weekends at Aunt Becky's house, with Aunt Bik-Yuk as babysitter.

However, these concessions did not mean that my parents and San's had reconciled. Father and Uncle Andy still weren't speaking. My parents still avoided Aunt Becky. We children were the only link between the families.

It didn't matter. I didn't care what the adults did. I was tired of worrying about them. I was sick of their stupid feud and its effects on my family. I just wanted to be left alone. I spent my time sleeping, reading, and writing. Although Mother no longer required it, I wrote for hours each day, filling spiral-bound notebooks with words like *hate*, *angry*, and *depressed*.

I felt in control of my life when I was writing. My emotions were wild and amorphous, but words had limits. They were concrete, markings confined to paper, their edges shaped by the motion of my hand, their meanings bound by dictionary definitions. I wanted similar boundaries for myself, and writing was my way of establishing them. On paper, my life seemed manageable. I couldn't feel any emotion deeper than *Webster's* described. I couldn't experience passions beyond the scope of my vocabulary. Or so I hoped.

It didn't occur to me that in these hours of writing I was attempting to travel beyond the limits of language, seeking expression for the things that defied words. I only worked to exhaust the depths of my emotions, to capture every possible nuance so that I wouldn't be caught unawares by my own sorrow. I wrote and wrote, and I felt safe because I could close the covers on my words. Every day, after I finished writing, I flipped the notebook shut and hid it under my mattress. Muffling myself.

Hill, my junior high school, was located three and a half miles from McMeen, in an affluent neighborhood called "Hilltop." Approximately one-third of Hill's students were bused in, half of

this number from Aunt Becky's neighborhood, half from "Five Points," a poor, primarily black part of town. The remaining students lived within walking distance.

Naively, I believed that the differences between the three groups wouldn't be immediately obvious. I hoped that distance would disguise my family's circumstances—that I could appear as wealthy as the Hilltop students, as sleek, as savvy, as white. I didn't think that anyone would notice my home-cut hair, my second-hand clothes, the one canine tooth darkening from lack of dental care. I didn't know how deeply my upbringing had marked me—how my mannerisms, style of speech, and cultural references betrayed me: While the Hilltop students talked of soccer clinics and weekend ski trips, I mentioned Hip Sing, the greyhound track, and the Vegas line on the latest Broncos game. While they nibbled delicately on their fried chicken drumsticks at lunch, careful not to bite too close to the bone, I longed to crush the wings between my teeth, to taste marrow like a true Cantonese.

My peers kept me in check. Their rolled eyes and turned backs let me know that I'd failed. I reminded myself to exercise restraint. At times the effort was physically painful. Words stuck in my throat, fragments of sentences, memories I swallowed. I spoke haltingly, waving my arms in the silences. I burst out laughing at inappropriate moments, and couldn't stop; I doubled over, hyperventilating.

I grew to hate school. I dreaded the beginning of every class. Those five minutes were the most painful part of adolescence, condensed and replayed eight times a day: The pause before entering, checking to make sure your hair was combed and your glasses clean. The disorientation of walking into a noisy room. The clustered, gossiping teenagers smiling to welcome everyone but you. The cute boys pinching their nostrils as you passed. The desperate attempt to make conversation beyond the word "hello." The faked busy-ness when everyone ignored you.

Embarrassed by my own solitude, I started doing homework in

the free time before each class. While the cool kids gossiped and flirted, I wrote book reports and found numerical values for the variable x. Working in five-minute intervals, I finished most of my homework before the end of the school day. It was only a strategy to appear indifferent, but before long I was actually enjoying myself. My assignments were more exciting at this pace. Their level of difficulty increased, making perfect scores harder to attain—and thus, more desirable. I challenged myself never to take schoolwork home. I snuck in homework time wherever I could get it—during morning announcements, after lunch, in the pauses between teachers' sentences.

I got a reputation: One, I was weird. Two, I was smart. The cool kids approached me when they needed homework help, trading conversation for algebra solutions, French translations, and novel synopses. Amused, I flaunted my straight A's like the cool girls' grosgrain headbands. I didn't mind sharing answers, but neither was I fooled. I knew I was being used.

I had mixed feelings about this dynamic. Part of me genuinely admired the girls' Farrah Fawcett haircuts, their Izod shirts, button-fly Levi's, and Pappagallo purses. I wanted to be invited to their Saturday night parties. I wanted to giggle in the shelter of their locker doors. I wished that they liked me for reasons beyond homework.

The other part of me pitied them for their lack of insight. They believed that I didn't know the truth. They thought they had me fooled. I could tell by the way they asked for help—by their saccharine smiles and overly sincere compliments. I watched with a sick kind of amusement, never correcting their assumptions. Condescension was my only defense.

Despite my reputation for being weird, I managed to make friends—kids who sat next to me in class, or smart, socially awkward girls like myself. For the most part, these were friends who

knew me in school but not beyond. They didn't know basic facts about me, like where I lived or whether I had brothers and sisters. Unless they'd attended McMeen, most weren't even aware that San and I were cousins.

I wasn't intentionally secretive, merely confused. I didn't know how to describe my life in a way that my friends would understand. Speaking in English, I had the vocabulary, but not the context: The words *family* and *home* would not carry the meanings I intended. Compared to their Chinese correlates, the English words were limited; they didn't imply generations bound up in one identity, rooted in one place. Using English, I couldn't convey my sense of loss. I couldn't make my friends understand how much it had hurt to leave Aunt Becky's house, how lonely it was to live in Glendale now. I didn't want to sound stupid, so I chose silence instead. I spent my time in my friends' worlds, rather than inviting them into my own.

This was true even of my relationship with Helen and Kezia, the classmates who knew me best. Helen was a heavy-set girl of Greek descent. She had gold-hued skin, dark blue eyes, and shoulder-length curly brown hair. She usually dressed in blue jeans, oxford-cloth shirts, and open-front vests. Her most prized possession was a framed poster of the lyrics to the Bee Gees' song "How Deep Is Your Love?"—an item I greatly coveted. Kezia was five foot eight and slender, with large feet. Her father, an English professor, had named her after a daughter of Job, from the Old Testament. She was the first atheist I'd ever known.

They lived near Hill, so I rarely saw them after school during the week. Instead, we talked on the phone and had a routine of meeting every Saturday at Cherry Creek, a ritzy shopping district not far from where Helen and Kezia lived.

We usually started the day at the public library on Milwaukee and Third. There, sequestered in the second-floor study, we would read aloud from adolescent sex books by Judy Blume and Norma Klein, confess our secret crushes, wonder how it felt to

kiss a boy, and make up scenarios where this might happen.

When we tired of the library, we left to window-shop. We always went to the same stores: gift shops that sold kaleidoscopes and wind chimes; toy stores full of papier-mâché hand puppets; an antiquarian bookstore; a stationer stocking novelty stickers and paper by the pound.

And, of course, there were the clothing stores—our Holy Grail. Aspen Leaf, Pappagallo, Merry Simmons. Places where the promise of popularity hung thick as designer clothing on racks along the walls.

I loved trying things on: Canvas espadrilles and corduroy jumpers. Fair Isle sweaters and navy wool blazers. Oxford-cloth shirts with button-down collars. Coordinating grosgrain head-bands and Bermuda bag purses. Tiny bow earrings. Ocean Pacific shorts. Topsider boat shoes. Long-sleeved white cotton blouses with round lace collars. Izod tennis jerseys. Ralph Lauren shirts. Striped web belts.

I spent hours spinning in front of mirrors. I admired the way piqué knits clung to my developing breasts. I smoothed knife-point pleats over delicate hips. Every Saturday, I dreaded the moment when I had to unbutton the shirts, unbuckle the belts, slip off the espadrilles, set down the Bermuda bags. I was con-vinced that these clothes had a transformative power. Wearing them, I was Cinderella at the ball, suddenly beautiful and popu-lar. Without them, I was only me. Denuded, I could not bear to look in the mirror. I was shorter, fatter, uglier, more acne-ridden. I wanted an Izod shirt so much it hurt to breathe.

The problem was, I didn't have any spending money. Any cash that I received—the five-dollar bills that Aunt Becky tucked into my Christmas cards, the singles that Hip Sing's gamblers handed out for luck—I had to turn over to Mother. If I'd gotten an after-school job, she would have expected me to give her those wages, too. Being a traditional Chinese, Mother didn't see me as an indi-vidual with needs separate from my family's; I was only one part

of a communal whole, every part of my being subsumed for the good of my family. My money was their money. Any time I wanted to buy anything, I had to ask my parents for it specifically. From bus fare to movie tickets to lunch money to books, my parents had to approve the item first. And lots of times, they said no. They never gave me more than a few dollars at a time.

I couldn't even imagine asking them for an Izod shirt. First of all, it was too expensive. Second, it wasn't necessary. Mother didn't believe that anyone needed more than four or five changes of clothes. She didn't believe in replacing clothing unless it could no longer be worn. Fashion was foolish, a luxury we couldn't afford. She would never understand why I wanted to spend fifteen dollars on a short-sleeved cotton-knit shirt, not when I already had a drawerful of clothes. If I wanted an Izod, I would have to get one some other way.

I would have stolen one, if I could have done it without getting caught. But I'd learned my lesson the summer after fifth grade, when I'd tried to shoplift a two-dollar necklace from Target. I'd been humiliated when the guard led me to his cubicle office at the back of the store. It was bad enough being marched past the other customers. But the worst part had been explaining that the store *couldn't* call my parents, because they wouldn't understand a word the guard said. He thought I was lying. "Oh, *come on*," he'd sneered. "How could your father live in this country for nearly ten years without speaking English?"

He'd disregarded my stuttering attempts to explain.

Ultimately, Cousin William had come to pick me up. Afterwards, I'd told Mother that the store made a mistake, and she'd nodded like she believed me. At the same time, she'd said that the truth was irrelevant—image was more important. I should not have allowed myself to be in a situation where such a mistake could happen. Because mistake or not, my reputation had been damaged, my family shamed. "Now," she'd claimed, "*Sing Tao* has published a story about your arrest, with a color picture

of your face. None of us can go anywhere without the Chinese community knowing."

For days I'd sifted through her newspapers, looking for my picture.

I couldn't go through that experience again, especially not at a store like Merry Simmons, where all the cool kids shopped. I needed to *buy* the shirt, fair and square, counting out the bills at the front counter for everyone to see. There was only one solution—my lunch money.

My parents based my lunch allowance on the cost of a cafeteria hot lunch. At Hill, this meant a dollar a day. But the Hill cafeteria offered *two* options: the one-dollar hot lunch, or à la carte items that ranged in price from seventy-five cents for a sandwich to a dime for milk. One day, purely by accident, I discovered that I could fill up on butter cookies and milk—about a quarter's worth of food—almost as well as on a full lunch. I realized that if I ate nothing but cookies and milk for lunch, I could save almost four dollars a week.

I followed this plan for about a week, then varied it, eating an apple one day, yogurt the next. When friends asked about my dining habits, I told them I was on a diet. At this time, I stood just under five feet four inches tall and weighed a little over one hundred pounds. I knew that I wasn't fat. In fact, I hated my body for its smallness. I wanted to be big-boned, tall, round-breasted— *American*. Not a "typical petite Oriental," the way one classmate's father described me. Obviously, dieting wasn't going to make me taller or rounder, but I knew that by invoking that one word, the mantra of American womanhood, I was going to be accepted by my girlfriends in a way I'd never been before.

And I was right.

Helen immediately decided to join me on my diet. She began throwing away the sandwiches from her brown-bag lunches. Every day for a week I watched her unfurl the top of her brown paper sack, reach into its mouth, remove the shiny, plastic-

wrapped sandwich, and toss it into the cafeteria wastebasket. There it lay among orange peels, apple cores, empty milk cartons, and grease-spotted Saran Wrap. I thought about Helen's two-story house with its stained-glass windows. I thought about our apartment in Glendale. I thought about the additional quarter I could be saving, and I volunteered to eat Helen's sandwiches for her. "As long as you don't want it," I said. She relinquished her sandwiches to me without protest, never questioning the logic of my "diet."

I ate Helen's sandwiches for about two weeks, congratulating myself on the cleverness of this scheme: I was saving money toward an Izod, and being quintessentially American by "dieting," yet I never went hungry. Then one day I overheard Helen complaining that I was a "mooch."

"What diet?" she muttered. "Elaine's just cheap. She eats *my* lunch every day. *I* have to starve, because she won't buy her own lunch."

Helen's sandwich turned to putty in my mouth. I chewed carefully, forcing the lumps down my throat, pretending that I hadn't heard. The next day, I refused her sandwich and made a point of buying a big lunch with my own money.

"What about your diet?" Helen asked.

I laughed ruefully. "I'm cheating. I guess I'll have to start over tomorrow." I let my eyes linger on Helen's midriff. "What about yours?"

"Oh." She looked embarrassed, stood up, hesitated, threw away her lunch. "Thanks for reminding me," she whispered. Our eyes did not meet for the rest of lunch period.

The next day, Helen made a ceremony of dumping her lunch into the wastebasket. Slowly, ostentatiously, I sipped a half-pint of two-percent-reduced-fat milk, making it last the entire forty-five-minute lunch period.

The following day, Helen resumed eating lunch.

I didn't.

I stopped eating lunch for five years. The system made perfect sense to me. I could have pocket money at no additional cost to my parents. In addition, I liked the feeling of control I got from refusing food. I went from allowing myself one item each lunchtime and filling up on an after-school snack, to eating an after-school snack only, to eating nothing until dinnertime.

These habits were reinforced by my feelings about my physical self. I felt profoundly ugly during this stage of my life—mostly because everyone had been telling me that I was ugly for the last seven years. At home, Mother sighed over the moles on my face, pried open my mouth to stare at the crooked teeth inside, and squinted to mock my nearsightedness. She behaved the way Aunt Bik-Yuk and Cousin Dani had always done, as if my body belonged to them, my elder female relatives, to poke and prod and criticize. And as a Chinese, as a girl, I had no right to complain. According to cultural dictates, I did belong to them.

Accustomed to being treated as an object and hearing such blatant criticisms, I had no filter against schoolmates' taunts. I accepted their view of me as truth, absolute. Over the years, I came to believe that being Chinese in itself constituted ugliness and asexuality. By the time my schoolmates learned the social grace to check their comments, I'd internalized their criticisms so completely that I supplied the taunts for them, silently and constantly, inside my own head. I never outgrew this habit; looking in the mirror, I always saw myself as ugly, so whenever anyone complimented my appearance, I assumed that they were mocking me. If a boy expressed interest in me, I wondered what was wrong with him.

Nothing in popular culture contradicted my assumption of Asian as ugly. The image of beauty during this time was uniformly blonde, buxom, and white. Farrah Fawcett was the epitome of female sexuality, the image we girls strove to emulate. Flat-chested, black-haired, and bespectacled, I was doomed to failure. All I had was thinness, which my friends commented on and admired dur-

ing our Saturday shopping trips. I worked to maintain this slen-
derness, believing in an inverse relationship between waist size
and beauty. The skinnier I became, the more attractive I felt.

What began as a ploy to acquire spending money became an
actual diet. I developed methods to limit my food intake. I got
foods that I enjoyed, and divided the portions into halves of ever-
diminishing size. My goal was to consume almost one half of the
entire portion on the first day, then almost one half of the half the
next day, and so on. I didn't succeed immediately, since I was
accustomed to eating. But I found ways to meet my goal. I ate
more slowly, pausing between bites, chewing each mouthful until
it was flavorless mush.

Success in this arena, as in every other, thrilled me. I loved the
sensation of my stomach cramping in hunger. It meant that I
could conquer biological urges. I could do anything. I began
refusing myself bathroom privileges. For years, I only allowed
myself to use the toilet once in the morning and once at night.

For the Chinese, fat is positive, a sign of prosperity. For this
reason, Aunt Bik-Yuk fed Jeffery constantly when he was little.
By the time he was in elementary school, Jeff was noticeably
pudgy. His pediatrician encouraged him to lose weight, but my
brother enjoyed eating as much as he disliked exercise. Wishing
to share my success with Jeff, I tricked him into long walks by
telling him they were "short cuts" to the bus stop. I advised him
on weight loss frequently, stating, "Just eat less and less. At first
your stomach will hurt, but after a while you get used to it, then
it feels good when your stomach is empty."

When Jeff disagreed, I thought him weak.

At my lightest, I weighed eighty-nine pounds. People at school
noticed. Kezia clipped articles from the newspaper for me.
Barbara, a girl I barely knew, gave me a copy of *The Best Little Girl
in the World*, a bestseller about anorexia. I read everything, fasci-
nated. I was prepared to discuss the literature, but I didn't think
that it applied to me. I didn't really think I was fat. I didn't think

I was thin, either. I just liked being in control of my body, and I wanted the pocket money that skipping lunch provided.

For a long time my parents didn't notice my weight loss. Then Mother became aware of the new clothes in my drawers, the Levi's jeans and Izod shirts. She asked where I'd gotten them, and I told her that a school friend had given me her castoffs. Mother looked puzzled, but she didn't press the issue. Still, she suspected that something wasn't right. She continually commented on my slenderness. Several times a week, she asked how much I weighed. I always said, "One hundred pounds." If she didn't believe me, I speculated that I might have lost a pound or two. I blamed it on genetics, pointing to Father, who was very thin. Only once did Mother ask directly whether I was spending my lunch money on clothing. I lied.

When I bathed, my hands and forearms turned blue. Secretly, I was thrilled, but I feigned concern and showed my mother. "Ah, Yee, you're too thin," she murmured. She brewed pungent, murky, deep black teas to help me gain weight. Teas consisting of tree bark, deer antler, herbs I couldn't pronounce. "This one bowl cost one hundred dollars," Mother said, crinkling her eyebrows severely. "See how much I care about you?" She served the teas in big soup tureens, and insisted that I finish every drop. I hated the bitter, silty taste. I choked every time I took a sip, hoping that Mother wouldn't force me to drink more, but of course she would: The ingredients cost one hundred dollars.

I could finish the bowl. I could do it in one big gulp, without stopping for breath. When forced, I did it this way, impressing my brother with the display. The real reason for my resistance was the fear that these potions would work. I didn't want to gain weight. I didn't want to lose control of my body.

I didn't go to the doctor. I hadn't been since the end of childhood immunizations. My family viewed Western medicine as the option of last resort. We bought health insurance only to cover hospital care in case of accident or severe illness. For the more

common maladies, Mother was the answer. All a doctor did was prescribe pills. My mother brewed potions that thickened your blood. She made hot rice poultices to draw the weakness from your body. She rubbed the curved edge of a spoon against throat and elbow pulse points to take away your cold. Sometimes these cures hurt—the poultices burned, and the spoons left patches of red and purple bruising—but I subjected myself to Mother's large-boned hands as long as I fit in her lap. I didn't know whether the remedies worked, but what child believes in medicine so much as in *mother*? I was resisting for the first time.

10

When Father Lived in Wichita

By the time the seventh grade ended, hunger had become a natural state of being. Abstinence was an automatic act, ingrained as a reflex; I thought no more about the denial of food than I did about breathing. I was concerned about losing weight, but it didn't consume all my attention. I was much more absorbed in other matters, such as my family's return to Casey's Palace.

Over the summer, nearly two years after it began, the family feud came to an end. One night when he came to pick Jeff and me up, Father finally agreed to walk from the car to Aunt Becky's front door, rather than waiting in the driver's seat, as he'd done for the last ten months. The next thing I knew, Mother was slipping inside to chat with Aunt Bik-Yuk, Father was fixing the clog in the bathroom sink, Aunt Becky was offering him something to eat, and soon my parents were visiting Jasmine Street after work every night, acting as if nothing had ever happened.

Still, I understood from Aunt Becky's tone of voice and the way that Father avoided Uncle Andy's eyes that trespasses had not been forgiven. They reunited only because family was duty, and so much family had been lost to immigration. They needed each other to remember the past.

I accepted their actions regardless of motivation. I was thrilled when Aunt Becky finally invited Father back to Casey's Palace: I'd daydreamed about the restaurant countless times over the last two years, remembering all-American busboys, shiny mopeds, and games of chase in the back lot. I imagined the busboys welcoming me back: They would steal my books and ask where I'd been. They would talk about how much they'd missed me. I couldn't wait.

But the restaurant was no longer the haven that I recalled. The hills in the back lot were gone, razed for condominiums and chain restaurants and a mall with shops to rival Cherry Creek North. I stood on the back stoop staring at the new buildings sadly. The hills where I dug for wet sand had been as much a part of the restaurant as the building itself. Now they were gone. The restaurant was diminished, its domain conquered. Even the building looked smaller and more worn. The bricks were pockmarked, the trim fading, the doors age-stained.

Business had declined. We were having trouble competing with the mall's fancy eateries. I couldn't understand why. I wandered through our dining room and bar, gazing at the red velvet-flocked wallpaper and the gilded ornaments, trying to see them through customers' eyes. What was wrong with the huge gold coach carriage over booth number two? When I was younger, it reminded me of Cinderella. I didn't get it. This place was home.

In my absence, the all-American boys had left. Now, for the first time, we had female bus staff and black dishwashers. I was shocked. I couldn't bear the idea of change. I knew that Annie and Casey didn't approve of busgirls, and Aunt Becky didn't approve of black people. Their attitudes should have remained static. What happened to the restaurant's exterior was bad enough. Why did the Rosenbergs and Aunt Becky have to become liberal on me?

I shouldn't have worried. The busgirl, Lisa, had been hired only because her mother was a friend of the Rosenbergs. Ordinarily, the Rosenbergs liked a uniform look in the dining room. They pre-

ferred big-haired, bosomy waitresses and clean-cut teenage bus-boys, the former for the purpose of pushing drinks on diners, the latter because they were unobtrusive. Waitresses were encouraged to wear clingy knits and high heels. Busboys were required to wear a white dress shirt, red vest, and neutral-colored pants. Their hair could not be longer than their shirt collar.

Lisa was in no way unobtrusive. She was five foot ten inches tall and intimidatingly beautiful. She had long blonde hair, blue eyes, and a curvaceous figure. Strangers off the street would follow her into the restaurant to compliment her. They usually asked if she modeled, or told her she looked like a blonde Brooke Shields. I was half jealous of her, half in awe.

"Why do you want to work here every weekend?" I asked her once. "If I were you, I'd go on dates every night."

She laughed. "Who would I go with?"

"The guys at Creek," I answered immediately, referring to Cherry Creek High School, where Lisa was a sophomore. "Don't you get asked out all the time?"

"Yeah, by weirdos."

I persisted, "No, really, why don't you ever go out?"

"Nobody asks."

I cocked my head, disbelieving.

"Really." Lisa elaborated bitterly. "Guys like to look, but that gets old fast. And once they get tired of looking at you, they stop caring. I'm . . . I'm not good enough for the guys at Creek. They want to go out with girls from families like theirs—girls with lawyer fathers and neurosurgeon mothers—not someone who has to bus tables to make extra money because her mother's a cocktail waitress. They can't relate to someone like that."

I was silent, upset by her revelation. I didn't want to hear that beauty was not enough—that popularity depended on having the right family. Because beauty could be bought. I could save up for Izod shirts and plastic surgery. No amount of money could change my family.

"Well, they're stupid," I said finally.

Lisa smiled. "You're cute."

I shrugged. We both went back to work.

Until Lindsey, Lisa and I had nothing in common.

Lindsey was a busboy at the restaurant, a freshman at Cherry Creek High School the year I entered the eighth grade at Hill Junior High. He had red hair and brown eyes and very pale skin. Light brown freckles, the tan of raw sugar, dotted his forearms. He shaved and wore Old Spice cologne. I thought he was terribly mature. I loved to inhale his scent when he wandered onto the back stoop to talk to me. I knew that he had a crush on me, and I was excited, confused, and thankful. I couldn't imagine what Lindsey saw in me. I thought that he must have been deceived by my contact with Lisa, misled into believing that I was as beautiful and desirable as she.

I responded to his attention in ways that I didn't understand, allowing him to lead me around the side of the building to rub bodies and kiss, tongue on tongue. The first time, I was hesitant, even a little repulsed. I was scared that I would do it wrong, but there didn't seem to be any technique involved. My tongue coiled around his effortlessly. I felt my center give. I turned to liquid, warm and sweet as caramel.

We cuddled in the service corridor between kitchen and dining room. We snuck into the basement to kiss and mash groins. At dinnertime we sat on the same side of a red vinyl booth, holding hands. Left-handed Lindsey ate enthusiastically, dexterous and unencumbered, while I right-handedly arranged my food in elaborate patterns, nervous about eating in his presence. The waitresses thought we were cute, but my parents didn't. They forbade me to give him our home phone number. They didn't want him calling. They didn't want me spending time with him. They said that I was too young for boys, and besides, he should have been Chinese.

Father demanded that I end the relationship.

I said no.

Father screamed, "How dare you disobey? You've disgraced the family!"

"It's *my* life!" I shouted, storming past him to the back stoop. I fumed. How dare they treat me like I had no rights of my own? I was sick of living for my family. I was sick of having to conform, to be meek and obedient just because I was born Chinese.

Aunt Becky appeared on the stoop behind me. She said, "You can't make these decisions for yourself, you're part of a family."

I remained silent, too angry to speak.

She said, "You're growing up. You need to learn what it means to be mature. It means you can't act on your whims anymore. You need to do what's good for your family. Otherwise, your reputation will be ruined. You'll destroy your father's life. It's *his* name, you know, not your own. This is what it means to be an adult—you learn to be cautious and follow your elders' lead."

"What do I have a brain for?" I asked. "Why do I bother to think?"

"You use your brain to judge what others will think is right. You take care of your family. That's who you are—your family. If you fail, if you are shamed, it's not 'Elaine' who's talked about, it's not even Man Yee. It's the Mar girl, the daughter of Yat Shing. That's the person the community will refer to. It's his reputation you need to protect."

I said, "My father's name. *His* name. What about me? Don't I count as a person?"

Aunt Becky made a sound of disgust. "What kind of question is that? You're alone only if you've been shamed. You're no one without your father's name."

I started crying. How could she negate me this way? How could she say that I didn't exist as an individual?

Aunt Becky said, "Hush up and be mature. Stay away from Lindsey." She stalked back into the kitchen.

* * *

If Lindsey were still a dishwasher, Aunt Becky might simply have fired him. Because dishwashers were kitchen staff, she had complete power over them. Busboys were a different matter. They worked in the dining room, so they were jointly supervised by Aunt Becky, the waitresses, and the Rosenbergs. If Aunt Becky fired Lindsey, she ran the risk of his complaining. She didn't want to take this chance. If he revealed the circumstances around his firing, my loose morals would be exposed, and our whole family would be shamed.

So my family tried to break us up through different means: Aunt Becky kept me busy with extra chores. Father swore and cried. He followed Lindsey through the kitchen threateningly. Mother came to Casey's Palace after her shift at Canton Landing, Uncle Richard's new restaurant, ended. She glared at Lindsey. She told me horror stories about sex, conjuring violent, graphic images—pelvises breaking under a man's weight, ripped vaginas being sewn shut, pregnant girls dying in childbirth, their shame bleeding out for all the world to see.

But I was overcome by the strength of my own desire. When Lindsey touched me, I felt whole and individual, integrated as I never had before. I didn't care what my family said. I refused to give Lindsey up. I found ways to sneak off with him.

We went on walks when business was slow, exploring the neighborhood, searching for a private place to kiss. One night we settled in the alcove entrance of a bankrupt restaurant several blocks away. Traffic came so close that we could hear conversations floating out of cars parking in the next lot. But no light bloomed in the sign directly overhead, so we imagined ourselves safe. We were left to each other in the dark.

"I like what you're wearing," Lindsey said, leaning in to kiss me. I responded, letting my doubts wash away, feeling pretty, never mind the thick glasses and flat nose, never mind Mother's

voice saying *Why do you slouch? looks so ugly,* or *Eat another bite and you'll weigh three hundred pounds.* Here I was in control, no social awkwardness as in school, wondering who would be my lab partner.

Lindsey pressed against me. His crotch pushed at my abdomen, a mysterious hard lump, rough in the seam of his chinos. His fingers traveled over my chest, tracing the barely formed breasts that lifted my shirt above the ribcage. His hands slipped under the shirt, pulling up the cloth, tugging it over my shoulders. I lifted my arms, mesmerized by the hands, the flicking streetlights, the dim *whir* of passing cars. I watched Lindsey tug at the elastic at the bottom of my bra, pushing it over my breasts, first left, then right. They looked absurd, I thought, squeezed flat, two-dimensional, nothing like the pictures in a *Playboy* magazine San and I had found buried in the field behind the restaurant years ago. I panicked, wondering how many breasts Lindsey had seen.

"Are they okay?" I asked.

"Nice," he murmured, not looking up.

We both stood there, staring at my chest. My arms hung limp at my sides. I didn't know what I was supposed to do.

Finally, Lindsey said, "Can I kiss them?"

I could barely breathe. I nodded.

I felt his lips on my nipple, his tongue on my skin, the sensation of my vertebrae unlocking, my bones gliding apart, smooth as beads on a wire. Involuntarily, I arched into him.

He fumbled with his belt. "Do you want to touch me?"

I stood up straight. I shook my head.

He rephrased the question: "Do you want to look at it? Please?"

I shivered, remembering how my belly stuck out just the year before, how young I'd looked in a puff-sleeved dress. I tugged at the stretchy cotton cups of my bra. "No," I said, "I want to go back."

On successive weekends, Lindsey's goal was to convince me to look at "it." I was curious, aroused, and frightened, all at once.

I'd only seen little boy penises: my brother's, and San's, when we were both five years old and in the tub together. I recalled the sex education segment in seventh grade science class, but those illustrations had been line drawings, with no indication of scale. I sat on the floor in a corner of the public library, searching for live photographs. Nothing, just more text: *at puberty testicles descend . . . penis grows in size . . . becomes erect when sexually aroused . . .* I tried to imagine the size of an erect penis. Thicker than a broom handle? In the bathroom I cautiously touched the lips of my vagina. I tried sticking a finger inside, but didn't get further than the first joint. It hurt and it felt weird. I washed my hands, furiously scrubbing the tip of my index finger.

I didn't have anyone to ask. None of my friends at school had boyfriends. Initially, I'd told them about the things Lindsey and I did, the tongue-kissing, the hands on my chest, but then I'd sensed that I was going too far. I shut up. I walked down the hall with Kezia and Helen, staring at the hickeys on Jennifer Litman's perpetually tan neck. Between classes, Jennifer engaged in frantic, passionate kisses with her boyfriend, Burke. Nervously, I echoed my friends when they called Jennifer a slut.

I considered my dual lives: The daylight hours of Hill Junior High, the public library, Cherry Creek shopping center. The weekend darkness of the restaurant, my family's full-mouthed Toishanese. My sexuality pushed me deeper into the nether regions, a private life I couldn't explain in my hours on the telephone with Kezia.

At the restaurant I watched Lisa flirt with the dishwashers. I admired her ease around them, the way she let their eyes rove her body, resting in the area where the top buttons gaped, not quite revealing cleavage. I wanted to ask her advice, but I didn't know how. I didn't want to reveal my naiveté and turn back into the geek that I was every weekday at school.

Without planning, Lisa and I took turns sneaking out of the restaurant. She smoked pot and "made out" with a dishwasher named Pat in the back seat of his car. They would file back into the kitchen breathlessly, not looking at each other, their cheeks flushed, Lisa's hair tangled. Watching them, Mother would hiss, "That Lisa! She has no shame."

I barely heard her. I was trying to imagine what they'd done in Pat's car.

I saved my best clothes for the restaurant, anticipating walks with Lindsey. I'd planned my life years before, saved a timeline in my head for the first date, first kiss, saying *no* when boys pressured me to have sex, everything memorized from books and science class. Lindsey was throwing my calendar off. My body was behaving in ways I didn't understand, coaxing me toward *yes*, beyond my control.

Every weekend we staggered down the street arm in arm until we reached the alcove of the defunct restaurant. He asked about my classes, and I listened to him talk about his band, but it was all perfunctory. We rushed through conversation so we could touch each other without feeling guilty. He fumbled at my clothes in the dusty entryway, shirt, bra, breasts, hands headed downward, a routine I knew. He unbuckled his belt, unzipped his pants. My resistance weakened, withered, a faint memory.

"Help me," he whispered.

I hesitated. The pulse between my legs quickened, and I reached forward, parting the "v" of his pants. His erection distorted the exposed patch of underwear, huge, monstrous, a distended tumor beneath the white knit. I wanted to see it but not touch it. I looked into Lindsey's face expectantly.

"Don't be scared," he said quietly. He unfolded my hand, flattening the palm over his bulge. I didn't move.

Lindsey closed his eyes, opened them again, and breathed,

"Wait a minute." He slipped his thumbs into the waistband of his briefs, and I dropped my hand so he could lower them.

There he was, penis exposed. I glanced down quickly and jerked my head up again, surprised by what I'd seen. It was paler than I expected, pink, almost glowing in the dim light. It looked huge, much thicker than a broom handle. I wondered how it could ever fit inside my body.

"Touch it," Lindsey urged.

I wrapped my hand around the penis. I was surprised by its warmth, its hardness, its smoothness. In the shock of discovery, all desire was leached from my body. I couldn't think of this shaft as a part of my boyfriend. It was a biological curiosity, distant from the person whose mouth and tongue and body excited me.

As if he understood, Lindsey kissed me. Tasting his tongue, I fell into his body, releasing the penis at the same time. After a few minutes, Lindsey said, "He's getting lonely down there."

"Oh," I exclaimed, embarrassed. Quickly I wrapped my hand around the penis, not knowing what else to do.

"Move your hand up and down," Lindsey suggested. "He likes that."

I slid my hand upward and down again. The penis felt hot and dry, awkward in my hand.

"Like that," Lindsey moaned.

Confused by the thickness of his voice, the guttural quality to his breaths, I dropped my hand. I wasn't so naïve that I believed that I'd hurt him; I was simply overwhelmed by the strength of his response, the loss of control it implied. For a moment, I hadn't recognized the boy I'd snuck out of the restaurant with. I wiped my palm on my jeans.

Lindsey's eyelashes fluttered. He gestured at the penis. "Do you want to kiss him?"

I shook my head, horrified by the suggestion. Kissing his penis. It sounded warped, aberrant. My school's sex education classes hadn't prepared me for this.

"Come on," Lindsey encouraged. "He'd like it if you kissed him." Sensing my hesitation, he continued, "My brother says girls do it all the time."

His brother was sixteen, a former busboy, another all-American boy, heroic in my eyes. He should know. I bent down and took Lindsey's penis in my mouth. It tasted like flesh, no different from Lindsey's neck. Relaxing, I circled my tongue over the tip, feeling the small pitted indent, tasting a pungent stickiness. My throat closed suddenly. I suppressed an urge to gag, released the penis, and stood.

Lindsey hugged me. "Mmm," he murmured happily. He undid the fly on my jeans and slipped his hand into my underwear. I jerked back in pain, aching from the pressure of his fingers. Misunderstanding, Lindsey asked, "Do you like that?"

"Not there," I grunted, almost in tears. "Not so hard."

His hand relaxed slightly. "Where?" he asked, his fingers still exploring my labial folds.

I shook my head, not knowing how to explain. I'd never touched myself before and didn't know how to guide him. I had no idea how to enhance the throbbing of desire. I liked that pulsing on its own, the warmth that was nearly an ache. I wasn't sure I wanted a more intense sensation; I didn't know if I could handle it.

"Where?" he asked again.

I shrugged helplessly.

"Do you want me to kiss you down there?"

I hesitated. The answer was no, but I was embarrassed to say it. I didn't want to confess my inexperience.

He lowered my pants and kneeled. I placed my hands on his shoulders, half in protest. He looked up at me. "I won't do this if you don't want me to."

I shook my head. "It's okay."

His tongue darted forward, wet and cold. I shivered, staring out into the parking lot, wondering what he tasted, repulsed by

the idea of my own fluids. I didn't know how Lindsey could stand being down there.

He paused and looked up at me. He repeated, "I won't do this if you don't want me to."

I remained silent.

He licked me once more and stood. "Did you like that?"

I winced. My back hurt from holding myself rigid. "I'll like it better next time," I promised.

He kissed me, and I relaxed, the desire returning. I rubbed my crotch against his, comforted by his mouth against mine, the intimacy reciprocal and safe.

The traffic on East Hampden had slowed by the time we emerged from the alcove. Basking in the warmth of my own body, I barely noticed the silence of the autumn night. Lindsey and I strolled back to Casey's Palace arm in arm, stopping occasionally to kiss and grope. My body felt alive, hips loose, bucking in air.

I was oblivious to my surroundings until we reached the restaurant's parking lot. Then I saw Father standing on the edge of the kitchen's light, fists planted on his hips. The red glare of his cigarette was a beacon of danger. I pushed Lindsey away.

"Where have you been?" Father demanded as we approached.

"We went for a walk," I answered defiantly, tossing my hair back.

Father roared, "Go inside now!" He pointed in the direction of the kitchen, shooting a glance at Lindsey and turning away abruptly, as if afraid of the damage his eyes could inflict. His words sounded choked when he spoke again: "The waitresses have been looking for him for an hour! Then I find you missing! No more of this! No more!"

Understanding only Father's tone, Lindsey bolted into the dining room. I ran inside and grabbed a tubful of dishes. I sprayed plates under the hanging nozzle. Mother was screaming some-

thing. I tried not to listen, but understood anyway—I was no good, running around with rotten *gui* busboys, they would mess with me, ruin me, then what would happen? I started to cry. Anger welled beneath my skin, stretching it tissue-thin, ready to burst. Rage bubbled like heat blisters on my limbs. My head buzzed. Feeling dizzy, I broke juice glasses against the counter, one after the other. My hands shook. I was ready to cut my own skin, just to release the tension straining its surface.

Mother appeared at the end of the dishwashing bay. "What are you doing?" she screamed. "Have you gone crazy? Stop that! Stop it this instant, or I'll beat you to death!"

I held a broken glass over my wrist. "Go ahead," I sobbed. "Go ahead! Hit me! Beat me! I don't care! I'll kill myself for you!"

Mother glared. "Do you know what you're doing? Do you understand that if you cut your arm there, you won't stop bleeding?"

"Why else would I cut myself?" I shouted back. "I told you— I'll kill myself for you!"

My relatives clustered around Mother. Father, Aunt Becky, Uncle Andy, Aunt Bik-Yuk, Cousin Dani. I stared them down, shaking and crying, holding the glass over my wrist. "I'll do it," I insisted. "I'll do it."

Cousin Dani shook her head in disgust. "*Aiya,* she's crazy, why else would she say such things?"

Mother warned me, "If you do this, there's no turning back. We'll call the police and have you put away." Her face crumpled. "A waste of time to raise you," she concluded. "It was a waste to raise you."

"Go away!" I screamed. "All of you go away! Leave me alone."

Aunt Bik-Yuk sighed. "Maybe we should do as she says?" she murmured tentatively. Father coughed out a response, Aunt Becky shrilled, Mother shouted again. Their voices blurred, discussing the next course of action. Then slowly they drifted away. I lowered the glass. Its shiny bottom was a crown in my hand. I

traced its crests, imagining my inner edges, sharp as glass.

I leaned against the sink counter, waiting for my sobs to subside. I threw the broken glass into the trash and rushed out of the kitchen. I shoved through the swinging door into the dining room service corridor. Through the cutout doorway, I saw Lindsey clearing tables. Good, I didn't want to talk to him. At the end of the corridor, Lisa sat in a corner by the laundry. I walked toward her.

She said, "Your mother's out of control."

I nodded.

Lisa frowned. "It was worse before, when they couldn't find you. Your dad was shouting and waving knives, your mom was going to have a cow. I thought they would kill Lindsey when they found him. You have to be more careful, or people are going to get hurt."

I wiped at my eyes. "I just want to have a life. I don't know what to do."

"Don't be so obvious," Lisa advised. "Back off a little. Don't disappear for an hour."

I protested, "Your mother lets you go out."

"My mother's never around," Lisa commented. She turned and slid her backpack off a shelf. "Look." She pulled out a blue ceramic-topped pillbox and opened it. "Here, take a Valium. It'll calm you down."

I gave her a confused look. I had no experience with drugs whatsoever.

"It's okay," she insisted. "It's a prescription. My mother takes them to help her sleep." She stood and motioned at her chair. I sat. Lisa went to get me a glass of water. She handed me the glass and the pill.

I swallowed the Valium with a sip of water and leaned against the wall, beginning to feel woozy.

<p style="text-align:center">*　　*　　*</p>

I was still there when the restaurant closed. "Get up," Mother snapped, "you've disgraced yourself enough. Don't make us wait all night for you."

I got slowly to my feet. I wondered how long I'd been sitting in the corner.

"Hurry," Mother said.

I followed her out through the dining room entrance. It was later than I thought. The parking lot was deserted.

"It's bad enough that you're running around with that ugly *gui* boy," Mother was saying, still walking ahead of me. "Now you've gone crazy, threatening to cut yourself, *breaking glasses*, you're lucky Aunt Becky doesn't make us pay . . ."

Father was waiting by the car. His face looked tense, his eyes were red. He unlocked the passenger-side doors and held them open for us. I climbed into the back seat. The vinyl felt cool against my palms.

In the front seat, Mother continued ranting, "She would make us pay, too, even fire your father, and then what would we do? He would have to go running back to Uncle Richard at Canton Landing, humiliate himself, letting the world know how this family fights . . ."

"Shut up!" Father shouted. "I've had it with both of you! No one has any respect in this family!"

"No one's disrespecting you," Mother muttered bitterly. "I'm just saying that you people born with the last name Mar don't know what it means to *be* family. *I* wasn't raised like this, brother and sister fighting, daughter and father fighting . . ."

"Why don't you ever listen?" Father growled. "I told you to shut up! All I want is some peace . . ."

Mother said, "It's your daughter to blame, running around with a *gui* boy like some dirty prostitute. She learned it from that Lisa, I'm sure. What do you expect from Joyce's daughter?" She sniffed. "That Joyce! The way she used to go out with black men, right in front of Annie and Casey, right in front of her bosses! No

dignity, no dignity at all! Of course, that's where Lisa learned it—we all see the way she runs around with that Pat . . ."

Her voice made my head hurt. I said, "Mother, shut up."

"See what I mean?" she grumbled. "The things you're learning from that rotten Lisa. She's the one I blame, not that you're innocent, of course."

"You're such a bitch!" I shouted in English.

She wiped at her face. Her voice had tears in it: "Yelling at your mother that way, like I didn't raise you, like my life wouldn't have been easier without you . . ."

Switching back to Chinese, I said, "What makes you think I want to be alive? Why should I be grateful to *you*?"

"There you go again," she cried. "Talking that way, humiliating your family . . ."

"Shut up!" Father screamed. "Both of you shut up!"

I said, "You don't want me to humiliate you, I'll run away. I'll live somewhere else!"

"Where?" Mother snapped. "What makes you think anyone wants you? You think you're easy to live with?"

I started crying. "Why should I want to live, when my own mother talks this way . . ."

"You think that boy Lindsey will take you in?" Mother continued, not paying attention. "You think he really likes you? All he wants . . ."

I rambled on, "I should have run away a long time ago, then I wouldn't have to worry about all your stupid bills, writing checks, opening bank accounts, sending money orders to Hong Kong . . ."

Mother said, "How can a daughter talk this way? No maturity at all. I was the best daughter, taking care of your Po-po from the time I was younger than you. Do you think I wanted to leave her? Do you think I want to be here, isolated from my entire family?"

"Shut up!" Father screamed again. He jerked the car over to the side of the road. "I want everyone to shut up!"

I sobbed, "And you with your stupid name, your stupid reputation. Mar this, Mar that, I can't even be my own person . . ."

Father said, "Listen to me! I'm warning you, listen to me and shut up!"

I continued crying, "Who asked to be your daughter anyway?"

"That is enough!" Father flung his door open. I watched him get out. Mother sat crying quietly. She was wiping her eyes with both hands.

"What are you crying for?" I muttered. "You're the one making us all miserable . . ." There was a pounding at my window. I turned my head. Father was trying to open my door. I could hear him shouting, his voice barely muffled by the glass.

"Get out!" he screamed. "You don't want to be my daughter, get out now!"

I crossed my arms. The door was locked, and I wasn't going to lift the latch. Father gestured at Mother's window.

"You see?" Mother cried. "You see what you've done?" She unlocked her door.

In the next instant, Father was reaching through her open door to unlock mine. "What are you doing?" I demanded. Father had my door open. He leaned in with both arms to grab me. He was crying.

"Get out!" he gasped. "You don't want to be my daughter, no one's forcing you! Get out now!" His hand grazed my face. I took told of his thumb, put it in my mouth, and bit. He punched me. My head hit the seat back.

"You bastard!" I screamed in English. "How dare you, you bastard!" I kicked at his groin and legs.

He continued pummeling me. He cried, "Why won't you get out if you don't want to be my daughter? Why are you torturing me?"

I shouted in English over his shoulder, "Help! Help! Call the police!"

"'Po-li-cee, po-li-cee,'" he said. "Call the police, I don't care.

My life has been a waste. Raising you has been a waste, what's the point anymore? Let them call the police, I'll call the police."

Mother's voice came to us from the front seat. "Are you both insane?" she asked. Her voice was serious. She'd stopped crying. "It's one in the morning. Stop screaming. Yat Shing, get back in the car."

"She doesn't want to be my daughter," he gasped. "I don't want her to be my daughter . . ."

"Yat Shing, get in the car now," Mother said urgently. "Forget your daughter. You have a son to raise, too. He's not a waste. Get in the car so we can go pick him up. Come on, your sisters will wonder what's taking so long."

"Your son," I cried, "your precious son. Boys and this family! No wonder I want to be dead, you treat me like a slave to take care of your precious boy. That's all I'm worth to you."

Mother said, "Yee, that's enough. You've angered your father enough. Now leave him alone so he can keep driving."

My legs were dangling out the car door. Father gave them a shove. I tumbled backward, deeper into the back seat. He slammed the door. I lay inside, crying.

Mother asked, "How dare you threaten your family with the police?"

I said, "You're not allowed to hit children in this country."

"*Aiya*," Mother said in a low, angry voice. "You think you know how to raise children. You're talking about leaving your parents, you're talking about wanting to die, how would you know what's right?"

I sat up. My father was leaning against the hood of the Buick, smoking a cigarette. *I hate him*, I thought. *I hate him*. My body starting shaking involuntarily.

"It's those *gui* you run around with," Mother muttered. "You have no sense of home . . ."

Father slid into the driver's seat. He slammed the door. "That's enough," he sighed wearily. "That's really enough."

Mother clammed up. We drove to Aunt Becky's house to pick up Jeff.

Father parked along the curb. "We're going to get your brother," he announced curtly. "You don't have to come in."

I hate you. The thought paralyzed me. I sat in the dark mutely, watching my parents make their way across the lawn. I stared out at the shadowed houses, the neat square lawns. I'd lived here a long time ago. I could vaguely remember that time, back when San and I ran outside barefoot to greet our parents, home from work. In our excitement, giggling, we used to dart across the lawn to Nancy's, ring her doorbell, then leave. In the morning, when Nancy's father came to complain, we would deny it. That used to be the worst thing I ever did.

A rap at my window. I turned. It was Aunt Becky. I shook my head. She rapped again. I stifled a sob and rolled down the window. She reached for my hand, but I pulled away. She didn't insist.

She said, "Do you want to spend the night here?"

I shook my head.

"It doesn't matter what's wrong." Her voice sounded slightly hysterical.

"Nothing's wrong," I told her calmly. I looked away. What difference did it make where I stayed? I knew that my parents were inside complaining about me. *She threatened to call the police,* they were whispering. *She threatened to break up the family. No home values. We're humiliated. We're ashamed.* The adults would all stick together. They were family, one identity, seamless. That's what it meant to be Chinese.

Aunt Becky said, "I have pajamas for you to wear. A facecloth for you to wash with. A toothbrush . . . You can stay. Sleep here. It doesn't matter what's wrong."

I stared out the front windshield. This was a test. I knew it. My parents wanted to know how far I'd strayed. If I agreed to stay at

Aunt Becky's tonight, I was lost to them forever. Maybe that was even the way they'd planned it. They wanted to get rid of me. Well, I'd show them. I shook my head at Aunt Becky. "I'm going home," I told her stubbornly.

She crouched outside my window in silence. "O-kay," she said finally. "But you can call me. If anything happens, you call me, and I'll come get you."

I shrugged and started rolling up the window. Suddenly Aunt Becky reached in and grabbed my hand. I stiffened. She said, "Your father loves you."

I didn't respond.

"No matter what he said, he didn't mean it. He loves you. When we lived in Wichita, before you came from Hong Kong, he talked about you every day. I've never seen a man love his child more."

I looked away. The intensity of his love was a burden. I could do without it.

"Your mother, too," Aunt Becky continued, "she would do anything for you. Your mother, your father, they both love you. They don't know how to say it, but they do the best they can."

Her hand pressed uncomfortably on top of mine. I shook her off. I closed the window.

We drove home in silence, anger radiating from our bodies. I ran from the car the instant we parked. I stalked up our building's back stairs, unlocked the door to our unit, and headed for the bathroom—the location of our apartment's single mirror. My face felt hot and swollen. I wanted to see if it was bruised. I stared at my face. It wavered above the sink, surprisingly pale. My left eyelid was puffy, but otherwise I showed no signs of having been hit. I leaned into my reflection, wondering if the eye would turn black. I hoped so. Then my father would understand what he'd done. Then my face would look as bad as I felt. I gripped the edge of the sink. I was scared to leave the room. I'd never been this

angry before. I wanted to kill my father. I didn't know what I might do once I walked out the door.

My head hurt. I felt dizzy. I needed to find some way of getting my emotions back in control. I closed my eyes. An image came to me. There was only one answer. I crept out of the bathroom. I found a spiral notebook and a ballpoint pen. In large letters, writing diagonally across the page, I scrawled the word "Father." I ripped the sheet from the notebook, grabbed a lighter in one hand. I went back into the bathroom, held the paper over the sink, and set fire to it. I dropped the paper into the basin. The flames leapt up at me, and I stood back, afraid. From a distance I watched the word burn. I watched flames tear at the word, rage at the word, until my anger was only a black scar crumbling on the side of the sink. I washed it away.

In the morning, my body bore no marks.

The situation at the restaurant didn't change. I continued sneaking out to fool around with Lindsey. My parents screamed. Father threatened. Aunt Becky swore. I cried in the dishwashing bay. Lisa gave me Valium and five dollars for a movie at the new mall.

Uncle Andy tried reasoning with me. "It's not so bad," he consoled. "You're young. Stop thinking about boys. Wait until you're seventeen. Pay attention to school for now. When you graduate high school, then you find a boyfriend, someone you can bring home. I'll tell you what. When you graduate, we'll go back to Hong Kong, San, you, and me. We'll find you a husband. We'll find San a wife. We can marry both of you in Hong Kong."

But I didn't want an arranged marriage. I didn't want to go back to Hong Kong. I wanted the scent of Old Spice and adolescent boy.

Eventually, however, Lindsey didn't want me. He couldn't stand the drama. "Geez, it's not that big a deal," he said. "It's been, like, a month and a half. Don't kill yourself over it. Are you insane?"

I let him go without answering.

11

TASP

I struggled to regain control of my body. I was repulsed by the way it had responded to Lindsey, the way I'd allowed desire to separate me from my family. It didn't matter that we'd broken up; my relatives still watched me suspiciously. Sex had damaged me forever. I was a pariah now, I could tell by the way the adults' voices lowered when I passed, by the way Mother's eyes watered at the sight of me.

I was angry at the way they judged me, but convinced that their pronouncements were correct: *Insane. Why else would she want to hurt herself?* I cringed at the memory of the broken juice glasses. I struggled to contain the hatred inside my own body. Hands shaking, I made long lists of the people I hated in my spiral notebooks, then cried when I saw what I'd done. *Mother was right*, I decided. *I have no friends because I'm so fierce.* I looked in the mirror and saw how ugly I was.

I worked to perfect myself. When I tucked my shirt into my pants, I measured the spaces between folds to make sure that they were even. I scraped my scalp raw parting my hair in perfect, straight lines. I stopped smiling because my teeth were crooked. I thought that if only I were a better person, my family would be happy again.

It didn't work.

At the restaurant, business got worse, and the Rosenbergs sold Casey's Palace. The new owner was a man named Davey, who changed the sign out front but agreed to let my family remain in the kitchen. "Why fix what ain't broke?" he chuckled, biting down on his cigar. "You know food, I know bars. We're in business."

"Yeah," Aunt Becky answered, her smile fixed, her tone ingratiating. Privately she hoped that Annie and Casey would open a new restaurant. One phone call, and she would leave Davey's Palace.

Davey was a scrawny bald man with pockmarked skin and a big nose. He trailed cigar smoke like footprints, marking his territory throughout the restaurant. I could tell how long he had lingered in any one place by the density of smoke in the air. I tried to avoid him, but it wasn't easy.

Unlike the Rosenbergs, who allowed the dining room to function according to its own momentum, trusting details to longterm waitstaff like Vi, Davey opted for a more aggressive approach. He changed things. He dimmed the dining room lights. He watered down the coffee. He recycled the bread in the bread baskets.

Vi was particularly annoyed by the bread issue. In one of his first acts as owner, Davey switched us from individual rolls to long French baguettes. This meant additional work for the waitresses, since they now needed to slice loaves in order to fill a bread basket. To make matters worse, Davey tried to regulate the number of loaves served. During the evening rush, he lurked by the dining room entrances, filling bags with the portions that returned uneaten. He pressed these leftovers on the waitresses, not allowing them to cut a fresh loaf until the remainders had been recycled, served to the next wave of customers.

"These are like bloody rocks," Violet complained, knocking a chunk against the counter for emphasis. "My regulars want to

know what's happenin'—they've been comin' here for years, and Annie and Casey never did anythin' like this."

Davey groaned. "Will ya give it a rest? You're giving me an ulcer! Annie and Casey this, Annie and Casey that. Ya wanna work for Annie and Casey, go ahead. Ya wanna work here, serve this bread." He jerked a bag toward her. Papery ash flew from the cigar between his lips.

Violet muttered angrily, "I'm going t' call Annie tonight, see if I don't. You'll run the place into the ground, you're so bloody cheap. I've been workin' 'ere ten years. How long have you been 'ere? You don't know your arse from your elbow, walkin' around with those smelly cigars, stinkin' to high heaven . . ."

Davey let her rant. He couldn't fire her. Vi was so popular with the customers that they'd been known to wait an hour just to be seated in her station. If she went, half our business would go with her.

Davey concentrated on saving money. He hovered in a corner of the service corridor, counting the number of napkins thrown into the laundry bin. "Beautiful!" he swore sarcastically. "How many napkins does one customer need? What do they do, take baths with these things?"

He watched the busboys clear tables after customers left. "You don't need to change the tablecloth every time," he advised. "Be careful busing, and we can use the same tablecloth again."

On most Saturday nights, for an hour or two at least, we could still fill the dining room. But nobody waited an hour for Vi's station anymore. There were periods of time when no customers came in. In our refrigerators, food rotted from lack of business. We were powerless to stop the decline. We didn't know where to advertise. We couldn't afford to remodel.

When our meat turned, we served it anyway, unable to order new stock without selling the old. The customers sent the food back, but my father insisted it was good, tasting it with gusto, declaring that he would eat it himself. We didn't charge for the

steak. The customers did not return. When Father offered me the leftovers, I choked the meat down loyally, hoping I wouldn't get sick.

My family was perpetually on edge, fighting constantly. They argued about ways to improve the business. They blamed Aunt Becky for not standing up to Davey, who had altered the menu without consulting her: He'd raised prices and added items like spaghetti and lasagna, which they didn't understand.

Aunt Becky pulled me aside to go over the menu. She said, "Spaghetti, okay. I'll buy a box of noodles. I'll make meatballs. But what about this word here that starts with 'l'? What is it?"

"Lasagna," I pronounced slowly, and tried to explain. "It's like spaghetti, but you bake it. Flat noodles, meat, tomato sauce, cheese . . ."

Aunt Becky interrupted, "It sounds hard to make."

"I think it is."

My aunt waved one hand dismissively. "I don't have time for this. Who's going to order Italian food at a Chinese restaurant?"

"So what are you going to do?" I asked. "What will you tell Davey?"

Aunt Becky laughed, "Who needs to tell him anything? I'll buy a frozen dinner at Safeway." She squinted at the menu. "Lasagna. They sell those frozen, don't they?"

I nodded, disappointed both by her silence and her duplicity. I couldn't believe that this was the same woman Mother and I had feared so long ago, living in the basement on Jasmine Street.

The summer after eighth grade, my parents, Jeff, and I moved into a house on Jasmine Street, half a block from Uncle Andy and Aunt Becky's. Mother said she was overjoyed, but buying a house only seemed to make her more tense. During evenings at the restaurant, with the four adults cluttering the kitchen aisles, their hands in search of chores, my parents argued more than ever.

Mother told Father he was too indulgent. Father said that she didn't know what she was talking about.

In response, Mother snorted, "A movie here, a book there, we'll end up on the streets. The children have TV, they can go to the library, what do you need to give them money for?"

Father answered, "It's not your money, so what are you worried about?"

Mother looked indignant. "*My* money? Whoever heard of such a thing, *my* money, *your* money? Isn't this a family?"

Father splashed water out of the wok. "Oh, don't pretend. Don't act so innocent. You know the way you are, with your Canton Landing job . . ."

"All I'm doing is helping the family—"

"There you go again—"

"If what you want is for us to be broke—"

"Hush up!" Aunt Becky shouted. "Davey will evict us."

"*Goddamn Davey*," Uncle Andy cursed. He sat up straight, as if just awakened. "How dare he come in here and tell me not to sleep in the basement?"

Aunt Becky sighed. "You know he's using that old office down there . . ."

"Using it for what? To smoke those stinking cigars? What business does he do down there?"

"It's an election year," Father complained. "That's what's wrong. Everything's always worse in an election year."

At that moment Davey burst through the swinging door. "What the hell's going on back here? We're tryin' to run a business, you're drivin' people away with all the noise!"

Violet was in the kitchen fetching salads. She slammed the refrigerator door. She held two salad bowls; her hands were shaking. "Bloody hell! What do you know? You're drivin' them away with your cigars!"

"Aw, geez, I don't need this. I like a good cigar. A cigar's the sign of a successful man . . ."

And so it went. At various points Lisa and I would be drawn into the arguments—Lisa by Vi, who had never liked Lisa's mother, and I by Mother, who was still trying to figure out where I got money for new clothes.

In the fall, I was promoted from dishwasher to busgirl. I hated it. At school, the kids talked about weekend parties and group movie dates. Even Kezia and Helen had weekend plans; they were invited to all-girl slumber parties, if nothing else. I was stuck at Davey's Palace, cleaning up after people on their nights out. I imagined the group dates of other adolescents, the darkened movie theaters where boys and girls dared to hold hands. I sat in booth number nine late at night, scribbling in my notebook while the band played "Feelings" in the lounge. Around midnight, when my family was mopping the kitchen floor, the band did their rendition of "Bad, Bad Leroy Brown." I felt my body jerk in response to the rhythm. Surprised and ashamed, I ducked into the dining room entryway, a space between two heavy doors where no one would see, and danced by myself.

As the year progressed, my discontent intensified. At school, our impending graduation from junior high had a leveling effect on people's popularity. Caught up in a haze of nostalgia, the cool kids started inviting me to their parties during spring semester. I was thrilled. *Finally,* I thought, *I have a genuine teenage social life!* Except for the restaurant. My parents still let me have Saturday afternoons free, but everything else belonged to the restaurant.

I could barely remember a time when the restaurant was not a part of my life. I knew its aisles like the planes of my own face. Its odors were as intimate as the sweat of my skin. I slept and woke according to the restaurant's schedule. But now I hated it, I felt consumed by it, and I worked to purge its influence the only way I knew how—by denying food.

In my mind, food was the source of all my unhappiness. I hated the way food controlled my life. I resented having to spend every weekend at the restaurant, thinking about food, worried about

the lack of business. I was disgusted by the vats of food, obscene quantities that we couldn't sell, the way its odor crept into our clothes, our hair, our skin. The way its presence signaled failure.

I tried to stop eating entirely. I divided my meals into portions of ever-diminishing size, never finishing more than one-half of the smallest portion. I swallowed minuscule flakes of bread and fish and meat, a rice grain, a thread of celery. I felt the food crawl down my throat and harden in my belly. I felt distended after every bite. I was disgusted, terrified that the food would accumulate, never to leave my body.

As a result, I was constantly hungry. Sometimes it was all I could do not to snatch the food off customers' forks. My fingers twitched involuntarily, as if in a fugue.

I wished for a family like Kezia's—the English professor father, the impeccably coifed young stepmother, the house full of books. I spent every Saturday afternoon at Kezia's house, dreading the moment when I would have to get on the bus to go to the restaurant. Dreading the return to my own life.

I considered Kezia my best friend, and I couldn't imagine what might happen to me after junior high school graduation, when I would be forced to attend high school apart from her, due to zoning. "Maybe I could pretend to live at your house," I suggested to Kezia one day. "You know, use your mailing address. Then I wouldn't have to go to GW; I could go to Manual with you."

She laughed. "My dad would *love* that," Kezia answered sarcastically. "*Another* daughter. He says that we drive him crazy as it is."

Embarrassed, I let her believe that I'd been joking. But I was completely serious. I wanted to accompany her to Manual High School.

The plan I eventually hatched to accomplish this was convoluted. It involved the class-sharing arrangement Manual had with another school, Denver East. Students at the two schools were

permitted to take classes at either, as long as they remained at their "home" school during periods three and four. Looking over Kezia's course catalog, I noticed that East offered German, which GW did not. In junior high school, I'd taken three years of French and two of Spanish. At home, I spoke Chinese. Armed with this information, I wrote a letter to the Denver Public Schools' central administration explaining how the study of German was vital to my future as a linguist. I requested permission to attend Manual in order to enroll in classes at East.

To my chagrin, they assigned me directly to East.

Kezia took the news in stride. "It doesn't matter," she insisted. "I'll still be your best friend. We'll call each other after school. We'll go shopping on Saturdays. We don't have to have every class together."

Terrified by the prospect of wandering through high school halls alone, I remained silent.

"Look," Kezia suggested tentatively, "why don't you just go to GW? You live three blocks away."

My heart clenched. I couldn't believe that my best friend would say such a thing. In a voice heavy with bravado, I answered, "I've always wanted to learn German."

A few weeks before school started, DPS sent a stack of forms for my parents to sign, approving the change in school assignment. I thought about forging Father's signature, then realized that I would have to explain the switch from GW to East at some point. Despite my parents' lack of involvement with my school life, I knew they would want to know where I went every weekday morning.

"You need to sign this," I announced, dropping the forms on the coffee table next to Father's ash tray.

He grunted, "What is it?"

"School stuff," I answered casually.

"Ahhh," he sighed. "Don't give that stuff to me, give it to your mother."

I picked up the sheaf of paper and delivered it to my mother, in her bedroom. "Sign?" she mumbled, squinting at the forms through a pair of drugstore reading glasses. "Sign what?"

"It's for school," I told her.

She frowned. "What does it say? Is it important?"

"It's so I can go to a school downtown," I said quickly, hoping Mother wouldn't ask any further questions.

"*Aiya!*" Mother looked up in alarm. "Why do you need to go to a school downtown? Why can't you go to Geor-gee Wash-ing-ton with San? Did you fail junior high school? How did I raise such a stupid daughter?"

I gritted my teeth. "No, Mother. I got all A's, remember? I want to go to this school downtown so I can learn . . ." I paused, trying to think of the word for "German" in Chinese. Finally I gave up and said it in English.

"Ger-man?" Mother repeated. "What's Ger-man?"

"It's the language that they speak in . . ." I paused again, gave up again, and finished in English, "Germany."

"I don't know what you're talking about," Mother scolded. "Ger-man-ee, what's Ger-man-ee? Why can't you go to Geor-gee Wash-ing-ton with San, so your parents don't have to worry about you?"

Father appeared in the bedroom doorway. "What's all the fuss about?" he asked roughly. "Why are you two always arguing?"

"I'm not arguing!" I shouted, on the verge of hysteria. "I'm just trying to get a good education, learn a new language, and Mother won't let me! She won't sign the papers!"

Mother countered, "Your daughter wants to go to a school downtown to learn some language I don't understand. Well, who's going to drive her to school, that's what I want to know! What happens if there's an emergency and we need to find her, that's what I want to know!"

Father sighed. "Where's this school?"

"On Colfax," I answered sullenly.

Father said, "Colfax? Out near Hip Sing? Your mother's right—how are you going to get there every day?"

"There's a school bus!" I answered. "Don't you think I know anything? Why would I want to go to a school I can't even get to? Why do you guys think I'm so stupid all the time?"

Father shook his head. "Who says you're stupid?" I opened my mouth, but he continued before I could say anything: "Fine, you want to go to school downtown, there's a school bus to take you, we'll sign the papers."

"Always so lenient!" Mother said. "Your daughter wants to do anything, you let her. What happens if there's an emergency? How will we find her?"

"Hush up, and give me a chance to think," Father retorted. He turned to me. "What language are you trying to learn?"

"German," I said in English.

Father opened a bureau drawer. "Ger-man, Ger-man. Let me find my book, you show me on a map. Ger-man. It can't be bad to learn another language." He sighed. Then, as if he'd just remembered Mother's question, he asked, "Now *where's* this school?"

"On Colfax."

"Colfax. Now Colfax, I know. It's a long street, but very straight. You can't get lost on Colfax. I'll be able to find your school." He grinned at Mother triumphantly. Still grumbling, she signed Father's name to the forms.

In the fall, I registered at East, planning my schedule around German, which—due to my letter—I was now obligated to take. Unfortunately, this complicated my schedule so much that I wasn't able to arrange for any classes at Manual. Kezia wasn't interested in cross-registering at East. A few months into the school year, our friendship began to disintegrate. Suddenly we

had nothing in common. The few times that we saw each other, we didn't seem to have much to say. Eventually we stopped making the effort.

I was terribly lonely at East. Hardly anyone from my junior high went there; the few who did were not my friends. East, I discovered, was even worse than Hill. The kids were even wealthier, even more poised. They knew each other from weekend ski trips and intramural sports—activities in which I'd never participated. They were beautiful, dressed well, and dated.

I hadn't had a boyfriend since Lindsey. Consumed with guilt about my early sexual activity, I wouldn't have known what to do with one now, in high school. I vacillated between an image of romance as the fulfillment of the Platonic ideal—the soulful joining of minds—and powerful bouts of sexual longing that embarrassed me. I struggled to hide my sexual desire for boys, expressing my unrequited crushes in platitudes about "soulmates," framing everything in terms of intellect.

I understood that my classmates kissed and touched—I even had a friend who jokingly commented that her boyfriend was becoming "nothing more than a sex partner." But I didn't judge them by the same rubric that I judged myself. They were, after all, white and American. They were allowed to have flaws, while I was not.

Whenever my body began to ache, unprovoked, heavy with sexual desire, I would pretend to be someone else. I stopped short of assuming the role of a real person. Sequestered in my bedroom, I made up fantasies about being some anonymous, slutty white girl—a *Playboy* bunny, stripper, or porn star. Women whose roles had been reduced only to sex. Women so unlike myself that assuming their identities felt safe.

I was miserable at school, at home, and at work: Business at Davey's Palace got worse, and Davey sold the restaurant. The new

owner, George, wasn't sure he wanted a Chinese kitchen. He wasn't sure he wanted a restaurant at all—he planned to turn Davey's Palace into a comedy club. On weekends I saw him leading groups of gray-haired, business-suited men through the interior. He pointed at the carpet, the walls, the kitchen. He used words like *acoustics*, *backstage*, and *seating capacity*.

While George planned, he kept us in limbo. "A trial period," he promised. "Who knows? Maybe I'll like having a Chinese restaurant." He slipped into a booth and asked Violet to take his order. He paid for his meal with a pair of tens.

In his last days as owner, Davey had switched us to plastic tablecloths. These had become sticky with use; their residue stained our customers' clothes. People swore and demanded refunds. They demanded payment of their dry cleaning bills. Aunt Becky stood behind the service window helpless, hands on her hips, expression furious. We couldn't afford to pay for customers who would never return anyway.

We stripped the tables bare and used paper placemats. "Which sign are you?" the customers grinned, studying the Chinese zodiac.

"Cheap," Violet answered to herself, smoking in the service hall. "We've become cheap. If only Annie and Casey could see."

My mother took the U.S. citizenship exam and passed. She came home with a miniature American flag. Father sighed and looked at me. He said, "We're the only two Chinese left."

"How dare you say such a thing?" Mother asked. Her face was angry and shocked. She stuck the flag into a pencil holder on her bureau. "You know I'm only doing this to sponsor my brother's immigration."

"Sure, sure," Father teased. "You're becoming so smart. First a driver's license, now this."

Mother dismissed him with a wave. "Don't be ridiculous. You know they're only pieces of paper to keep."

I picked up the flag and twirled it wistfully, thinking about the American rites of passage. I couldn't become a citizen until I was eighteen. I'd turned sixteen and had yet to get my driver's license.

I said to Father, "If you let me practice with your car, I could get my license."

"Naw!" Father growled. "I need it for work. Don't they give you practice time at Triple-A?"

I groaned. "Father! The class ended weeks ago. Besides, they only teach you basics. You're supposed to practice at home to get comfortable."

"Don't be ridiculous," Father said. "What did I pay them for? If you need more practice hours, we'll enroll you in another course."

"But Aunt Becky lets San—"

"No." Father snapped open a newspaper.

I jammed the flag back into the pencil cup and left my parents' room.

I didn't understand why he was being so unreasonable. All the kids in my class had already gotten their licenses—and cars, as well. Hondas, Volkswagens, Toyotas. A wood-paneled GM station wagon. An old battered Beetle, nicknamed the "serenity-mobile." One girl even drove a secondhand red Mercedes. Nobody my age rode the school bus anymore. I hated being such a freak. I hated my parents for not helping.

Junior year, the kids at school started talking about college. Harvard, Princeton, Yale, MIT, Vassar, Brown, Bryn Mawr. These were the names whispered by the college-track students, the labels my classmates aspired to, replacing Izod, Calvin Klein, and Ralph Lauren. The kids shuffled brochures on desktops, planning trips with their parents to tour the schools "back East." They smiled at me kindly. "You're so smart. *And* you're Chinese. You could get in anywhere. Which schools are you visiting?" they asked.

Full of bravado, looking up from my spiral notebook, I told them, "I'm really thinking of attending country *abroad*. Oxford or Cambridge. I'm a British citizen, you know."

"British?" they asked, disbelieving. One girl told our guidance counselor that I was a compulsive liar.

I confronted her in the hall, between classes: "Hong Kong is a *British Crown Colony*," I spat. "I'm a citizen of Hong Kong. Therefore I'm *British*!"

"So you're really going to Oxford?" she asked, her eyes doubtful.

"If I get in," I muttered, stalking away, wishing fervently that I knew how to apply. I would have given anything to leave this country for one where I could feel like I belonged. I half-believed that citizenship itself could effect this transformation.

As the year progressed, my classmates began making summer plans. Harvard and Yale summer school. Cultural exchange trips to Japan. Volunteer opportunities in Central America. "What are *you* doing?" they asked me curiously. "No matter how smart you are, it can't hurt to pad your college applications."

I shrugged, feeling stupid and out of it. Not only couldn't I afford a summer excursion, I hadn't even *thought* about trying to pad my college applications. What did I know about college? My parents couldn't even speak English.

Then, triggered by my PSAT scores, an application to the Telluride Association Summer Program arrived in the mail. According to the brochure, the program was a six-week, scholarship-only seminar at Cornell University, in Ithaca, New York. Grateful for the word "scholarship," I completed the application immediately.

In the early spring, the selection committee called to schedule an interview. I was one of only three students at East and Manual combined to have made it to this stage.

* * *

The interview was scheduled for two o'clock on a Sunday afternoon, but Father refused to drive me. We sat in the kitchen at eleven that morning, discussing the conflict. He wore pajamas printed with brown medallions. His hair was uncombed. He blinked at me through a haze of cigarette smoke.

"I have to go," I explained patiently. "It's very important. They're only talking to three kids from my school. It's a scholarship program. It'll help me get into college."

Father exhaled. Smoke hovered in the sunlight between us. Dust motes floated in the blue-white cloud. He tapped his cigarette on the ashtray rim. "It's too far. I don't know where it is. I have to work, and what about you? You're waitressing tonight."

"My shift doesn't start until four. The appointment's at two. It'll last, what, maybe an hour? So three o'clock. Even if it takes an hour to drive back from Englewood to the restaurant, there's enough time."

My father frowned. "What am I supposed to do? Drive back and forth an hour each way to drop you off and pick you up? You said the interviewer was talking to you alone, nothing for me to do. It won't work. Isn't there a bus you can take?"

I sighed in frustration. "No. It's too far out."

"Then you can't go."

"*Father.*"

He stubbed out his cigarette. "There's nothing to discuss. With everything that's been on my mind lately, I don't have time to think about this, too." He rose and left the room.

I scowled at the notepad on the table. I'd transcribed the directions to Dr. Ritvo's house in excruciating detail, every turn in the road, every exit number, every landmark. I wanted this scholarship badly. In addition to its prestige value, the scholarship would grant me an opportunity to travel. Since arriving in America, I hadn't left Denver—not unless you counted the Loveland racetrack.

Mother entered the kitchen, her slippers slapping gently on the bare floor. She sat in Father's chair, not commenting, although conversations floated like smoke through the thin walls and small rooms of our house. "What do you want for lunch?" she asked. "Noodles? Or should we go to McDonald's? Kentucky Fried Chicken? We haven't been there in a long time."

"I want to go to this interview," I said softly. "Why won't he drive me?"

Mother looked annoyed. "Ah, Yee, why won't you be mature? You know this isn't a good time. Your father's very anxious about Aunt Becky and Uncle Andy leaving to work for Annie and Casey. He's never run his own kitchen before, and with business the way it is, and George not even sure he wants us—"

"Mother, I know—"

She continued, undeterred, "—and me quitting Canton Landing. You know we always had that, at least, some extra money. But now I have to go help your father."

"Don't you two want to be boss? You're always complaining—"

She laughed, "Ah, Yee, you have to understand—it's easy to complain. That's why everyone does it. But to be boss? It only means more worry. Before, it didn't matter whether there was business or not, we always got paid. Now we have to pay people and wait to see if there's enough left over for us."

"Not until summer," I reminded her. "Maybe business will improve."

"Improve? It would have to improve a lot. No, Yee, things aren't the way they used to be, with Annie and Casey and their rich gambling friends. Now everyone's died or gone to Las Vegas." She sighed and looked out the window. "I'm even wondering whether it's a good idea for your uncle to come . . ."

"Mother!" I exclaimed, horrified.

She blinked. "Never mind. I don't mean it."

I doodled an eye on my notepad. In the background I heard water running—my father in the bathroom. I wished he would

change his mind. I drew a stick figure on a skateboard. I wished I could drive.

Mother said, "He's afraid, you know."

My pencil stopped. I looked up. "Huh?"

"He's afraid of getting lost."

I pointed at the notepad. "I have directions."

"How's he going to read them? He doesn't know English."

I stared at her dumbly. I honestly didn't understand. "But he drives," I stammered. "He takes us places."

Mother looked sad. "Only places he knows. Never far, because he has to memorize directions. Why do you think we never visit your Cousin Dani? Her new house is too far away. He's afraid he'll get lost. And then what would he do? He can't read street signs. He doesn't speak enough English to ask directions."

"But it can't be that hard," I protested, refusing to believe her. "He doesn't need to read very much. Just a few street names, exit numbers, things like that. The next time he needs to go anywhere, I can call to get directions for him, and write the street names on a sheet of paper. All he has to do is look for that name on a sign."

Mother shook her head. "Crazy daughter," she said softly. "It's not that easy. There are so many signs, so many words to sort through. You know English, so you don't understand. It's not as easy as you think."

"Father's not stupid," I told her defensively.

"I never said he was—"

My father's voice came from the hallway, interrupting us. "What's all this talk?" he grumbled.

"Nothing," I said quickly, embarrassed.

He walked into the kitchen. He'd gotten dressed. His hair was combed, and he carried a sport jacket over one arm. "Come on," he said. "We should run our errands now if you want to get to the interview on time."

Mother started in surprise. "Shing . . . ?"

"Don't make a fuss," he growled.

I felt too overwhelmed to look my father in the eye. I hurried out of the room to get ready.

We pulled up in front of Dr. Ritvo's house. Father opened his wallet and handed me a twenty-dollar bill. "For a taxi to the restaurant," he explained. "If it's not enough, I'll pay the rest when you get there."

I folded the bill and stuck it in my pants pocket. "Do you remember how to get back?" I asked.

Father averted his eyes. "Yeah. Don't worry about me. Don't think about that. Just do well on your interview. I'll see you later."

I hopped out of the car and watched him drive away.

I spent the next hour discussing Plato with Dr. Ritvo.

"So is the world of ideals more important than the world of actuality?" he asked.

I answered earnestly, "Yes, if you believe that objects cannot exist before the *idea* of them does. You know, the old, 'concept of the table before the table.' Plato's cave and all."

Dr. Ritvo glanced into a file folder. "I see from your application that you write poetry. What does Plato's cave mean for you in terms of your poetry?"

I considered the question. I said, "I guess that in many ways I believe that the written word constitutes a reality of its own. Like the way a character in a novel seems to take on a life outside of the page. How many times have you gone on thinking about a book after you've finished it? And been so affected by the story that you make up futures for the characters, extending beyond the author's ending? That's what writing is for me, the creation of a reality that in many ways is more powerful than the actual world."

"Fascinating," Dr. Ritvo murmured. He glanced down at his notebook. "I think we've covered everything. You know that the

title of the seminar is 'Representation in Literature and the Visual Arts.' If you're accepted, you'll be discussing many of these same issues. The curriculum hasn't been finalized yet, but I know you'll be reading Plato and Nietszche—two of your favorites—as well as some works of fiction. And of course there are slides, for the visual arts part of the seminar. Are you still interested?"

"Of course," I breathed. "I can't imagine anything more exciting than talking about this for the entire summer."

He laughed. "You might want to slow down, so you don't burn yourself out before you're thirty."

I blushed. "Everyone's always calling me 'intense,'" I admitted. "But I can't figure out what that means."

Dr. Ritvo said, "Everyone I met during my summer at TASP was intense, so you'll fit right in—even if you don't know what the word means." He looked at his watch. "Are you okay getting out of here? Or do you need directions to get back?"

I stood up. "Actually, I'd like to use your phone. If that's all right." My palms were damp; I wiped them on my thighs. "I need to call a taxi," I explained.

"Oh." Dr. Ritvo looked surprised. "You didn't take a taxi all the way here, did you? We could have met during the week at my office downtown."

"That's okay," I said quickly, anxious to make a good impression. "It's just . . . my father dropped me off, but he needed to get to work."

"On a Sunday?"

"Yeah, we have a restaurant. That's where I need to go, too. I waitress on Sunday nights."

"Why don't I drive you?"

"Are you sure that's okay?"

"Sure, no problem. I have some free time."

"Okay," I said, feeling awkward and embarrassed. I wondered how this would influence Dr. Ritvo's report to the selection committee.

* * *

"It's near Tamarac Square," I told him, buckling my seat belt.

Dr. Ritvo turned the ignition. "Southeast Denver," he commented. "That's easy enough. But you should have told me it would be a problem coming to my house. We could have rescheduled."

"It wasn't a problem," I insisted. "Really." After a pause, I added, "Besides, you said today was best for you, and it didn't matter for me, so, well, you know . . ." I let my voice drift off.

Dr. Ritvo changed the subject: "How often do you work?"

"Every weekend." I wiped my hands on my knees. "I bus tables on Fridays and Saturdays, and I waitress on Sundays."

"Do you like it?"

I shrugged. "I guess I'm mostly just used to it. We've run the restaurant since I was little."

"What kind of food?"

"Chinese. Some American, but mostly Chinese."

"I should try it sometime."

"Oh, you should!" I agreed. "Business has been slow because of the mall, but we have the best food. Anyone who's tried it will tell you."

He didn't respond, so I rambled on, filling the silence. "We have some regulars who've been coming in for years. At the restaurant and the bar. This guy Bud who comes in all the time calls it a 'family bar.' I guess that's kind of weird, because families don't come in to drink. So maybe he means the people at the bar are like a family to him. He's older, maybe fifty, but he hangs out with this guy Scott all the time. Scott's barely twenty-one. He has a Sunbird convertible with a hard top. Last summer, when I was learning to drive, he let me practice in it, with the top off."

Dr. Ritvo made a noncommittal noise. He said, "It sounds like you have quite a rapport with them."

"Oh yeah," I said confidently. "We all do. This one waitress, Vi, she's been working there for years, and she knows everyone. She says that Bud's having an affair with Scott's mother, but Scott denies it."

"What's Vi like?"

"She's about five-two, but she always looks taller, because she wears platform shoes and piles her hair on top of her head. She's fifty, but she looks great—that's because she's had two facelifts and dyes her hair red. I'm not telling you any secrets, by the way—she tells everyone. She loves plastic surgery. She's English. Her first husband was killed in the war. She drinks one margarita at the end of every shift."

Dr. Ritvo laughed, "That's some detail."

"It's a gift," I joked.

"Okay, tell me about some of the other people at the restaurant."

"Who do you want to know about?"

"Tell me more about the people at the bar."

"Okay. There's this bartender Bucket. He's been working there forever. He's about six-four and has a mustache like Burt Reynolds. He's pretty good-looking, I guess, but he's not my type. Plus, his hair's thinning on top. It's hard to tell, because he's so tall, but when he bends over, you can see. He always has girl-friends—really young girlfriends—but he won't commit. Vi says he'll be sorry when he's an old man."

"How old is he now?"

I frowned. "I don't know. Thirty, thirty-five."

"Is he the only bartender?"

"No, there are others. This one Michael, who's really cute. He wants to be a comedian. Todd, who's from Boston. He's married, but we think he's having an affair with one of the cocktail wait-resses. Let's see, there's also Leo. He gave my little brother a toy whistle once. Oh, and Chuck. I love Chuck. He's gay, and he has a black boyfriend. Sometimes on Chuck's nights off, they come in

together, in matching sequined outfits—only Chuck's is white, and his boyfriend's is black!"

There was a silence. Dr. Ritvo cleared his throat. "Well, that's really something," he finally said.

"Yeah." The car rolled past green highway markers. We neared our exit.

In an effort to be polite, I asked, "So where did you end up going to college?"

"Harvard."

"Did you like it?"

"I did," he said slowly. "But the thing is, it was a little of a disappointment after TASP. Not nearly as intense."

"Huh." I stared out the window. I had no experience to draw on, nothing to add. I said, "And then medical school, huh?"

"Now *that* was intense." He chuckled.

"What kind of doctor are you?"

"A psychiatrist."

"Oh, wow. Do you like it?"

"Absolutely." He turned onto Hampden. "There's nothing more fascinating than the way people's minds work."

"Oh yes. The world of the imagination. The ideal world." I laughed, glad to be back on safe ground.

"Not quite ideal," Dr. Ritvo commented. He peered out the windshield. "Okay, tell me where."

"Up ahead. There." I pointed.

He pulled into the parking lot. "So this is it," he said curiously. He rolled down his window and stuck his head out for a better look.

"Yeah, remember, come by for dinner sometime!"

"Maybe I will." He waved good-bye.

"Thank you!" I called after him.

I entered the restaurant through the side door and waved hello to the day shift bartender. I turned left, in the direction of the kitchen.

Strange, the dining room lights were off. Father usually turned them on. He came in, unlocked the kitchen door, turned on all the lights, and brewed himself a cup of coffee before starting work. I walked down the hall. The kitchen door was bolted. No lights in there, either. I began to feel panicked. Oh God, what if he got lost? What if he was in the middle of Broomfield without a way to get home? I walked back toward the bar. Maybe I should call the police. What would I tell them? My head was all muddled. I stepped outside to think.

I pushed through the side door just in time to see his car jerk into the parking lot. It swerved around the back of the building, where we always parked. I started walking toward it. I heard the slam of the car door, then Father appeared in view, rushing around the corner of the building. His arms were swinging wildly, his eyes were wide, his mouth tense. "Why didn't you wait for me?" he panted. "Why didn't you stop?"

"When?" I asked, confused. "My interviewer drove me back so I wouldn't have to take a taxi."

"I know! I was there! I parked across the street to wait for you. I honked when you came out of the house. I followed you all the way, honking. *Beepbeep! Beepbeep!* Didn't you hear me? I chased after you on the highway." His voice broke. "I thought I would get lost."

I bowed my head, ashamed of how much I had liked Dr. Ritvo. I pulled the crumpled twenty out of my pocket and gave it back to Father.

I got the scholarship.

Against Mother's protests, Father gave me permission to go. He bought me a suitcase and a plane ticket, and on the morning of June 26—his birthday—I boarded a plane for Ithaca, New York.

Telluride House was a big stone residence on the periphery of the main Cornell campus. It was three stories high and had a big

wooden porch overlooking the front lawn. The House was silent when I arrived. I ascended the front steps gingerly and wandered through an empty foyer, parlor, and library before hearing faint voices down a flight of stairs. I followed the voices down to a ground-floor dining room: I'd arrived late, in the middle of the TASP welcome meal.

There was a hush as I entered the room, then Levin, the college-age student advisor, stood and introduced himself. He helped me find a seat at one of the long tables, and handed me a plate. The meal was buffet-style. In celebration of our first night, the main dish was a vegetarian lasagna. There were also green beans, bread, potato salad, and chocolate chip cookies. I scooped out a portion of lasagna and sat picking at it, too nervous to eat.

In all, there were twenty-eight TASP students—fourteen assigned to the art seminar in which I was enrolled, and fourteen to a seminar on politics. For a few brief moments that first night, the other TASPers were strangers to me, a random collection of hair colors, first names, and regional accents. Then, after the usual introductions—hello, how are you, where are you from, my name is—the conversation took an unusual turn. People began identifying themselves by their passions—harp music, avant-garde drama, the Episcopalian church, nuclear disarmament. For the first time, kids my age delved into what I meant when I proclaimed, "I am a poet." In about fifteen minutes I was engaged in five different conversations. I found myself relaxing, and if I didn't eat my lasagna, it was only because I forgot, not because I was afraid.

I was, I discovered, far from the most flamboyant member of this crowd. We were each a little bizarre, each in our own way. There was Sabrina, an alarmingly pale girl who listened to Kate Bush and quoted Ionesco. Kirstin, who'd come from New Jersey with a harp strapped to the back of her parents' car. David, who played the organ and wanted to be a priest. Jim, a beautiful, slightly androgynous boy who dressed entirely in black and

found sexual innuendoes in everything. Matt, a self-proclaimed genius who could cut you to ribbons with two sentences. Patty from Peru, who wondered where the maids were.

If I didn't fit in, at least I didn't stand out.

I stayed up past 2:00 A.M. talking to Jim on the fire escape. I said, "If there is no God, then we as individuals must define our own reasons for existing. But what happens when we can't find value in existence? How can we justify continuing to live? Isn't the real question—as Camus says—why *not* kill yourself, rather than why?"

Rather than talk about all I had to live for—the way everyone always did when I brought up these questions—Jim considered my words seriously and contributed his own interpretation of existential and nihilist philosophy, concluding every so often, "And if everything *is* meaningless, and there is no intrinsic value to life, then we should have as much sex as possible before killing ourselves."

No matter how extreme or absurd my arguments got, Jim refused to be shocked. I found him extremely attractive, scary, and soothing, all at once.

My roommate, Alice, was asleep by the time I crawled into bed. I pulled the covers over my body quietly, careful not to awaken her. I drifted off without another thought. Not long afterwards, hunger startled me into consciousness. I slipped out of bed and snuck down to the kitchen. Inside, there were two banks of refrigerators. Only one set was locked. I found leftovers in the other—lonely green beans, congealed lasagna, and a huge bowl of potato salad. I reached for the bowl of salad, cradled it in the crook of my arm. Beneath the glisten of Saran Wrap, the potatoes were yellow with mustard and egg yolk, dotted with spots of bright green peas. I peeled off the plastic, and drops of condensation sprayed my arms. I ate with a spoon, planning on just a few

bites, just a swallow to help me through the night. But I was so hungry, I couldn't help myself. I ate and ate, until I had finished the entire bowl—at least a gallon of potato salad.

I washed the bowl, hoping no one would notice the missing food. On the way out, I grabbed a handful of chocolate chip cookies. I ate them on the way upstairs. I returned to my room, brushed my teeth, and fell soundly asleep.

I tried to fast the next morning, but never made it past lunch. It was too difficult to focus on not eating when the conversations around me were so interesting. As the summer progressed, I lost the sense of hypervigilance over the other parts of my physical being: I stopped wearing makeup. I appeared in public wearing glasses, rather than contact lenses. I wandered into seminar wearing the same t-shirt that I'd slept in, adding only a pair of sweatpants for the professors' sake. And I ate. I raided the kitchen with the other TASPers in the middle of the night. I toasted and buttered English muffins. I snacked on cookies. I barely noticed the food. It was only energy, used to feed my brain. At the age of sixteen years and ten months, I suddenly discovered that I needed food to think clearly.

I did not have a similar epiphany regarding sex. I suffered my crushes, but continued to view sexual desire as wrong. I thought of desire as a weakness to be overcome by intellect—the smarter you were, the less need for sex. When my fellow TASPers began pairing off, I couldn't figure out what they were doing behind closed doors all the time. Concluding that they'd found their Platonic ideals in each other, I imagined conversations like the one I'd had with Jim on the fire escape the first night. I wanted that kind of connection. I believed that Jim was my Platonic ideal, but he became involved with Kirstin instead. So I resorted to honing my intellect publicly, with the assorted single students.

* * *

Seminar met for three hours every morning, excluding Saturday
and Sunday. Active participation was required, and we were
assigned one paper and copious amounts of reading every week.
In our free time, we were expected to socialize only with other
TASPers—the program was described as "semi-monastic," and
outside visitors were frowned upon, if not outright forbidden.

No one complained. We huddled on sofas and floors and stair-
cases long past midnight, past 1:00, 2:00, 3:00 A.M., discussing
our conceptions of God, reality, politics, even Liberace. We raided
the kitchen for our favorite breakfast foods before dawn, know-
ing that we'd be too tired to eat when it officially became morn-
ing. We walked to Collegetown to see the latest Indiana Jones
movie. We ate Chinese food and ice cream. We stood on street cor-
ners and sang—even I, who'd never been musical, who was afraid
of public humiliation, who'd learned to tune out music long ago,
so that I could complete my homework in the dining room at
Casey's Palace.

We were in love.

We reveled in our monastic state, wearing our seclusion like
holy garb, believing that we had been called by the gods of acad-
eme. We studied one another for marks of grace—an unblinking
stare, a particularly fevered pitch of voice. We found our leaders,
and built shrines to their personalities.

We were enamored of Guiseppe, our literature professor. We
loved his Italian accent, the way he pronounced "seminar," his use
of "problematics" as a noun. We congratulated him on his appoint-
ment to Yale. One student was so taken with Guiseppe that in an
argument over the correct pronunciation of "Nietzsche"—whether
the last syllable should be said with the soft "chuh," like a grunt,
or the hard "chee," like a sneeze—he told Michael, a student from
Germany, to consult the Italian professor.

There were cult figures among the students as well: Sanjiv,

who had a singsong Indian accent and described Bombay's monsoon season with glee. Ezra, a six-foot-two anti-nuclear pontificator who'd grown up without ever watching TV. And Matt, whose dead-eyed self-assurance suggested genius. He had a way of declaring you wrong without saying a word.

Matt was one of the TASPers I knew least well. He was in the politics seminar, and seemed uninterested in poetry. I was terrified of approaching him, not only because of his reputed brilliance, but also because he tended to be surrounded by acolyte peers. One day in the middle of the summer, I was sitting on the stairs when he came up to me.

"I hear you're a poet," he said, then paused, expressionless, to wait for my response.

"Yes," I answered, hoping to match his calm. "I am."

"Then I want you to do me a favor."

I cocked my head, excited despite myself.

"I want you to read 'Howl' for me. Aloud." He held out his copy of the Allen Ginsburg poem.

I took the book, opened it to the correct page, and began reading. Matt sat on the step below me. I was about ten stanzas along when, wordlessly, Matt took the book out of my hands. He closed it, stood up, and said, "Thank you." He walked away without explanation.

I had no idea what had happened, I had no reason for wanting Matt's approval, and yet I felt like a pile of rubble. I was sure that somehow I'd failed some test, and I was less of a poet for it.

If I had had the courage, I would have hated him.

Later that day, I described the scene to another TASPer. "Don't worry," he said. "Matt's not really that smart. Everything he knows, he learned by locking himself in a room with a pile of textbooks."

"That's pretty impressive," I pointed out.

My friend scoffed, "Yeah, but you can tell he's only read the words on the page. Half his vocabulary's mispronounced."

I blushed, knowing that I had the same problem, having grown up in a household of non-English-speakers.

My friend misinterpreted my expression. "Elaine, don't let him get to you. Just remember that no matter what he calls his neighborhood at home, it's still Queens."

I found myself missing Denver without knowing it. Alice said that I talked about Denver all the time. "Prairie dogs, Rocky Mountains, I'm sick of it," she grumbled. But I persisted. I complained about Ithaca's thick, sea-level air, the lushness of the trees, the empty sky to the West—I couldn't locate myself without the mountains. Running errands around campus, I was constantly getting lost. Once, in Collegetown, Alice and I needed to flag down a police car to drive us back to Telluride House.

I prowled the mailboxes for letters and care packages. But I never got anything. My parents and I didn't read the same language, so letters from them were impossible. Jeff was only ten and not a natural writer. San sent me a letter once, but it only contained my SAT scores and a message from my parents—*Do you have enough money?* I wondered whether my family missed me. Whether they loved me at all.

I called home every Sunday, just to check in. The conversations were always the same, always five minutes long: *How's the weather? Are you eating enough? What are you eating? Do you understand your lessons?*

I wanted to tell my parents about my revelations, but I didn't have the language for it. How could I describe my essay on Narcissus as metaphor for the artist? How could I talk about our debates over the existence of external reality? My family and I didn't relate to each other on this level.

Conversely, I was unable to explain the brevity of these conversations to my friends. "Don't you get along with your parents?" Alice asked sympathetically.

I said, "I do, but they don't speak English."

Confused, Alice said, "I thought you spoke Chinese."

"I do," I answered sadly. "Just not enough."

The weeks wound down. One day during our last week, I saw a TASPer leaving the administrative office looking embarrassed but happy.

"What's that about?" I asked Alice.

"Oh." She nodded sagely. "He saw his recommendation."

"We can do that?"

"You can if you didn't waive the right to view your file. Go ask Levin."

My pulse quickened. I wondered what Dr. Ritvo had written about me. I nudged Alice. "Come with me."

She shook her head. "Not me. I already got into Yale. Why look back?"

"Curiosity?" I suggested, envying Alice her security. She was skipping senior year of high school, and would be going straight from TASP to Yale. I wished I didn't have to put up with another year at East.

Alice yawned. "You go ahead. There should be other people in the office. I'm going to lie in the hammock. Come get me when you're done."

She headed for the back of the house. I went to find Levin.

Minutes later, I was leaning against the office desk, holding a manila folder with my name on the label. I leafed through it, looking for Dr. Ritvo's recommendation. It was handwritten and very short, two paragraphs on a single-sided notebook page. I read it quickly and closed the folder.

A TASPer named Steve was sitting in a chair reading his at the same time. He looked up. "How was it?" he asked in his thick Long Island accent.

"Fine," I said, not meeting his eyes.

"Tell me what it says," he wheedled teasingly.

I smiled weakly. "No, I wouldn't want to embarrass you with my brilliance."

"That good, huh?" He chuckled.

"Yeah, listen, I'm going to get some air." I slipped my file into Levin's mailbox. Steve was talking, but I couldn't hear the words. My head buzzed. The office was too dark. My face felt hot.

I walked out onto the porch, stared out past the lawn. No grass, no trees, no sky, no mountains. All I could see was Dr. Ritvo's handwriting, a single phrase repeating itself inside my head: *Vivid descriptions of the characters who inhabit the seedy restaurant where her father is a line cook.*

Seedy restaurant.

Line cook.

I wondered if I really needed to go home.

12

Radcliffe

"Bennington. Hampshire College. University of Chicago."

Mrs. Braverman shook her head. "I was thinking of Radcliffe for you."

"Radcliffe," I repeated, pretending to know what she was talking about. "Okay. I'll apply to Radcliffe."

Mrs. Braverman smiled. She'd wanted to go to Smith herself, but gave it up to support her husband through law school. "I suppose they call it Harvard now, for girls as well as boys. In any case, I think it's a good choice for you."

"I don't know," I answered doubtfully. "They have requirements there. And grades. I'd rather go to a more experimental college."

"That's what you *think* you want. But rules might be good for you. You can't skip class to write poetry all your life. Now, what about somewhere in-state? You're applying to CU, of course—"

"No, I'm not."

My English teacher looked surprised. "But it's the best of the state schools, and you need a safety school."

"I'm not applying to any schools in-state."

Mrs. Braverman laughed. "Elaine, my dear, *you* know that

you're brilliant, and *I* know that you're brilliant, but the Radcliffe admissions board might not know it. Let's be practical. This isn't the time for you to be arrogant—"

I opened my mouth.

"—or 'principled,' as *you* would call it. Besides, you have to consider the Boettcher. You have a very good chance of getting a Boettcher, which would pay for all four years of college. Full tuition, full expenses. But only in-state. You know that."

"What about Radcliffe?" I asked petulantly.

"You could still choose Radcliffe. But let's say, let's just say, that you don't get in. Wouldn't it be nice to have the option? You could go to a school like Colorado College, which is a very fine college." She grinned wickedly. "You know who's there, don't you? Chris Weaver."

I blushed.

Mrs. Braverman winked, knowing that I'd had a crush on Chris two years earlier.

"Nothing in-state," I repeated.

Mrs. Braverman sighed. "Elaine, someday that arrogance is going to get you in trouble."

I didn't answer. I didn't want to explain that it was fear, not arrogance, that motivated me. If I applied to an in-state college, I wouldn't have any excuse not to apply for a Boettcher. If I applied for a Boettcher, I might get it. If I got it, there wouldn't be any reason not to accept. And if I accepted, I would never get away from home.

I'd cried every day in the two months since returning from TASP. I missed my friends. I missed hanging out in dark cafes. I missed going to obscure foreign-language movies. I missed the daily discussions about art and philosophy.

Whenever the pain seemed to recede, and I cried a little less, I prodded the longing again. I reminded myself of how miserable I was, afraid of slipping back into my old life. I didn't want to be stuck worrying about a failing Chinese restaurant forever.

* * *

While I was at Cornell, Little Uncle had arrived from Hong Kong. He'd moved into a room in our basement, and worked for my parents at the restaurant every day except for Tuesday—Father's old schedule. He was shorter than I remembered, more frail, more defeated-looking. His hair had gone gray. He never laughed. He moped around the kitchen listlessly, doing everything my parents asked: He carried a colander of peeled shrimp from the sink to the refrigerator. He counted squares of pressed duck and gave them to my father. He demonstrated no affinity for these tasks, no ability to withstand their tedium. He often stood out on the back stoop, staring into the darkness and smoothing the hair I remembered as black.

Watching my uncle shuffle through the house and restaurant, I couldn't bring myself to feel anything but annoyance and guilt. He embodied everything I hated about my family—the inertia, the displacement, the lack of hope. Every time he released a baleful sigh, every time I teased him and he did not laugh, every time he interrupted my writing with a reminiscence about Hong Kong, I gritted my teeth and scribbled more furiously, refining my college application essays.

Applying to college required more of my parents' input than I'd anticipated, and I was frustrated by their lack of support. Mother refused to supply basic information about our finances. "How much can we afford to give you for college?" she asked incredulously. "We can't afford anything. You tell me you're so smart, why don't you get a scholarship and go for free?"

"Please give me a copy of our tax return," I begged.

Mother was furious. "No. This is not something that children need to know."

"But I need it to get money to go to college."

"Don't be ridiculous. I told you already. Colleges give you money for being smart. How much your parents make has nothing to do with it."

"Harvard gives need-based scholarships," I explained patiently.

"Then it can't be a very good school," she retorted. "The students there must be stupid, if they can't qualify for academic scholarships."

I sighed. "No, Mother, the problem is that everyone there is smart, and Harvard wants to make sure they can all afford to attend."

"That doesn't make any sense," Mother insisted. "In China, the smartest students always go to college for free. The government makes sure of it."

"It's different here—"

"I know, what a rotten country, what terrible schools . . ."

I let her rant. Eventually, she gave me a copy of their tax return. I was shocked. My parents made sixteen thousand dollars a year—roughly the cost of tuition at Harvard. I didn't understand how this was possible. We had our own business, we owned a house. How could we have so little money? In the end, confused, I could only conclude that we were normal. Harvard was out of whack. Its tuition was unrealistic and exorbitant. No one could possibly afford to pay that much. No wonder seventy percent of the students were on financial aid.

I asked my parents for a check to cover the Harvard application fee. Again Mother yelled, but Father passed me the checkbook. I wrote it out, and he signed, the way we handled all our bills. I xeroxed the application and tucked the original in an envelope. I licked the flap, counted out the correct postage, and mailed it off. I stood at the mailbox, imagining myself discussing Plato in a Cambridge cafe.

The Bennington application required a recommendation from my parents, so I threw it away. Until that moment, Bennington had been my top choice. Now it was Harvard.

A few weeks later, I asked my parents for a check to cover the Princeton application fee.

"Didn't I already give it to you?" Father asked.

"That was for another school."

Father snorted in disgust. "In China, you write one application, and the government assigns you to a university."

"Father," I said impatiently, "this isn't China."

He handed me the checkbook. "This is the last check," he said, averting his eyes. "I can't give you any more."

I saved my tips to buy a money order for the Hampshire College application fee. I threw all my other applications away. Business was bad, and I was eating lunch, so I couldn't afford to apply to any more schools.

It never occurred to me that my family might qualify for a fee waiver. Even after discovering how much my parents made, I didn't think we were poor. I had nothing to compare their income to. I didn't know how much any profession made. I figured that two hundred thousand dollars a year—the President's salary—was the top end of the income scale. I didn't think any private citizen's salary could come close, not even that of a doctor or lawyer. In my mind, thirty or forty thousand dollars a year was wealthy. We were middle class.

Besides, I would have to ask the school guidance counselor for help to apply for a waiver, and that would be too embarrassing. I only knew of one classmate who was asking for fee waivers, and that was because he was applying to twelve schools. Everyone agreed that he was behaving like an idiot.

Three completed applications. Harvard, Princeton, Hampshire College. Now all I could do was wait. I vacillated between frenzied panic and arrogant, calculated faith. I figured that at the very least, Hampshire would take me. It was a lesser-known, experimental school that got a smaller volume of applications than the Ivy League. It needed applicants like me.

In my low moments, I thought about my less-than-perfect board scores and my near-failing calculus grades. I wondered

what would happen if all three schools rejected me. I considered applying to CU, which accepted applications through March. Then I imagined myself in Boulder with all the lacrosse and soccer players from high school, and I felt sick. Any cool I had relied on my arrogance and eccentricity. It would be erased if I ended up at CU instead of Harvard.

I decided not to go to college if all three schools rejected me. If I didn't get into Harvard, I would sit at home writing poetry. I would start an underground press. I would become famous subversively.

Then I took a look around the restaurant and I started feeling sick again. We were now called "George McKelvey's Comedy Club." There was a stage in the bar where professional comedians and wannabes performed six nights a week. Only a banquette partition separated the bar from the dining room. At eight o'clock, when George or Charles, the club manager, dimmed the lights, the dining room would be thrown into darkness as well. When the restaurant customers complained, George grumbled, "They're lucky. We could charge them cover. They're seeing a top-notch comedy show for free."

But our customers didn't want to see the show. They wanted to talk. George and Charles repeatedly shushed them, and after a while, even our regulars went away. Mother fired all the dishwashers and busboys. Only Lisa and I remained, both of us waitresses now. On Saturday nights, counting our single-digit tips, we would look at each other and say, "We must be here out of love, because it sure isn't for the money." I knew I was stuck. I often wondered why Lisa bothered to stay.

George offered half-price food specials to boost bar business. There wasn't enough volume for us to make up the difference. We were losing money on the deal, but didn't know what to say. Where would my parents go if George closed down the kitchen?

I told Charles that Little Uncle was a talented photographer. "Practically professional," I said. "It's his life dream."

Charles said, "We could use a photographer for publicity stills.

Ask your uncle to take a few rolls. We'll reimburse him for the film."

When I told Little Uncle, he smiled for the first time in months. I led him into the bar one afternoon, and he assessed the room for angles and lighting.

"This will be difficult," he murmured. "So crowded, so dark. I'm not sure I can do it."

"Please," I begged, thinking about the way Charles looked at my family, his eyes pitying, his mouth twisted in a sneer.

Little Uncle shook his head. "I can't. The pictures won't turn out."

"You never want to do anything," I snapped, almost in tears. "If you tried, you could get a job as a photographer. You wouldn't have to sit in our basement being sad. You could do something you liked."

My uncle seemed to shrink before me. "Little Yee," he murmured. "Man Yee. Do you remember how many pictures of you I took in Hong Kong?"

I turned to walk back to the kitchen.

"I'll do it," he said softly, following me. "If you help me buy film, I'll do it."

The next weekend, he stood at the back of the bar with his camera. A show was in progress. The only light came from the stage.

"Action shots, close-ups," Charles instructed. "Tell him that's what we need."

My uncle edged between tables, angling his body for a better view. The customers shoved him. They gasped in annoyance. The camera clicked. Flashbulbs went off. The comedian blinked, lost his timing, began again.

Charles said, "Get your uncle out of there. He's ruining the show."

I led Little Uncle back to the kitchen. Returned to the bar. Asked Charles, "When do you want the pictures by?"

"As soon as possible," he said sincerely.

A week later, I saw him snickering over the snapshots behind the bar. He never paid us for the film.

* * *

On Sundays, Father and I went to work alone. Some nights we didn't have any customers, not even a takeout order. Father sat in the kitchen, smoking and watching TV. I sat at a booth in the dining room, reading and doing homework.

Sometimes on the way home, for no apparent reason, Father would tell me about his childhood. "I caught baby birds in the yard," he chuckled. "I fed them grains of rice from my own bowl . . ."

And I would feel like crying, thinking of my father starving in Toishan.

Late that winter, Little Uncle decided to leave. "He wants to try his luck in San Francisco," Mother said, half in sorrow, half relieved. "He has friends there."

He packed his bags, and we drove him to the airport. Jeffery cried. I was too stunned to have any reaction. In my mind, Little Uncle was still a voice on a tape recorder from Hong Kong, teaching me my name: *Mar Man Yee, ah? Mar Man Yee.*

As soon as I was called for a Harvard interview, I told Charles I had gotten in. "On a scholarship," I emphasized, meaning financial aid.

He smiled, glowing from cocaine. "That's pretty impressive," he said. "I was never very good at school. I'm much more of a businessman."

"I hear Harvard has a decent business school," I shot back.

Charles grinned. "Maybe someday you'll come back and buy us out."

He was flying. I couldn't hurt him, but still I tried. I said, "When I do, maybe you'll still have a job."

He laughed and excused himself to snort another line.

* * *

By the time I got in, I'd repeated the lie so often that the truth was anticlimactic: I was going to Harvard. On April 15, the real answers came—two fat envelopes and one thin. Harvard and Hampshire College wanted me, Princeton did not. Without waiting to consult my parents, I mailed off a reply to Harvard that same afternoon.

"Does this mean you're leaving?" Jeffery asked.

"Yes, but not until September."

He started crying. "First Little Uncle, and now you. I'll be at home all alone."

I tried tickling him. I didn't know what else to do.

When my parents came home that night, I told them—for the first time—that I was going to Harvard.

"Where is that?" Mother asked.

I showed her on a map.

"It's too far away. You can't go."

No, I thought, *don't stop me. I'm doing this for you.* Aloud, I said, "I already sent the reply."

"It doesn't matter. You can't go. What would we do if something happened to you? What if you got in trouble? How could I help you? It was bad enough when you went to New York for the summer, I was worried sick. I'm not letting you go to college so far away."

Father said, "Will you two hush up? A man can't think in his own house. Let me make some calls, talk to some friends, figure out what this Harvard is. We'll work it out."

Lying in bed that night, I talked to the God in which I didn't believe, praying for my parents to understand.

A week later, Father said, "This Harvard's a big deal. How did you get in?"

I shrugged, embarrassed.

"Kissinger went to Harvard," Father breathed reverently. "Kennedy went to Harvard."

Mother said, "So what? I'm not sending our daughter so far away."

"Oh, hush up," Father said. "I'm telling all our friends."

Mother sighed. "Your father's far too indulgent," she told me. "Letting you travel all over America."

I closed my eyes, thanking God, Jesus, the spirits, and Kissinger. I had not told Charles a lie.

I told my remaining regulars that I was going to Harvard. They slipped me extra-large tips and wished me luck. Irv and Barb offered me their daughter's castoff clothes.

Barb said, "You'll need new stuff for college, and Kelly has plenty of clothes that are barely worn. Nice wool pants and Polo sweaters. They'd probably fit you."

"Are you sure?" I asked hesitantly.

"You'd be doing us a favor," Barb assured me. "Kelly's growing like a weed. She'll never wear these things again."

I thought about my lunch money and all the lies I'd ever told Mother. But I was free now. I was going to Harvard. I could tell the truth. I said, "I should ask my mom."

Barb smiled. "Go on," she nodded in the direction of the kitchen. "I'd love to meet her."

I blushed. "She's not here on Sundays. We've been kinda slow lately. You know."

Barb rummaged in her purse, found a pen, scribbled on the back of a placemat. "Here. Call me. You can come by next Saturday afternoon."

I slipped the number into my pocket. After work that night, I told Mother about Barb's offer.

"How kind," Mother murmured. "What do they do?"

"He's a dentist. She works part-time in a clothing store."

"A dentist." She looked sad. "No wonder they can afford to give away clothes. Okay then. But be polite. Don't take too much."

The following Saturday, I walked from the restaurant to the Kesselmans'. They lived ten minutes away, in a two-story house

off the main road, cradled at the end of a cul-de-sac. Barb was home alone, with Kelly's discards spread all over the living room. She gave me a glass of Crystal Light, and we started sorting.

"What are you? A four? A six? Here, take this. Oh, this one should fit. And this, it'll look cute on you."

I held the clothes up to my body: A hand-knit Norwegian cardigan in a blue-and-white snowflake pattern, minutely detailed, anchored by a row of pewter buttons. Woolen Ralph Lauren Polo sweaters in heather gray, moss green, rusty orange. Khaki skirts from Liz Claiborne. Gray flannel trousers and heavy maroon wool slacks, lined with cloth that was thicker and softer than my parents' shirts. I thought about Saturday afternoons at Merry Simmons. I thought about Mother's words: *Be polite. Don't take too much.*

"It's too much," I murmured.

Barb said, "Oh, no, don't worry about walking, I'll drive you."

"But . . ."

"No, really, let me get a trash bag, it'll be easier for you to carry everything." She got up and went into the kitchen, returning with two black plastic trash bags and a fresh glass of lemonade. She handed me the lemonade and snapped open a trash bag.

"Sweaters," she said, stuffing them in the bag. "You'll need lots of warm stuff. I used to live in Philadelphia, I know." She paused to smile at me. "I wish I could come with you," she confided. "Denver's a cow town, no real culture. You'll love the East Coast. Harvard, now that's where Irv should have gone, but he couldn't, they had quotas back then."

I must have looked puzzled, because she added, "For Jews. There were too many Jews at Harvard, so they set quotas. You're lucky they don't do that anymore, because Orientals would be the first to go. WASPs hate smart people."

I laughed. "I didn't check any of the race boxes," I told her. "I didn't want special treatment."

Barb gave me a look I couldn't interpret. "They figure it out," she said gently. She shook out a skirt. "But enough of that, let's have some fun. Here, how about turtlenecks? Kelly loved them. She wore them all the time, but they're still good, no rips, hardly faded. You can't have too many turtlenecks. And how about this skirt? Perfect for summer. You'll need things for summer, too. Oh, and this purse, it was mine, but I don't use it anymore. *Take* it. It's beautiful leather, a Coach purse. What else do you want? Too bad your feet are so small."

I looked at my watch.

"None of that," Barb teased. "I told you, I'll drive you back. And . . ." She paused and became serious. "How often will I see you again? You're going to Harvard. You won't be a waitress at your parents' restaurant anymore."

"I could write to you . . ."

"Oh, don't be silly! Why would you want to waste your time doing that?"

I shrugged, blushing; I'd been serious. Barb continued stuffing clothes into trash bags, ignoring me.

Mother came to greet us when Barb's car pulled into the back lot. "Thank you, thank you," she said awkwardly in English, helping me drag the trash bags out of the back seat. Inside the kitchen, her mouth became tight. "Did you leave anything for their own daughter?" she asked.

I was too ashamed to answer.

At home that night, I sorted through the clothes a second time. I held the sweaters and pants and skirts against my face, inhaling Kelly's scent. I washed everything that didn't have a "dry clean only" label. I washed the turtlenecks three or four times, but the smell of Kelly's sweat wouldn't go away. I stuffed them into the trash barrels on the back porch, knowing that they would never be mine.

* * *

When the end came, it was almost a relief. One Saturday night that summer, shortly before I was due to leave, Charles intercepted us on our way out the door. It had been another luckless midnight closing. A thin web of hairnet still encased Mother's short strands. Father carried his jacket folded over his arm. Jeff was cracking himself up with his own jokes. I smelled like soy sauce and cigarette smoke. I had less than ten dollars to show for it.

Charles said, "I need to talk to your father. Will you translate?"

I nodded, though I knew that translation wouldn't be necessary. The expression on Father's face told me that he already understood.

Charles started, "We want to thank your family for all its hard work . . ."

I didn't pay attention, although I waited until he finished before opening my mouth. "George—"

Father cut me off, "Ask him when. How long do we have?"

I repeated the question in English.

Charles said, "Two weeks. A month if you need it." He extended his hand.

Father said, "Yeah." He turned and walked away. Mother and Jeff went with him.

Charles lowered his hand. He said, "Good luck at Harvard."

I stared into his eyes. "I don't need luck."

Charles looked away. "I'm sorry."

I followed my family to the car. "Sorry, sorry," Mother muttered sarcastically. "Thank you, sorry. They've been planning this all along."

Jeffery said every curse word he could think of: "Goddamn bastard bitch shit damn fuck I hate them."

I slid into the back seat in a daze. *Harvard,* I thought to myself. *Harvard.* I repeated the word like a mantra. I couldn't wait to get away.

Every night afterwards, we carried a few more trays, another tureen, another stack of bowls to the car at closing time. Father

set up the storeroom shelves in a basement room, and finally, twelve years of my life condensed into an eight-by-ten space. Twelve years over. Even if I came back to Denver, I could never return to the restaurant.

I packed for Harvard. I folded Kelly's clothing into an oversized duffle. I loaded my poetry books into a box and wrapped a cord around my typewriter case. I took my brother out to lunch. We sat up late watching TV with his hand on my knee.

The next morning, we drove to the airport. We put my bags on the conveyor belt and paid seventy dollars in excess baggage fees. "I'm sorry," I whispered, watching Father count out the bills.

He shrugged. "It can't be helped. Don't worry about us, we have jobs at Canton Landing. You concentrate on doing well at Harvard."

"The entire Chinese community knows," Mother added. "Don't you shame us."

I started to open my mouth.

"She won't shame us," Father said quickly, averting a fight. "She'll be another Kissinger. Too bad she wasn't born in this country. She could be President."

I squeezed my brother's hand. "Fee will be President."

"After *I* go to TASP and get into Harvard," he agreed.

We walked to the gate and waited for my boarding call. The loudspeaker hummed. I got in line.

"Be careful," Mother said, wiping at her eyes. "Call when you get there."

Jeffery let go of my hand.

Wordlessly, Father handed me a book of stamps.

The loudspeaker sounded again, *Final boarding call* . . .

I walked through the gate, located my seat, and buckled myself in. As the plane took off, I felt the pressure of tears building behind my eyes. I was shocked. All this time, I'd thought that I wanted to leave.

epilogue

The Second Immigration

Iremember the exact moment I became intimidated by Harvard
College. It happened in September 1984, on the steps of Thayer
Hall, the week before freshmen were due to arrive in Cambridge.
I'd come early, along with other members of the incoming class
(all financial aid recipients) who needed the extra money we
could earn by cleaning the freshman dorms. Difficult as the work
was, I felt comforted by our shared experience. The brochures
weren't lying, I thought in relief—I wasn't the only one who was
short of cash and having trouble financing a Harvard education.
And my future classmates weren't so scary; SAT scores shrink in
importance when you're scrubbing out toilets and mopping
floors. Roaming Harvard Square with them in the packs so char-
acteristic of students, I was lulled into a false sense of community.

One day, having finished our work, we settled on Thayer's
steps and started complaining about federal policies on student
aid. These were the Reagan years, and we were concerned about
recent cutbacks that could affect us quite directly.

"What's the new income cutoff?" someone wondered.

"Something low," I speculated cautiously, testing the group to
see just how similar our backgrounds were. "Maybe thirty thou-

sand?" I suggested, naming a figure that was nearly twice my family's total annual income.

The response was a disdainful scoff: "No way! Then my family would be *way* out of it."

By the time the rest of the freshmen arrived, I had the good sense to feel out of place. If these were the financial aid recipients, I reasoned, the other students must be even wealthier. Watching prep school alumni find each other, and seeing Harvard fathers rediscover old roommates as they helped their children settle in, I quickly realized that it was more than money that I lacked.

Before the end of Freshman Week, I was mimicking certain patterns of speech, saying "Exie" for "Exeter student," and exclaiming to a parent, "Oh, *you're* from the class of fifty-eight as well?" To which the alumnus said delightedly, "Yes! Is your father?" And I had to explain that all I meant was, as well as all the other members of the class of '58 I'd already met that day.

The most publicly embarrassing encounter was another conversation with an alumnus. A kindly man from a long line of Harvard graduates, he shared with me all the advice he'd already given his son. He seemed genuinely curious about my interests and hobbies and anxious to help me make the most of my college experience. Then, remarking on how proud my parents must be, he asked, "Where did they go to college?"

"They didn't go to college," I replied.

He was so confused by this answer that after a few awkward "oh's" and some frantic chewing of the ice from his glass, he excused himself to get another drink. Sometime later I discovered his son's middle name adorning one of the buildings in Harvard Yard.

I quickly learned to evade, or even lie, in order to avoid the agonies suffered Freshman Week. I spent the next four years creating excuses for my parents' failure to visit me, and pretending that I really would rather stay in the dorms over Thanksgiving and spring breaks to get work done.

I mixed up my stories only once: The month before graduation, I told half my friends that my parents weren't attending the ceremony because they were angry at me for not moving back to Denver afterwards. I explained to the other half that my parents were too busy with "business" to take time off. Eventually the two groups compared notes and confronted me about the differing stories. In response, I mumbled, "Well, it's a little of both. They're mad at me, and they're busy." I walked away with downcast eyes.

I didn't want to explain that over four years the distance between Denver and Cambridge had grown until I was as far away as another country. My parents weren't able to visit. Like my grandfather, I'd immigrated with no way to send for my family.